NEWPORT
FIRSTS

NEWPORT FIRSTS

A Hundred Claims to Fame

BRIAN M. STINSON

Published by The History Press
Charleston, SC
www.historypress.net

Copyright © 2018 by Brian M. Stinson
All rights reserved

Front cover, clockwise from top left: courtesy of Bonnie L. Mohr; author's collection; courtesy of Daniel Titus; author's collection; author's collection.
Back cover, top: courtesy of Library of Congress; *bottom*: author's collection.

First published 2018

Manufactured in the United States

ISBN 9781467119467

Library of Congress Control Number: 2017960346

Notice: The information in this book is true and complete to the best of our knowledge. It is offered without guarantee on the part of the author or The History Press. The author and The History Press disclaim all liability in connection with the use of this book.

All rights reserved. No part of this book may be reproduced or transmitted in any form whatsoever without prior written permission from the publisher except in the case of brief quotations embodied in critical articles and reviews.

Barbara Chapman and Patricia Caswell—two Newport educators who made a difference. Both cared deeply about the people and welfare of Newport, Rhode Island.

CONTENTS

Acknowledgements 11
Introduction 13

1. First Free Public School (1640) 15
2. First Baptist Minister (1644) 18
3. First Permanent Quaker Settlement (1657) 20
4. First Conferral of Masonic Degrees (1658) 24
5. First Written Constitution Guaranteeing the Right to Religious Freedom (1663) 28
6. First Conscientious Objection Law (1673) 31
7. First Court-Martial Trial (1676) 33
8. First Traffic Ordinance (1678) 37
9. First Intercity Stagecoach Service (1716) 39
10. First Spermaceti Candle Factory (1748) 42
11. First Medical Lectures on Anatomy and Surgery (1755) 44
12. First Trust (Business) Inaugurated (1761) 48
13. First Overt Acts of Violence against England (1764–1769) 50
14. First Society News Column (1767) 52
15. First Spinet Made in America (1769) 54
16. First Circus (1774) 55
17. First Act Prohibiting the Importation of Slaves (1774) 57
18. First Naval Engagement of the Revolutionary War (1775) 60
19. First American Surgeon General and First British Spy (1775) 62

Contents

20. First Independence Act (1776)	64
21. First Secretary of Navy (1777)	67
22. First Foreign Admiral Buried on U.S. Soil (1780)	68
23. First Newspaper Published Abroad by an Expeditionary Force and Foreign Newspaper (1780–1781)	69
24. First Medically Educated Dental Surgeon (1780–1781)	71
25. First Successful Smallpox Vaccination (1800)	72
26. First Gas Streetlight (1806)	74
27. First Methodist Church with Steeple and Bell (1806–1807)	76
28. First Defeat of a British Squadron (1813)	77
29. First Felt Manufacturing Mechanical Process (1820)	80
30. First Tomato Eaten (1822)	82
31. First Free Black Church (1824)	85
32. First U.S. Post Office Building Erected for that Purpose (1829)	87
33. First Trial Involving a Clergyman Charged with Murder (1833)	89
34. First Ambassador to Brazil (1841)	91
35. First American to Attend École des Beaux-Arts (1846)	93
36. First U.S. Naval Academy (1861–1865)	96
37. First Extensive Geological Survey of the Gobi Desert (1864–1865)	98
38. First Public Roller-Skating Rink (1866)	100
39. First Cattle Club (1868)	102
40. First U.S. Torpedo Manufacturing Station (1869)	106
41. First American to Introduce Coaching as a Pastime (1875)	108
42. First Lawn Tennis Court (1875)	110
43. First Plans and First Model for the Statue of Liberty (1876)	112
44. First Polo Introduced into the United States (1876)	115
45. First Marine Biological Laboratory (1878)	118
46. First Female Lighthouse Keeper (1879)	120
47. First Director of the U.S. Geological Survey (1879)	126
48. First Female Telephone Operator (1879)	129
49. First Opalescent Glass (1880)	130
50. First National Bicycle Society and National Convention (1880)	133
51. First Roller Polo (1880)	135
52. First Multi-Recreational Facility (1880)	137
53. First U.S. Men's Singles Tennis Match Sanctioned (1881)	140
54. First Shore-Based Naval Recruiting Training Station and U.S. Naval War College (1883 and 1884)	142
55. First American to Climb the Statue of Liberty (1884)	145
56. First International Polo Match (1886)	147

Contents

57. First Professional International Tennis Match (1889)	148
58. First Nine-Hole Golf Course (1890)	150
59. First African American Radiology Specialist (1894)	152
60. First Golf Tournament on a National Level (1894)	154
61. First U.S. Amateur Golf Tournament (1895)	156
62. First U.S. Open Golf Tournament (1895)	158
63. First Man to Sail Around the World Alone (1898)	159
64. First Parade of Automobiles and Speeding Arrest (1899)	161
65. First Distress Signal (1905)	164
66. First Submarine to Cross the Atlantic Ocean under Its Own Power (1917)	167
67. First Color on Film (Technicolor) (1922)	168
68. First Airplane Passenger Service (1923)	172
69. First *Fortune* Magazine Biographical Sketch (1930)	174
70. First Suspension Bridge Use of Shop-Fabricated Parallel-Wire Strands (1969)	178
71. First International Sail Training Races Ended in United States (1976)	180
72. First Non-Corrosive Stainless Steel Bus (1978)	183
73. First American Skipper to Lose the America's Cup (1983)	184
74. First Combined Emergency, Transitional and Low-Income Housing Complex (1989)	185
75. First Judicial Complex Named in Honor of a Woman (1990)	187
A Note on Sources	189
Bibliography	191
Index	203
About the Author	207

ACKNOWLEDGEMENTS

Of the information in this book, 99 percent was obtained at the Redwood Library and Athenaeum, located on Bellevue Avenue in Newport. The Redwood Library can make the accurate claim as being the oldest library building in the United States. The Library Company of Philadelphia, founded by Benjamin Franklin, is older, but it is not located in its original building.

I wish to thank the entire staff at the Redwood Library for their quick responses to my numerous requests. Most, if not all, of the staff members would go on to become friends. I want to thank former head librarian Lynda Bronaugh and the former special collections librarians, Lisa Long, Laurel DeStefano and Robert Behra. Robert was extremely helpful, always on the lookout for potential claims. When it came to the bibliography, Robert set the standard and pushed me to the limit, as I spent sixteen months doing the original bibliography for this book.

Myles Byrne and Jennifer Caswell from the library disposed of all related technical challenges. Keep in mind, the original manuscript was typed on a word processor and had to be transferred to Microsoft Word. Sounds easy, right? But it took more than two years of scouring the country to find the correct software to accomplish this feat.

And, lastly, to the former Redwood librarian Wendy Kieron-Sanchez, who, to this day, helps in various aspects needed to bring this book to life—thank you.

Acknowledgements

Daniel Titus and his staff at Salve Regina University took the enormous amount of photographs, negatives and slides and scanned them into the proper format. I thank Dan very much for his assistance.

I wish to thank George Herrick for sharing his knowledge of publishing and history and for always being accommodating and taking time for me.

An enormous debt is owed to Newporter Lynne Tungett. As the original publisher of *Newport Life Magazine* and presently *Newport This Week*, she published over the years an extensive amount of Newport firsts in all her publications, including the *Pineapple Post*. I appreciate her help and guidance; I treasure our friendship very much.

Thanks needs to be given to Mark McKenna. Not only did he produce many of the claims, but his vast knowledge of Newport is also simply amazing. Over the years, he spent endless nights at my apartment in the Christmas Tree House, poring over the finalized research and reading from the manuscript. This home is known as the Clement C. Moore House, located at 25 Catherine Street, where, it has been said, Moore wrote "'Twas the Night before Christmas." The poem dates to about 1822, but the house was not constructed until the 1850s, which makes that story preposterous.

In addition, I want to thank my parents. They helped in endless capacities, from typing and proofreading to my dad sharing his extensive knowledge of religion, which helped break down the various denominations. However, the majority of the digitized version and typing was done by Linda Hurteau.

INTRODUCTION

It's easy to confuse a first event with an oldest one, or to confuse the longest operating with the most continuous. The wording of the claim is critical. Newport makes over 150 claims for a "first" on a national level. But for how many can we really take credit? This is not exactly science. Some claims are sketchy at best, having never been examined for reliability and accuracy, usually derived from newspaper clippings, index cards, programs and tales passed along over time. How many are truths? How many are legends? This book includes 75 stories, featuring more than 100 claims for Newport, Rhode Island. (Claims not included in chapter titles are set in boldface.)

A "first" refers to the first time something (an event or building, for example) happened. An "oldest" claim refers to a previous claim to a first, but it no longer exists. An excellent example of this is the claim that the Touro Synagogue is the oldest synagogue in America. The Shearith Israel Congregation of New York City, founded in 1654, built its structure in 1730. Its original house of worship was built on what is now known as South William Street, in New York City. The congregation is currently worshiping in its fifth synagogue. Touro congregants actually settled in Newport in 1658 as Jeshuat Israel. The Touro Synagogue building was finished in 1763, thus leaving the oldest (not first) synagogue distinction to Touro.

The researcher or reader must beware. You can't always believe what you read. To determine a fact's authenticity, it should be cross-referenced in several sources. In many cases, modern books or articles about Newport contain information that is not completely accurate. When this information

Introduction

is then recounted by another writer, a new interpretation enters the equation, leading to a snowball effect of inaccuracy. The use of primary sources always outweighs the use of secondary sources. Locally, the *Newport Mercury*, city atlases and city directories represent an excellent basis for cross-referencing historical information.

So, with that in mind, after diligent research and cross-referencing, the following claims about Newport's colorful past can be made. Keep in mind—the truth always outweighs the fallacy.

Please note: This book represents claims for "first." The companion book to be released at a later date will explore the "oldest" claims of record.

1

NEWPORT WAS THE SITE OF THE FIRST FREE PUBLIC SCHOOL IN THE ORIGINAL THIRTEEN BRITISH NORTH AMERICAN COLONIES

(Established August 20, 1640)

The schools in early America were very different from the public schools of modern times. The free public school system of today had not yet been developed. The colonists who had come from England, where there were only endowed tuition schools, not free public schools, had to devise their own plans for education. The original schools of colonial America were not supported by general taxation, as is done today, but by income derived from various sources, including donations, subscriptions and land grants. People of sufficient means contributed, while poorer individuals did not.

Schools in colonial America were under the direct control of individual towns and were established by vote at town meetings. The only existing documentation of the establishment of the Newport school is best described by the Reverend John Callender in his 1739 book *Historical Discourse*:

> Mr. (Robert) Lenthal, of Weymouth, who was admitted a free man here, August 6, 1640. And August 20, Mr. Lenthal was by vote called to keep a public school for the learning of youth, and for his encouragement there was granted to him and his heirs one hundred acres of land, and four more for an house lot; it was also voted, "that one hundred acres should be laid forth, and appropriated for a school, for encouragement of the poorer sort, to train up their youth in learning, and Mr. Robert Lenthal, while he continues to teach school, is to have the benefit thereof." But this gentleman did not tarry here very long: I find him gone to England the next year but one.

The town records of Newport between 1640 and 1682 no longer exist. This is due in part to the British occupation of Newport during the American War of Independence. The records were seized and subsequently dispatched on a boat that sank in New York City's Hell Gate. All that remains are records after 1682, and those are badly damaged. When Reverend

Callender delivered his *Historical Discourse*, he had the records concerning the school at his disposal. With the exception of the Callender's testimony, no documentation concerning the Newport school of 1640 survives today. In addition, it has been said that Newport was the **first recipient of a land grant for schools**.

In fact, there were other schools in the colonies before the one in Newport. How close these were to being public, and the extent of the land grants, is a matter of debate and open to interpretation. It has been suggested that there were schools in operation at the Jamestown, Virginia and the Plymouth, Massachusetts settlements as early as 1620 and 1621, respectively. In 1633, a school was established on the island of Manhattan by the Dutch West India Company. Considered to be the most famous is the Boston Latin School of Boston, Massachusetts, established in 1635 or '36, often claimed to be the first public school in America. Others in New England include: Charlestown (1636) and Salem, Massachusetts (1637); New Haven (1639) and Hartford, Connecticut (1639); and, most important, the one established by a town vote on May 20, 1639, in Dorchester, Massachusetts, one year prior to the

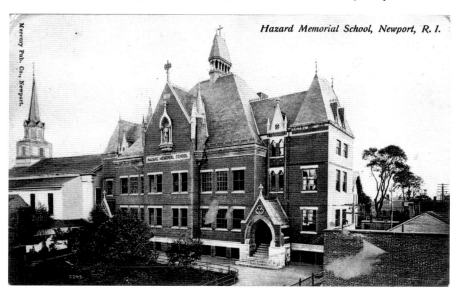

Hazard Memorial (demolished) is shown in this circa 1905 postcard. By 1971, Newport had ten public neighborhood elementary schools, five parochial schools, two private elementary schools, one public junior high, three private prep schools (girls only), three high schools (two Catholic, one for boys and one for girls) and two colleges. Today, there is only one school in each category (elementary; private elementary, junior and high schools; and college). The municipal parking lot behind the theaters at Washington Square occupies its location. *Courtesy of Daniel Titus.*

Newport school. It is documented that this Dorchester school was a public school supported by direct taxation and founded on a land grant.

> *There shall be a rent…imposed upon Thompson's Island (Boston Harbor) to be paid by every person that hath property in the said island…towards the maintenance of a school in Dorchester; this rent of twenty pounds a year to be paid to such a schoolmaster as shall undertake to teach English, Latin and other tongues, and also write.*

Although Newport's school was not the first, it was definitely the beneficiary of some unusual attention for early education in colonial America and predated schools in most communities. Never proven, the school and the school lands here were thought to be located in what is now Middletown, and since the lands were mostly woodlands, they yielded very little income.

2
NEWPORT WAS HOME TO THE FIRST BAPTIST MINISTER IN THE ORIGINAL THIRTEEN COLONIES

(1644)

Physician, minister, statesman and pioneer of religious liberty, Dr. John Clarke (1609–1676) and his legacy tends to be overshadowed by Roger Williams.

A man of exceptional ability, Dr. Clarke arrived in Boston in 1637. He spent that winter in New Hampshire before venturing south to this area the following spring. On the advice of Williams, the founder of Rhode Island, he settled on the Island of Aquidneck (or the "Isle of Peace," as it was named by the native Indians). As one of the cofounders who purchased this island from the natives on March 24, 1638, he originally settled at Pocasset, on the northern tip of the island, now known as Portsmouth.

About a year later, he settled in the southern part of the island. As one of the founders of this community, he signed a written agreement on April 28, 1639, that marked the establishment of Newport. These settlers had picked the finest part of the island, with its natural harbor and exceptional beauty.

According to Joseph Nathan Kane's *Famous First Facts*, "the First Baptist Church of Newport, R.I., founded by Dr. John Clarke, its first pastor (now the First Baptist Memorial Church), was definitely called a Baptist Church in 1644. A church and a meeting house, however, are believed to have been erected as early as 1638." If this date is to be accepted, then Dr. Clarke was on the northern part of this island at Pocasset. Keep in mind, in this era, it was not unusual for fellowship to be held in a home. Although only a member for three months and not a minister, Williams has been credited as being the founder of the Baptist religion in America in 1639 at Providence, Rhode Island.

Around the time in which Dr. Clarke died, hostilities with the Native Americans escalated into King Philip's War. Noted for his fellowship and leadership, perhaps Clarke could have helped defuse the situation in Rhode Island had he been feeling better. Aquidneck Island was the only safe haven where people could come to escape the war.

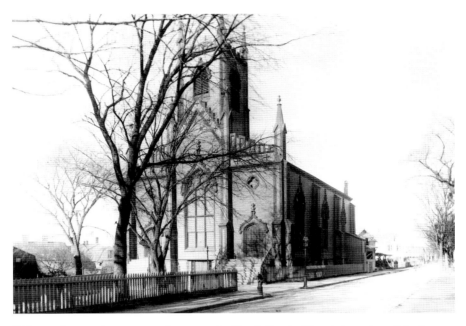

This massive wooden structure, known as the North Baptist Church (now demolished), once stood at the northwest corner of Farewell and North Baptist Streets. Today, an affordable housing complex stands on the land. *Author's collection.*

At the time, Rhode Island was the only colony offering true religious freedom, and Dr. Clarke ensured that freedom of worship was a basic individual right when he authored the Charter of 1663, which provided absolute **religious freedom for the first time in world history**.

He served as minister until he died here in Newport (April 20, 1676), and his church is now known as the United Baptist Church, John Clarke Memorial, of Newport. The current edifice located on Spring Street was built in 1846. Dr. Clarke is buried in the cemetery on Dr. Marcus Wheatland Boulevard, across the street from the rear of the Newport Police Station.

3
NEWPORT WAS THE SITE OF THE FIRST PERMANENT QUAKER SETTLEMENT IN NORTH AMERICA

(1657)

Newport was the most influential of all the Quaker settlements. But evidence suggests that Quakers were residing in other colonies, including Maryland and the Carolinas, and almost simultaneously Quakers were holding meetings in Flushing, New York (1657); Newport (1657); and Sandwich, Massachusetts (1657).

The first Quakers in America were Ann Austin and Mary Fisher, who disembarked in Boston, Massachusetts, on July 11, 1656. Upon their arrival, these women were searched and imprisoned; their books were confiscated. The ruling Puritans feared the introduction of Quaker beliefs, which led to laws being enacted in various colonies over the next few years with stiff penalties, including death.

In 1657, Quakers boarded the ship *Woodhouse* in England and sailed for Boston. However, the boat was blown off course and landed between the Dutch plantation (New York City) and Long Island in August. Of the eleven Quakers on board, five went ashore and ventured toward Flushing, where there was some tolerance for their religious beliefs, although problems still existed with the authorities. Later that year, the Flushing residents protested the ban on worship by Presbyterians, independents, Baptists and Quakers. Known as "The Flushing Remonstrance," it was dated December 27, 1657. At the end of this very unusual document, a reference was made concerning the patent of October 1645 in the establishment of the Town of Flushing, which granted people the right "to have and Enjoy the Liberty of Conscience, according to the Custom and manner of Holland, without molestation or disturbance." Although there was tolerance, the Quakers held their meetings in secret until John Browne invited the Quakers to worship in his home in 1661. This secrecy accounts for a lack of historical records before this date.

The remaining six members stayed on board the *Woodhouse* and sailed for Rhode Island. With their arrival in August 1657, they were absolutely free and would not be subject to persecution of any kind. This became

a safe base for spreading their religious beliefs and opinions to the rest of America.

Rhode Island was the only colony offering true religious freedom. This colony was vastly different from its neighbors, especially when compared to the Puritan colony of Massachusetts, where religious intolerance was the norm. The nub of the dispute that infuriated so many people was between the "Legalists" and the "Antinomians." The Puritans fell mostly in the camp of the Legalists, while the Quakers were basically Antinomians. The latter group believed that, because of their faith, they were free from the obligations of moral law. For this reason, the Puritans mistrusted the Quakers and harshly dealt with any who practiced their faith openly. Rhode Island received exiles from other colonies and, of course, those who came voluntarily. Newport became known as the "sewer of New England" and "Rogue Island" due to its religious freedom.

Rhode Island had achieved and maintained the separation of church and state. Rufus Jones's *The Quakers in the American Colonies* described the situation. "It was here on the island of Aquidneck that the principle of

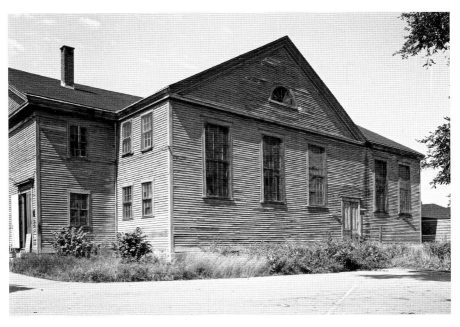

Built in 1699, the Quaker Meeting House is the oldest religious edifice in Newport, located at the northeast corner of Farewell and Marlborough Streets. This photo dates from 1969. *Courtesy Library of Congress.*

spiritual freedom got its most impressive exhibition in the primitive stage of American history." Jones wrote:

> In 1641, the persons who composed the Newport settlement seem to have arranged themselves into two religious groups. One party, with [William] Coddington, [John] Coggeshall and Nicholas Easton as leaders, formulated views which seem extraordinarily akin to those later held by the Society of Friends; while the other group, led by John Clarke, formed a Baptist Church. There was, it plainly appears, thus differentiated here in Newport, fifteen years before the coming of the Quakers, a group of persons who were Quakers in everything but the name. [They] had already arrived at a type of religion in many respects like that of the Quakers, and those who joined themselves to that movement…adopted the new name with hardly a change of idea, ideal or practice.

Some of the founding families of Newport accepted the Quaker faith and doctrines. Influential men with power, chiefly Coddington, Easton and Walter Clarke, were presidents or governors of the colony at one time or another and joined the Quaker movement in the latter part of 1657 or by 1660.

Another community that appeared to be tolerant of Quakers was Sandwich, located in the Plymouth Colony (present-day Cape Cod, Massachusetts). In 1656, when the two women had their troubles in Boston and were sent away, another ship arrived just after their departure with eight Quakers on board. They were subject to imprisonment, and their books were seized. However, a respectable innkeeper from Dorchester, Massachusetts, named Nicholas Upsall, a Quaker sympathizer, protested their treatment before they were sent away on the same vessel, which carried them here.

Subsequently, Upsall was ordered by the court to go to Sandwich, where he spent the winter of 1656–57 before removing to Newport. While in Sandwich, meetings were held at the home of William Allen, attended by Upsall, Richard Kerby and the wife of John Newland. In 1657, there is no evidence that the Quakers were jailed or abused, even though the authorities of that colony were not pleased with their presence. The Quaker movement began to take hold in Sandwich in 1658.

It is difficult to substantiate where the first Quaker settlement was in the colonies. Quakers were not well liked in Flushing and Sandwich, but at least there was some tolerance toward them. But Newport was quite different

compared with the others, as the Quakers were totally accepted regardless of their religious beliefs, faced no consequences and did not have to practice their faith in secret.

For many years, the Quakers were prominent members in the community and exhibited a strong influence over all aspects of life in Newport, especially as a ruling political force. Bear in mind, the Quakers were in Newport for fifteen years before the arrival of William Penn to this country.

4

NEWPORT WAS THE SITE OF THE FIRST CONFERRAL OF MASONIC DEGREES IN THE ORIGINAL THIRTEEN COLONIES

(1658)

A Mason is a member of Freemasonry, a fraternal organization that includes a system of morality with a religious character, but it is not a religion. It is a philosophy of ethical conduct, imparting moral and social virtues that foster individual development and brotherly love.

Prior to 1717, when four lodges in London formed the first Masonic Grand Lodge, it was a secret society. The modes of recognition, the opening and closing of ceremonies and the rituals for conferring three degrees of Freemasonry remain secret, while the knowledge of the meetings and the workings of the lodge are public.

Even prior to the formation of the Grand Lodge in 1717, there is ample evidence that Freemasonry existed. However, knowledge of the actual form and extent of it is still a matter of debate. There are very few records of Masonic activity prior to this date.

The Union Lodge of Dorchester, Massachusetts, established in 1733, was the first lodge in the original thirteen British North American colonies to be chartered by the Grand Lodge in England. There is ample evidence of lodges operating in the colonies between 1717 and 1733. However, they did not operate under a charter from the Grand Lodge. It is possible that constituted lodges did exist prior to 1717, but since Freemasonry was a secret society, any such existence cannot be conclusively proven.

As far as Newport being the first: the claim has warranted the attention of many historians, with one strongly stating that it is "a tale of modern fabrication." As the story goes, a statement was made by a Brother Gould in a *Guide to the Chapter*, published by him in 1868. It read: "The earliest account of the introduction of Masonry into the United States is the history of a Lodge organized in Rhode Island, A.D., 1658 or fifty-nine years before the Revival in England, and seventy-five years before the establishment of the first Lodge in Massachusetts."

A Hundred Claims to Fame

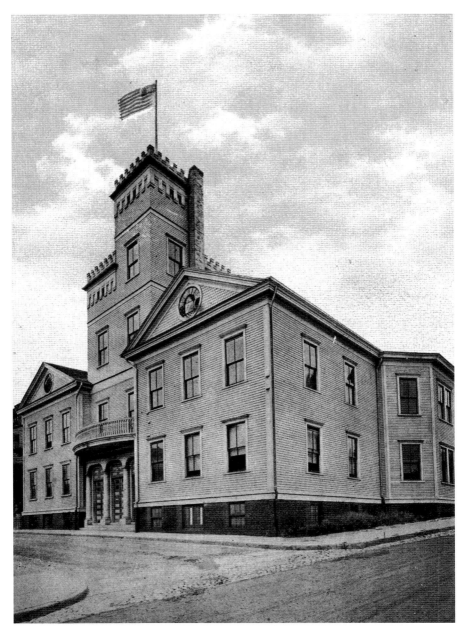

Its formal name is St. John's Lodge, but Newporters know it as the Masonic Temple. Located in the heart of historic hill, the temple occupies the northeast corner of School and Church Streets. This circa 1905 postcard clearly shows the top part of the building, which toppled during the 1938 hurricane and was never rebuilt. *Courtesy of Daniel Titus.*

This late nineteenth-century view of School Street shows the massive columns of Masonic Temple (*right*). Today, the structure is undergoing a massive restoration and is no longer used by the Masons. *Courtesy of Daniel Titus.*

Another reference to the claim appeared in Reverend Edward Peterson's *History of Rhode Island*, published in 1853, which in part reads: "In the spring of 1658, Mordecai Campennell, Moses Peckeckol, Levi, and others, in all fifteen families, arrived at Newport from Holland. They brought with them the three first degrees of Masonry, and worked them in the house of Campennell, and continued to do so, they and their successors, to the year 1742."

At the end of his statement, Peterson referenced his source as documents in the possession of Brother Gould. These publications may have caused a bit of an uproar for some, especially for the Massachusetts Lodge. Subsequently, Gould was contacted. He stated that when his father was administering the estate of a distant relative who was a descendant of Governor Joseph Wanton, a former governor of Rhode Island, his father found in a garret under a leaky roof a dilapidated, moth-eaten trunk containing papers and documents, one of which read: "Ths ye (the day and month were obliterated) 1656 or 8 (not certain which, as the place was stained and broken: the first three figures were plain) Wee mett att ye House off Mordecai Campunall and affter Synagog Wee gave Abm Moses the degrees of Maconrie."

At the time of the request, Gould could not place his hands on the document. Even if genuine, this scrap of paper would not substantiate the

claim for Newport as the first. Historians have done a careful examination of this subject and have concluded that there is absolutely no evidence to support this claim. But since the Masons were a secret society prior to 1717, one can never know for sure who had the first lodge.

5
NEWPORT WAS HOME TO THE AUTHOR OF THE FIRST WRITTEN CONSTITUTION GUARANTEEING THE RIGHT TO RELIGIOUS FREEDOM

(Charter of 1663)

July 8 is extremely significant in the annals of Rhode Island history. It marks the birth of our colony, the bestowing of the official name and the establishment of the right to religious freedom. King Charles II of England granted a royal charter in 1663 written by Dr. John Clarke, joining all the settlements surrounding Narragansett Bay into a new single colony called "The Colony of Rhode Island and Providence Plantations."

Not long after Newport was established in 1639, Roger Williams, the founder of Providence and Rhode Island, obtained a charter in England incorporating the towns of Providence/Warwick on the mainland and Portsmouth/Newport on Aquidneck Island into a colony entitled "The Colony of the Providence Plantations in the Narragansett Bay in New England."

Charter in hand, Williams returned from England in 1644. Problems arose, as Williams was not authorized by the two towns on Aquidneck to secure such a charter. It would take four years before this charter was accepted.

With political upheaval taking place in England in the year 1649, William Coddington, who helped in the founding of Newport and who was also at this time the president of the colony, took a bold step and made a secret trip to England. He obtained a commission annulling the existing charter. The stipulations of this commission separated the towns on Aquidneck from the towns on the mainland and made him governor of the islands of Aquidneck and Conanicut (Jamestown) for life.

It is evident that this news was not well received by Clarke and Williams, who were dispatched to England to nullify the work of Coddington. Successful in their endeavors, Williams returned, while Clarke remained in England for the next twelve years to protect the interests of the colony.

A Hundred Claims to Fame

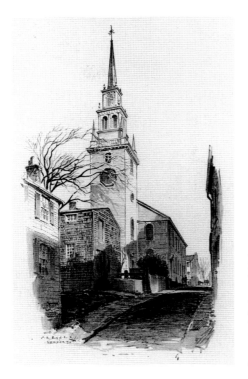

For centuries, Trinity Church was tightly hemmed in by buildings, and Frank Street ran adjacent to it. This O.R. Eggers drawing appeared in the *American Architect* (1921). Today, these buildings were either moved or demolished, and the area is now known as Queen Anne Square, a counterfeit town common. *Author's collection.*

Throughout the existence of the colony, Rhode Island was not well liked, due to the religious beliefs held here. In addition, there were territorial disputes with neighbors Connecticut and Massachusetts.

When Charles the II came to the throne in 1660, the existing charter was disposed of; a new one had to be secured for this colony as soon as possible. It is very fortunate that Dr. Clarke was in the right place at the right time. As a statesman, he served his colony well. As the author of the Charter of Rhode Island of 1663, he included items that might be subject to ridicule by others. He secured the new charter with the signature and seal of Charles II on July 8, 1663. It stipulated that this colony would now be known as "The Colony of Rhode Island and Providence Plantations."

One historian said, "This charter was the first such charter to specifically state that freedom of worship and conscience was a basic individual right." This charter is considered remarkable, according to Wilbur Nelson's *The Life of Dr. John Clarke*: "In it, absolute religious freedom was, for the first time in the history of the world, secured and guaranteed. It was so democratic, both in letter and in spirit, that doubts were entertained in England whether the King had a right to grant it."

It has been further stated in the words of Dr. Clarke, inscribed on the west façade of the Capitol in Providence, "That it is much on their hearts (if they may be permitted) to hold forth a lively experiment, that a most flourishing civil state may stand and best be maintained, and that among our English subjects, with a full liberty in religious concernments."

During Dr. Clarke's tenure in England as the agent of the colony, he supported himself by mortgaging his property in order to maintain the necessary funds to complete his endeavors.

6

THE FIRST CONSCIENTIOUS OBJECTION LAW IN THE ORIGINAL THIRTEEN COLONIES WAS ENACTED IN NEWPORT

(August 13, 1673)

A conscientious objector is a person who holds beliefs and principles in conflict with policies of the state on the issue of armed conflict. Such a person cannot and will not participate in warfare or armed conflict.

This has been the subject of a heated debate over the course of history, as some persons have left their country, families have been torn apart and people have endured prison sentences, creating criminal records for themselves because of their beliefs and moral principles.

During the colonial period, the Quakers, or Friends, were largely the governing body in this colony. These men, ruled by conscience and adhering to principles of peace, were deeply troubled by the military campaigns happening nearby. Although Rhode Island was not directly involved, the proximity of New Amsterdam (New York City) caused heightened anxiety and tension in Newport, due to the conflict between the Dutch and the English. Additionally, problems arose in the 1670s between Anglo Americans and the native Indians. While some colonies were bent on suppressing and annihilating the Indians, Quaker officials tried to maintain peace through negotiations while resisting military assistance. This alienated some people.

At the height of the conflict in New Amsterdam, the pacifist-leaning political body under the leadership of Governor Nicholas Easton, in order to clear their consciences, enacted the first colonial law providing for conscientious objection. A few paragraphs of this rather lengthy document are as follows:

> *At the remeetinge of the Proceedings of the Generall Assembly called by the Governor's warrrant to sutt att Newport the 13th of August 1673.*
>
> *Bee it therefore enacted, and hereby is enacted by His Majestys authorety that noe person nor persons (within this colloney) that is or hereafter shall be*

perswaded in his or their Conscience or Consciences (and by him or them declared) that he nor they cannot nor ought not to trayne, to learne to fight, nor to war, nor kill any person nor persons.

That neither he nor they shall at any time be compelled against his or their judgment and conscience to trayne, arme or fight to kill any person nor persons by reason off or at the comand of any officer of this Collony civill nor millitary, nor by reason of any by-law here past or formerly enacted, nor shall suffer any punnishment, fine, distraint, pennalty, nor imprissonment, who cannot in conscience traine, fight, nor kill any person nor persons for the afore-said reasons expressed with many more implyed and others for brevety concealed, such said men of such said understandings shall be exempt from trayninge, arminge, rallyinge to ffight, to kill; and such martiall service as men are by any other debility.

A solution was agreed to by the Dutch and English, but there was still one problem left for the men of conscience: the bloodiest colonial war was just over the horizon.

7

NEWPORT WAS THE SITE OF THE FIRST COURT-MARTIAL TRIAL TO BE HELD IN THE ORIGINAL THIRTEEN COLONIES

(August 24–25, 1676)

In a collision of two completely different cultures, catastrophic results were inevitable. King Philip's War was the bloodiest of all the seventeenth-century confrontations between English colonists and Native Americans. When the war, which lasted one year, was over, at least a dozen towns had been destroyed, six hundred buildings burned, damage in excess of $1 million was inflicted and upward of one thousand colonists and three thousand Indians had perished. It is almost impossible to verify actual numbers and facts of this conflict, since it has usually been told from the white man's point of view. The reporting of history at times has been violently distorted. One historian says, "We have all come to believe in certain truths about our past.…Perceived by us as truths, these myths die hard."

Relations between the Indians and the Pilgrims were friendly at first. It was Massasoit who aided the Pilgrims of Plymouth through their tough beginnings. Possessor of a great mind, noble and true to his word, Massasoit was the chief sachem of the Wampanoags, whose territory stretched over most of southeastern Massachusetts between Cape Cod and Narragansett Bay in Rhode Island.

On March 22, 1621, Massasoit, with the colonists, signed a treaty of friendship and alliance, resulting in peace for more than forty years, until his death in the autumn of 1661. At his death, his son Wamsutta (or the English name conferred upon him, "Alexander") became chief sachem. It was soon rumored that Alexander and another Indian tribe, the Narragansetts, were plotting against the colonists. Summoned to Plymouth, Alexander was arrested. Surprised, humiliated and disgraced, he was sent back to his home, where he would die only days later. The colonists claimed that his death was due to a broken heart and spirit. The Indians claimed that he had been poisoned. Intriguing questions persist.

Did white men perceive the Indians as objects to be exploited? Did they see Native Americans as savages who ate with their fingers and lived in crude wigwams? Did the Indians have to give up their land amid unsubstantiated accusations of wrongful conduct?

Metacom (or Metacomet, known by his English name, King Philip), the youngest son of Massasoit and brother of Alexander, assumed the position of chief sachem of the Wampanoag tribe in 1662 and tried to respect the sovereignty of the colonists. Interested in peace, Philip renewed his father's treaty; for several years, there was no conflict. Like his brother, accusations arose against him, and he was summoned to Plymouth for questioning. While there, he was forced to agree to a new treaty, with new stipulations attached. Philip felt humiliated and wronged by the colonists. What he wanted was a stable life for his people while maintaining a self-governing tribe and avoiding encroachment on his people's territory.

While the colonists were bent on repression and annihilation of the Indians, Philip was plotting a subtle form of revenge. When an informant brought news to the colonists about a supposed plot against them by Philip, the informant was later found dead. Three of Philip's men paid with their lives, even though the plot was never verified. Sensing a need to stand up for his people and their beliefs, Philip's plan was to harass and loot towns but avoid direct conflict. This plan soon got out of control, and hostilities broke out between the colonists and Indians by June 1675. Scattered fighting escalated into the Great Swamp Fight at South Kingstown, Rhode Island.

On December 19, 1675, the brave and heroic Canonchet was killed in a fierce and bloody battle. The son of Miantonomi, he was chief sachem of the Narragansetts, the largest and most powerful of all the New England tribes, who had joined in the fray against the colonists. As the series of raids continued and hostilities increased, the colonists called upon Indian warfare expert Colonel Benjamin Church. (He is not to be confused with his grandson Dr. Benjamin Church, the first surgeon general and notorious mole.)

The forces under Church were well organized and effective in their pursuit of the Indians. By the summer of 1676, various Indian leaders had been killed, executed, captured or sold into slavery. On August 12, 1676, the war practically came to a close in a battle fought in the vicinity of Swansea, or Rehoboth, Massachusetts. There, King Philip was shot with a bullet through his heart. He slumped and fell face first into the mud. Colonel Church was near, as his men, upon hearing the news, cheered.

When Church viewed the fallen sachem, he commented that King Philip was the "doleful, great, naked, dirty beast he looked like." Because of the great harm supposedly caused in the conflict by King Philip, an Indian, Church gave a noble speech in his honor and then ordered that, in accordance with the laws of England for high treason, King Philip be beheaded and quartered. His dismembered body was taken to Plymouth, where his head was put on a spike atop a pole for everyone to see. It stayed there for at least a generation. One historian said, "Dr. Cotton Mather relished the sight and more than once took off the jaw from the skull of that blasphemous leviathan."

Many legends abound concerning the true character of Philip. Was he a coward, as the colonists portrayed him? Or was he a great Indian chief who protected his people?

With the death of Philip, the search continued for other Indian leaders, most notably Quanopen. A relative of Canonchet, he may have been second in command of the Narragansetts during the Great Swamp Fight. He had three wives, one of whom was Weetamoo, the Queen of Pocasset. The widow of Alexander, she insisted all along that he had been poisoned. Weetamoo and Quanopen are best remembered by Mary Rowlandson, who kept a diary of the war. When her house was destroyed in the Indian attack on Lancaster, Massachusetts, on February 10, 1676, she was taken prisoner and accompanied the Indians throughout their travels.

During this time, she would mend the clothes of the Indian children and made a shirt for Quanopen, who had purchased her from another Indian and was now her master. She even made a memorable dinner for Quanopen and Weetamoo, making a social blunder by serving them both from the same dish. Unlike Weetamoo, who treated her poorly, Quanopen was described by Rowlandson as being kind and gentle. She was considered valuable property, but she desperately wanted to be released. She was finally ransomed for cloth, cash and liquor, of which the latter made Quanopen a bit indifferent. She was released in May, after three months in captivity. The Indians who had come to know her as a friend wished her well.

But fate was near for Weetamoo and Quanopen. A week before the death of Philip, Weetamoo was found dead in the Taunton River. She, too, would have her head cut off and set upon a pole, only this time, it was done in Taunton, Massachusetts. Quanopen was captured in August 1676. On August 24 and 25, a court-martial trial was held in Newport. There were at least thirty members of the court ready to pass judgement on Quanopen

and other Indians. The governor, Walter Clarke, and other Quakers may not have attended due to their beliefs that the war was unjust.

A selected excerpt from the official transcript of the court-martial in Newport, dated August 24, 1676, follows:

> *I, Edmund Calverly, Attorney Generall, in the Behalfe of our soveraigne Lord the King Charles the second…Doe impeach the Quanpen otherwise Sowagonish, an Indian Schim…for being disloyall to his said Majesty… within sixteen Months…doe great Damage to our soveraigne Lord the King, by killing his Subjects, burning their Houses, killing and driving away their Cattell, and many more Outrages of that Nature.…I doe on the Behalfe of his said Majesty, impeach the as a Rebell in the Face of this Court, and pray Justice against thee the said Quanapen, otherwise Sowagonish, res Ic.*

Quanopen honorably admitted to being in arms against the English and said he was at the Great Swamp Fight, assisting in destroying and burning towns and carrying away English captives. The members of the court voted: "Guilty of the Charge, and that he shall be shott to death in this Towne on the 26th Instant, at about one of the Clock in the Afternoone."

Quanopen and two or three of his brothers were among the five or six Indians tried, with four being sentenced to die. Were the sentences carried out? Most likely they were, and the executions would have been carried out in the common, later known as the Parade (today's Washington Square). The square today stands as a grim reminder of the trial and of inexcusable results of that war.

NEWPORT WAS THE FIRST CITY TO PASS A TRAFFIC ORDINANCE IN THE ORIGINAL THIRTEEN COLONIES

(1678)

There was one thing that all of the colonial villages held in common: the dirtiness and danger of their streets, lanes and thoroughfares. The problem here was not as bad as in England, but rubbish and refuse of all kinds were hurled into the streets by residents of the village. Even though this was common, it was a delight to no one—except the swine that roamed the streets freely.

As the villages grew, so did the issue of maintaining order in the streets. There was so much activity—people on foot and on horseback; workers pushing wheelbarrows, carts and wagons—that by the mid-seventeenth century, the thoroughfares were dangerous to horse and man. This problem resulted in frequent accidents in Boston, Newport and New Amsterdam (New York City).

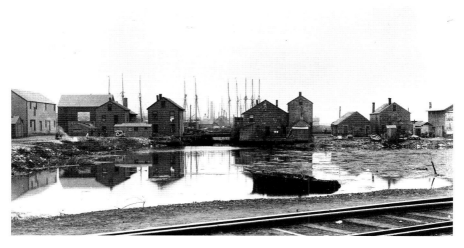

Newport was a typical seaport, filthy with narrow streets and obscure wharfs. This late nineteenth-century view of Long Wharf was made before the saltwater basin was filled in due to a mosquito issue. *Author's collection.*

Newport Firsts

The public streets and thoroughfares were the principal playground for children of the village. In 1655–56 in Boston, the town meeting approved the first of several ordinances to protect all residents, especially children. A monetary fine was included, but the ordinances proved difficult to enforce. A few paragraphs of this rather lengthy document are as follows:

> *The General Assembly of Rhode Island in 1678 passed an act to prevent "excessive riding" in the streets of Newport. They Voted, Whereas, there was very lately in the towne of Newport, on Rhode Island, very great hurt done to a small childe, by reason of exceeding fast and hard ridinge of horses in said towne, this Assembly takeing the aforesaid matter into their searious consideration, and being desirous for the future to prevent the like mischief.... This too was accompanied with a monetary fine.*

But Newport was not the first to pass a traffic ordinance; that distinction belongs to New Amsterdam more than twenty-five years previous. On June 27, 1652, a traffic law was passed to prevent accidents within city limits, and monetary fines were to be issued to drivers breaking the ordinance. It stated that no wagons, carts or sleighs were to be driven at a gallop.

9

THE FIRST INTERCITY STAGECOACH SERVICE IN THE ORIGINAL THIRTEEN COLONIES

(1716)

Public transportation, also known as "public conveyance," began early but developed slowly in America. Most colonists seldom ventured outside of their own town limits. Road travel was treacherous. The time or day of one's arrival at a destination was unknown. Potential hazards and hair-raising experiences were routine.

Since travel was time-consuming, it required overnight accommodations. Taverns played an important part in the early days of travel. They offered the weary traveler another dimension in a potential nightmare experience of legendary proportions, due to the uncertainty of the quality of accommodations and services. Concerning the tavern experience, one gentleman wrote in his diary, "lying there that night, I was almost eat[en] alive with bugs." Although there were problems for some, tavern life was agreeable to others. In this era, travel by water was the most effective mode of transportation.

In the beginning, horseback was very common, since the roads were primitive trails and did not allow for wagons. These roads, developed from Indian paths, were not created overnight but rather over a long period of time. A glance at a map today reveals that the older highways are former paths and should not be confused with the National System of Interstate and Defense Highways. Eventually, wheeled vehicles would appear on the roads.

Hackney carriages were in operation in Boston and New York City. In addition, there were probably stagecoaches operating, but only as goods, services and passengers warranted. Public coaches, however, were not common until after the mid-eighteenth century. Kane's *Famous First Facts* reads, "**Intercity Stagecoach Service** was inaugurated November 9, 1756 between Philadelphia, Pa., and New York City by John Butler, Francis Holman, John Thompson, and William Waller." However, the Newport claim predates Kane's claim by forty years.

But there are references to coaches operating earlier, such as the one between Burlington and Amboy, New Jersey, in 1732. Also, numerous

stagecoaches operated between Boston and Newport, notably the John Blake stagecoach line of 1720 and the Franklin/Wardwell Stagecoach line, which began operation in 1716 and predates all others of record. Travel between Boston and Newport was flourishing, as they were two of the five largest cities in America and the closest geographically in comparison to the others. Newport was the most important commercial center in Rhode Island. The stagecoach line with regular service is shown in an advertisement from the *Boston News-Letter* of October 8 to October 15, 1716, as follows: "These are to give Notice That a Stage-Coach will set out from the Orange-Tree in Boston, to Newport in Rhode Island, and back again, once a Fortnight while the Ways are passable: To be performed at reasonable Rates by Jonathan Wardwell of Boston and John Franklin of Newport."

Advertisements appeared over the ensuing years for this line, as well as advertisements for another stagecoach line between the two cities—all prior to the claim made by Kane. It has even been established which ferry off Aquidneck Island was used by the Blake line (1720); it is not the one taken by the Wardwell/Franklin Enterprise (1716). The Blake line went via Bristol Ferry through Providence and onward to Boston. Perhaps there were two very different and distinct routes. This is why the Blake line referenced Bristol Ferry (Portsmouth–Bristol) in its advertisements, to inform passengers that a more westerly path would be taken between the two cities. Additionally, there may not have been enough patronage to support two stagecoach lines over the same route.

The basis for the following route is derived in part from a reference in Ana and Charles Chapin's *A History of Rhode Island Ferries: 1640–1923* that reads: "May 8, 1688, a highway was laid out from Taunton through what is now Fall River to Little Compton. It was described as following 'the ancient path' which was doubtless the old trail leading through the Indian lands and travelled by the inhabitants of Rhode Island on their journeys over Sanford's Ferry to Boston."

This particular route most likely left the island over the Sakonnet River (Portsmouth to Tiverton) and headed north (present Route 138) to Fall River, Massachusetts.

Logically and logistically, it makes complete sense that the stagecoach could have gone over the present-day Route 138 through Taunton, Massachusetts, a city of commercial importance in the early eighteenth century and directly west of Plymouth (Route 44). Not only was this the shortest distance from Newport to Boston, but it was also almost in a straight line. However, back then, the shortest distance was not always the

best route. Additionally, there is some question as to what happened to the stagecoaches when they descended upon the ferries of Aquidneck Island. It is most probable that the ferries were not large enough to accommodate the stages. So, was there another stage waiting on the other side to complete the journey?

Some have speculated that the Franklin involved in this enterprise was Benjamin's brother James, who lived in Boston at the time. However, brother John was a Newport soap- and candlemaker at the time. Or, it could have been an entirely different Franklin family. But questions remain. Did the stagecoach end its journey at a Newport tavern or at the Town House (the present-day site of the Colony House and/or the Old State House, which was known by that particular name during that era)? Keep in mind, the calculation of mileage was not from city to city but from tavern to tavern. Wardwell owned the Orange Tree Tavern, located on Hanover Street, and he operated the first hackney coach in Boston.

If the stagecoach route of the Franklin/Wardwell line is to be accepted as the way of passage, then one can relive history. Not many people today realize that prior to Route 24 being built, the major route between Boston and Newport was Route 138, which is still in existence.

10
NEWPORT WAS THE SITE OF THE FIRST SPERMACETI CANDLE FACTORY IN THE ORIGINAL THIRTEEN COLONIES

(1748)

Noted for the extent and excellence of its spermaceti works, Newport, prior to the American War of Independence, had no fewer than seventeen manufactories in operation at once. In the early stages of colonial America, candles were scarce and expensive. Candles were usually made from bayberries and tallow (the hard fat from sheep and cows). There were tallow chandlers in existence, but the majority of candles were made at home, and for those who could afford it, they used their own molds.

The characteristics of candles dramatically changed due to whaling. Whaling in America dates from the seventeenth century, but, by accident in 1712, the first sperm whale was captured. As the story goes, a Nantucket, Massachusetts whale man was suddenly blown from shore out to sea and came upon a "school" of whales. Killing one, he brought it back with him. This, in turn, led to an extraordinary development in the pursuit of whales. Until then, the hunting of whales was confined to coastal waters.

The sperm whale, which hardly ventured close to shore, was to be found way out at sea. The pursuit, hunting and capture of these creatures spawned entire new industries. Chiefly, this required the outfitting of larger vessels capable of long distances and a new breed of whale man for the hazardous occupation of deep-sea whaling.

Spermaceti is defined as the waxy substance extracted from the oily matter in the head of the sperm whale. Originally, it was thought that this fatty substance was of value for medical purposes—a cure-all. However, its true value soon became apparent, as a superior illuminating fluid. This revolutionized artificial light.

The spermaceti candle was considered the first standard candle. In time, an entire industry developed, and the subsequent manufacture thereafter became extremely lucrative. For candle-making, it required an elaborate process of extracting the oil from the spermaceti. Those who possessed the

secret process were quite fortunate. It was a secret so closely kept that it would be years before others obtained the knowledge.

There are several versions concerning the person responsible for the technique and for the first candle factory. Kane's *Famous First Facts* states, "**Candle Factory** for making Spermaceti candles was established by Benjamin Crabb in Newport, R.I. in 1748."

In addition, various accounts of its origins are attributed to Newport merchant Jacob Rodriguez Rivera. Rivera, of Jewish descent, came to Newport around 1745, and it has been said that he introduced and engaged in the manufacture of spermaceti candles—the first to do so.

And then there is Dr. John Vanderlight, a native of Holland who married into the famous Brown family of Providence. Vanderlight has been credited with its introduction, using the Dutch process. He helped the Brown family candle-making business and perfected his techniques to a fine art. By 1749, Crabb (sometimes spelled Crab) was living in Rehoboth, Massachusetts, when he petitioned the Massachusetts court in regards to the manufacture of spermaceti candles. His intention was to obtain an exclusive right to produce, with the stipulation that he instruct and encourage others in this form of production. In early 1750, with stipulations attached, the request was granted, but it appears that Crabb did not pursue it. It has been suggested that Crabb moved to Rhode Island, where he built a candle factory, which was soon destroyed by fire.

This statement conflicts with Kane, who said Crabb was here in 1748 and that fire destroyed the factory in 1750.

Another source that various authors have drawn upon is Obed Macy's *The History of Nantucket*, which stated: "The first manufactory of sperm candles in this country was established in Rhode Island, a little previous to 1750, by Benjamin Crab, an Englishman. His candle-house was burnt in 1750 or 1751."

Bear in mind that Macy did not reference Newport, although the island of Aquidneck, where Newport is situated, is technically called Rhode Island. In colonial times, the two place-names were sometimes synonymous.

It is not known where Benjamin Crabb's factory was located, but who was first? Due to the secrecy factor, conflicting information and lack of corroborative documentation, I cannot substantiate who introduced this method and who had the first factory. Interestingly, the story that began this chapter points to Newport and Rhode Island.

Not only was this city a leader in spermaceti works; it was also the epicenter for artificial light inventions in this country. In addition, a gaslight and the incandescent lamp were done here, which greatly benefited mankind.

11
THE FIRST MEDICAL LECTURES ON ANATOMY AND SURGERY IN THE ORIGINAL THIRTEEN COLONIES WERE GIVEN IN NEWPORT

(1755)

For one of the most commonly mentioned Newport firsts, there is considerable confusion surrounding Dr. William Hunter, who delivered the lectures. His birthplace and arrival in Newport and the year and type of lectures he delivered have all been in question.

He was born in Scotland (1730?), but the date and exact place are unknown. He arrived in Newport around 1752, but some have placed his arrival as early as 1750 or as late as 1754. The latter year is based upon the diaries of Reverend Ezra Stiles, which is the most plausible and accurate of all the sources, although Stiles did not arrive in Newport until 1755.

A stickler for detail, Reverend Stiles wrote of Dr. Hunter:

> *He was a Scotch physician—spent about two years in attending the medical lectures at the University of Edinburgh—then came over to America in 1754 circa, with nothing. Settled in Newport where he got an estate, turned chhman (churchman, i.e., Church of England), became as haughty as a Scotch Laird, high in ministerial and parliamy Measures, an inveterate Enemy to American Liberty—dressed well, was much of the Gentleman, lived high and luxuriously—could approve nothing but what was European, despised American Literature and Colleges—of polite morals.*

Dr. Hunter possessed a large collection of surgical instruments and had the most extensive medical library in all of New England. His lectures have been described no less than seven different ways, including "the first medical lectures ever given in the colonies." There were others prior to the 1755 lecture given by Dr. Hunter, and they are listed below.

It has been suggested that Dr. Cadwallader Colden was the first to attempt to establish a systematic course of lectures in Philadelphia around 1717. In 1730 or 1731, a Dr. Cadwalader gave a series of lectures and

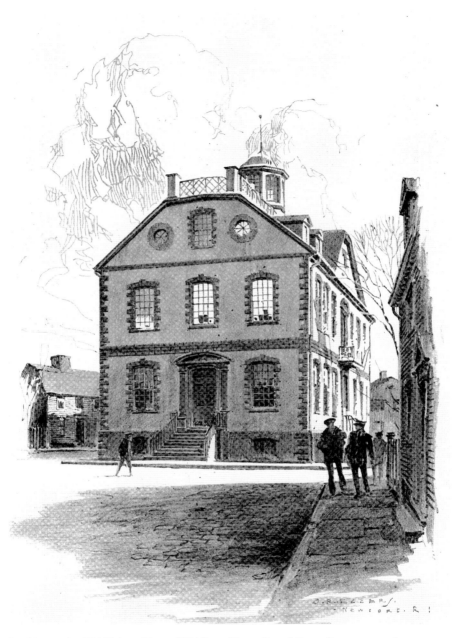

Looking at the Old Colony House/Old State House from Liberty Square, near the intersection of Farewell and Marlborough Streets. This O.R. Eggers drawing appeared in the *American Architect* (1921). The building has been inaccurately referred to as the first medical school and oldest capitol in the United States. *Author's collection.*

> At Rhode-Island,
> On Monday the 3d of February next, will begin
> An Anatomical Expofition
> of the Structure of the human Body, to which will be added, a brief Explanation of the Principles of the Animal Œconomy; the whole interfperfed with occafional Remarks and practical Obfervations, and to conclude with a Courfe, of
> Chirurgical Operations,
> with the Application of the Bandages.
> Any Gentlemen who intend to favour me with their Company, may communicate it by Letter, or perfonally with me here, and receive any farther Information from
> Their humble Servant,
> Newport, 3d Jan. 1755. WILLIAM HUNTER.

The medical lectures of Dr. William Hunter were advertised in the *Boston Evening Post* on January 27 and February 3, 1755. Hunter's anatomical and surgical lectures were held at the Old Colony House/Old State House. *Author's collection.*

demonstrations in Philadelphia. It is a matter of debate concerning the extent and systematic approach of these lectures.

In Philadelphia on November 21, 1750, a Dr. Adam Thomson delivered a medical lecture before a large audience. Two years later, on January 27, 1752, an advertisement appeared in the New York weekly *Postboy*. Subsequent advertisements referenced surgeon Thomas Wood for a course, which lasted one month. It is not known how extensive these lectures were.

Regarding the medical lectures of Dr. William Hunter, there is confusion. Historians have stated that they were given for two years in succession; the years referenced have included 1754, 1755 and 1756. His lectures were definitely given in early 1755, as determined by an advertisement placed in the *Boston Evening Post*. They may or may not have been given for two consecutive years as stated—there is a lack of evidence to support it. However, the lectures were held at the Colony House, and tickets of admission were printed on the back of playing cards.

As far as the claim is concerned, the most detailed and defined phrasing comes from E.B. Krumbhaar, who thoroughly researched the topic. He concluded that "they were the first systematic, advertised public lectures on the subject known to have been delivered in this country." He further stated that Hunter "deserves the fame for having been the first known in this country to have given a publicly announced, successful course of lectures on anatomy and surgery."

It is evident that Dr. Hunter did not give the first medical lectures. And bear in mind that Krumbhaar used the word *known*, which opens

up numerous possibilities for others. I am hesitant and have reservations concerning the claim for Dr. Hunter.

At the time of his lectures, Hunter made his home at the corner of Touro and Thames Streets (today, the site of Banana Republic, but not the original building). In 1761, he married Deborah Malbone, daughter of Godfrey Malbone, one of Newport's most well-known families. They subsequently lived with their children near the northeast corner of Mary Street in a building that no longer stands (approximate location, 170–172 Thames Street). In addition, they owned an apothecary shop, which is still operational.

While attending some sick prisoners, Dr. Hunter contracted a "putrid fever" and passed on. He is buried in the Trinity Church graveyard, where his gravestone reads, "Who departed this life on 30th January 1777 in the 47th year of his age."

12

NEWPORT CLAIMS TO HAVE BEEN THE FIRST PLACE IN AMERICA IN WHICH A TRUST WAS INAUGURATED

(November 5, 1761)

Referred to by some as the "Spermaceti Trust," this was not a trust (a company that buys the stock of all the competing companies in an industry and runs them through a single board of trustees). Rather, it was a cartel (a group of sellers in a particular market who band together in order to influence the price by controlling the market supply). The label of "trust" came about due to the underlying nature of intentions of collusion. Whatever business term is applied, this signed agreement by the participating members would be illegal in the United States today.

Due to the supply and demand, these companies banded together to protect interests, profit, livelihood and survival. As the leading spermaceti chandlers, five of the nine businesses were Newport entities, while the others were located in Boston, Philadelphia and Providence.

The twelve articles of agreement carried many stipulations, including: (1) manufacturers would unite for seventeen months; (2) restrictions on head matter and commissions to be paid; (3) price fixing the sperm candles to be sold in New England; and (4) by all honorable means, prevent the starting of any other spermaceti works.

In time, accusations, gossip, innuendoes and rumors would abound among the members. Whether fact or fiction, suspicions arose concerning undercutting. In typical cartel fashion, the temptation of cheating to gain market-share advantage ran rampant, even if only suspected. And this often marks the beginning of the end of a collusive agreement.

With the United Company of Spermaceti Chandlers, it is most likely that the original articles were adhered to most of the time, because a close watch was kept by members. It is not known how long the original agreement lasted. In a sense, the efforts of these men were a failure, since they were unable to fix the price of candles, prevent the establishment of new spermaceti works and place restrictions regarding head matters for any length of time. However, without this organization and the agreement that

gave it stability, the industry would have been driven into the ground as a result of even fiercer competition.

It has been suggested that the United Company of Spermaceti Chandlers was an outstanding example of attempted monopoly and price-fixing in the eighteenth century. Bear in mind that these happenings took place many years before the establishment of modern industrial giants such as Standard Oil and the resulting passage of legislation outlawing these practices in the United States in the late 1800s and early 1900s.

The fact that Newport had five entities involved in the process is impressive, but with the coming of the American War of Independence, the spermaceti industry would cease, along with many other Newport enterprises. Never again would Newport match its magnitude as a leading commercial seaport in the original thirteen British North American colonies.

13

THE FIRST OVERT ACTS OF VIOLENCE IN THE ORIGINAL THIRTEEN COLONIES AGAINST GREAT BRITAIN HAPPENED IN NEWPORT

(1764–1769)

Some of the most famous episodes of defiance by American colonists against England's enforcement of the Acts of Trade and Navigation took place here. Sent to enforce revenue laws and crack down on smuggling—an activity generally considered to be rather respectable—royal officials in the colonies tended to be incompetent and corrupt. The evasion of these laws was widespread, especially here in Rhode Island, due to the heavy reliance on seafaring commerce.

The people felt that the Charter of 1663 was violated when the HMS *St. John* was assigned to Narragansett Bay and Newport. When the crew was caught stealing hogs and poultry, along with other infractions, the townspeople became infuriated, and the episode came to be called "The *St. John* Affair." On Goat Island today, the plaque on a rock reads, "By order of Gov. Stephen Hopkins and General Assembly 13–18 pounder cannon shots were fired at the 8-gunner schooner St. John on July 9, 1764 to protect smuggling."

As the story goes, the cannon shots were intentionally misdirected. When a report was made, local officials wanted to know why the gunner did not, in fact, sink the *St. John*.

A second incident involved the *Maidstone* of the British navy in 1765. The people were sick and tired of the threat of impressment (the British were trying to obtain seamen to fill out its complement), so an angry mob dragged one of *Maidstone*'s boats up to the town and burned it while threatening one of the ship's officers.

"The *Liberty* Affair" is generally regarded as the **first act of violence against Great Britain by the colonists**. The sloop HMS *Liberty* was grounded near Long Wharf, and her masts were destroyed. The sloop's small boats were hauled to a patch of land now known as Equality Park on Broadway and burned. A plaque on a rock in the park commemorates this

A Hundred Claims to Fame

Literally, numerous fortifications litter the islands in and around Narragansett Bay and Newport Harbor. This 1970 aerial view of Rose Island shows World War II debris. *Courtesy Library of Congress.*

bold moment of rebellion. "On this old common the boats of HMS Liberty were burned July 19, 1769 by the citizens of Newport who had previously fired upon and destroyed the sloop. This was the first overt act of violence against Great Britain in America."

By the following week, HMS *Liberty* drifted to Goat Island near the burial place of the pirates. The next week, during a heavy thunder and lightning storm, the HMS *Liberty* was discovered on fire. It burned for several days and was nearly consumed. Was this intentional?

Were Newport's acts the first against Britain? It is most probable that overt acts had happened elsewhere in the colonies. Furthermore, matters may be complicated in properly defining "overt acts." Local histories abound with incidents. For instance, there was a hand-to-hand confrontation in 1769 in Marblehead, Massachusetts, between colonists and British subjects.

THE FIRST "SOCIETY NEWS" COLUMN TO APPEAR IN A NEWSPAPER IN THE ORIGINAL THIRTEEN COLONIES WAS PUBLISHED IN THE *NEWPORT MERCURY*

(BEGAN 1767)

What constitutes a "society news" column or page? It all depends on one's perception. Some will say that society news revolves around high society—what the rich are doing, what charity functions they are attending. Others will contend that the column can consist of marriage and death notices. A few might suggest the gossip column as a candidate, but a gossip column discusses the private lives of people based on speculation. It should never be confused with the society feature.

From their inception, American newspapers placed a strong emphasis on shipping intelligence—a staple for news. If this was already being reported, why not incorporate the people who were on board the ships?

The first journalists to introduce a "society news" column were, first, Samuel Hall, who had taken over the Franklin printing house and newspaper, the *Newport Mercury*. He began the column in 1767. It was then continued when Solomon Southwick bought the newspaper the following year.

Carl Bridenbaugh's *Colonial Newport as a Summer Resort* gives an excellent account:

> *No record of concourse of visitors was kept until after the founding of The Newport Mercury in 1758. The enterprising Samuel Hall and his successor, Solomon Southwick, took a forward step for American journalism when, in 1767, in addition to the usual shipping news, they began to print lists of summer arrivals. From 1767 down to the outbreak of hostilities in 1775 these notices became a regular feature of The Newport Mercury. It was Southwick's custom in this period, to print the names of prominent visitors in capitals, whereas the familiar coming and going of the mercantile group was restricted to ordinary font. The activities of the world of fashion, thus early in our colonial society, became better headline material than the*

> *simpler doings of mere men of affairs. Here, in embryo, is our modern society column, a feature unique in the colonial press.*

Bridenbaugh further stated: "Any social item of local importance was reported in the provincial press, but notices of this special type are not to be found in other colonial newspapers."

Bridenbaugh used the word *unique*, not *first*, in reference to the column. This column existed sixty years prior to the turning point in American journalism: the birth of the modern newspaper. During the "penny press" era, these newspapers were geared to the ordinary person. The two most notable newspapermen and their papers were Benjamin Days of the *New York Sun* (established in 1833) and James Gordon Bennett Sr. of the *New York Herald* (established in 1835). It has been suggested that these two newspapers laid the foundation of modern journalism. Due to competition in the field, this was the era of the low-cost newspaper. The name of the game was circulation. Driven by circulation, the key was to entice the ordinary person to buy a paper.

NEWPORT RECEIVED THE FIRST SPINET MADE IN THE ORIGINAL THIRTEEN COLONIES

(September 1769)

An article that appeared in the September 18, 1769 issue of the *Boston Gazette and Country Journal* stated:

> *It is with Pleasure we inform the Public, That a few days since was ship'd for Newport, a very curious spinnet* [sic], *being the first ever made in America; the performance of the ingenious Mr. John Harris, of Boston…and in every Respect does Honour to that Artist, who now carries on said Business at his House a few Doors Northward of Dr. Clark's North-End, Boston.*

By 1883, it was thought that the spinet (an old-fashioned musical instrument like a small harpsichord) was in the possession of a Mrs. Breese. It was of some antiquity and had seen much use. The Breese house no longer stands. It is now the present-day site of an office building at 364 Thames, located at Fair and Gidley Streets.

16

NEWPORT HOSTED THE FIRST CIRCUS IN THE COUNTRY

(1774)

The early circus in our country generally consisted of an equestrian show or exhibition. The rider would use one, two or three horses in a variety of feats of horsemanship. The English introduced this form of riding to America.

The first circus, which in essence was an equestrian exhibition, was given by John Sharp on November 19, 1771, in Salem, Massachusetts. In 1772 and 1773, another Englishman, Jacob Bates, toured the colonies, including Newport. There could have been other riders touring the colonies at that time.

The claim for Newport may have been confused with the case of Christopher Gardner, who performed amazing feats of horsemanship in a public exhibition in Newport beginning on May 27, 1774. Who was this Newporter, Christopher Gardner? He was, in fact, **America's first native-born circus performer**.

Very little is known about Gardner's early years, but we do know that he was the son of Captain Henry Gardner, who kept a tavern in town. Gardner learned his riding skills from Bates when he toured the colonies. When the circus came to Newport, Gardner joined the show and traveled to the other cities. After Bates returned to England, Gardner returned to Newport to form his own show. The *Newport Mercury* on May 30, 1774, summed it up best:

> On Friday last the manly exercise of HORSEMANSHIP was performed, to admiration, before a great number of spectators in the manage at the north-east part of town by Christopher H. Gardner, son of Capt. Henry of this place. It was allowed by the best judges present, that he excelled the celebrated Mr. Bates in several parts of the performance. It is surprising that this youth should, in a little time, arise to such perfection in this art, as has cost some of the best performers in England many years to acquire. As he is the first American that has exhibited in this way, he certainly merits encouragement from his countrymen, who are sons of that ancient flock of

Britons, whom they have never yet disgraced by want of genius, learning, courage and manly accomplishments.

Gardner advertised in the August 29, 1774 edition of the *Mercury*, which stated that his last performance would be held at the same manage. This could have taken place in the Vernon Park, Kay Boulevard section of Newport.

Additionally, Thomas Poole of Philadelphia, in an announcement dated August 15, 1785, stated that he was "the first American that ever exhibited equestrian feats of horsemanship on the continent." Supposedly, Poole introduced the clown. Whatever the case, Gardner predates Thomas Poole by eleven years. It was not until 1792 that English horseman John Bill Ricketts produced the first real circus in the United States, known as Rickett's Circus. Ricketts had a building erected in Philadelphia. George Washington attended on April 22, 1793, and January 24, 1797.

17

THE FIRST ACT PROHIBITING THE IMPORTATION OF SLAVES IN THE ORIGINAL THIRTEEN COLONIES WAS ENACTED IN NEWPORT

(June 13, 1774)

In the realm of seafaring activities, Newport, Rhode Island, was a heavyweight. A colonial capital, Newport was the fifth-largest city in population in America prior to the War for Independence.

In a time when transportation of goods over land was non-existent, the sea-lanes of commerce played a vital role. Newport was a major player, along with Boston, Charleston, New York and Philadelphia. As a commercial center, legend has it that Newport could have been the size of New York today when you consider the level of commerce then and that the islands of Manhattan and Aquidneck are almost the exact same size in area. Aquidneck is slightly longer. Newport's importance came to an end when the British occupied the city with military forces, ruining it economically and physically. Had this not taken place, Newport might truly be a different place today.

Newport, with its harbor and deep natural bay, was a safe port of call where vast fortunes were made. Due to the surrounding terrain, its small size and limited raw materials, Newport and Rhode Island needed to be heavily involved in the import/export trade in order to sustain an economy.

Newport was a leader in the spermaceti industry and was noted for its involvement in the notorious "triangular trade." Some of the people of this city were revolutionary forces, developing and exploiting the activities of that trade route. There were many factors in this complicated but extremely lucrative trade of raw materials, manufactured goods and human cargo.

Slavery, in one form or another, has been around since the beginning of human history. In 1619, in Jamestown, Virginia, the first arrival of twenty Negroes aboard a Dutch ship signaled the introduction of slavery to these shores. It was not until the late seventeenth century that such a shipment arrived in Rhode Island, when fourteen Negroes were sold in this colony. Newport's involvement in the African slave trade dates from 1725.

This lucrative trade was extremely dangerous, as long distances of travel were required. Known as the triangular trade, it involved Africa, England, North America and the West Indies. Many of the various materials and goods involved were textiles, fish, grain, meat, molasses, rice, timber and tobacco. Keep in mind that Newport was not the only point on the triangle in the North American colonies. At first, Newport controlled the spermaceti candle trade, followed by the rum trade, importing molasses and exporting rum.

Newport became known for its production and distribution of spermaceti candles and for its rum. With the importation of raw ingredients such as molasses, the exporting of rum was a major component in the economy of the colony, as it offered a stabilizing effect. Estimates of the number of distilleries in operation in Newport at that time range from ten to twenty-two, as some operated as the demand required. The rum was sold here, in other colonies, in Africa, in the West Indies and anywhere else people would buy it. The spermaceti works and rum distillers of Newport enjoyed a monopoly. Were it not for this valuable commodity, it is claimed that the colony would never have entered the slave trade.

This formula for the distribution of rum was so successful, it has been said that the same approach was applied to the transporting of Negroes. The rum was sold in Africa in exchange for slaves, who would be taken to the West Indies and exchanged for molasses, which in turn was shipped to Newport, where it was processed into rum. The cycle would then be repeated. Newport enjoyed an excellent trading-partner status.

However, Newport's economy was based mainly on spermaceti and rum and not as a slave-trading port, as has been suggested. The latter part is a myth. Contrary to belief, very few slaves ended up in Newport and North America. The large percentage of slaves stayed in the Caribbean, where the climate was better suited the labor they were purchased to do. Moreover, the ones who ended up in this country entered through Charleston, South Carolina, and stayed in the South. Newport was not a distribution point.

Newport was founded on religious freedom, and its various religious denominations were adamantly against slavery. It did not sit particularly well with some people, most notably the Quakers, who had been a political force in this colony for almost one hundred years prior to the American War of Independence. They believed slavery was inhumane. Various antislavery legislation had been passed in this colony over the years. A law regulating slavery was passed in Warwick in 1652 (**first law regulating slavery in the colonies**), and an Indian antislavery law was passed in 1675/76 at Newport. Keep in mind, the Indians were enslaved long before the Negroes.

A Hundred Claims to Fame

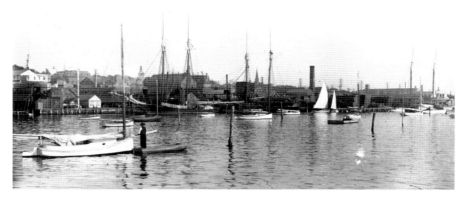

A man tends to his catboat with the waterfront as a backdrop in this late nineteenth-century photo. Newport was the only colonial city in the United States left virtually intact, but the wharf and downtown area were bulldozed into oblivion in the mid-1970s. *Author's collection.*

In June 1774, the General Assembly, sitting at Newport, passed an act prohibiting the importation of Negroes. It reads in part:

> *Whereas the Inhabitants of America are generally engaged in the Preservation of their own Rights and Liberties, among which that of personal Freedom must be considered as the greatest; as those who are desirous of enjoying all of the Advantages of Liberty themselves, should be willing to extend personal Liberty to others:*
>
> *Therefore be it Enacted, by this General Assembly, and by the Authority thereof, It is Enacted That for the future, no Negro or Mulatto Slave shall be brought into this colony: And in Case any Slave shall hereafter be brought in, he or she shall be and are hereby rendered immediately free, so far as respects personal Freedom, and the Enjoyment of private Property, in the same Manner as the native Indians.*
>
> *Provided, nevertheless, That this Law shall not extend to Servants of Persons traveling through this Colony, who are not Inhabitants thereof, and who carry them out with them when they leave the same.*

Subsequently, over the years, other antislavery laws were passed in this colony. Keep in mind, however, that Vermont was the first state to completely abolish slavery.

18

THE FIRST NAVAL ENGAGEMENT OF THE REVOLUTIONARY WAR TOOK PLACE OFF THE WATERS OF NEWPORT

(June 15, 1775)

On June 12, 1775, the Rhode Island General Assembly voted and authorized the commissioning of two sloops, earning Rhode Island the title **first navy of the colonies** and the **first naval force to be established in America by any public authority**. This measure preceded by four months the Continental Congress' authorization of the Continental navy (October 13, 1775).

The General Assembly authorized two sloops, the *Katy* and the *Washington*. The larger of the two, the *Katy*, is credited with being the first vessel of the Rhode Island navy. Commodore Abraham Whipple, the most experienced sea captain in the colony, was placed in command. Three days later, on June 15, Whipple sailed the *Katy* down Narragansett Bay and immediately engaged the British.

This naval engagement pitted the *Katy* against the *Diana*, which was employed as a tender to the twenty-four-gun British frigate HMS *Rose*, responsible for patrolling the bay to enforce the mother nation's Navigation Acts. Since its arrival six months earlier, the HMS *Rose* with Captain James Wallace had infuriated the colonists by harassing and interrupting sea commerce and seizing goods and vessels. The *Diana* was a direct result of this form of forfeit. Months earlier, it had been seized by Captain Wallace, her cargo taken and the vessel turned into an armed tender now at the disposal of the British.

On the day of the engagement, under Master Savage Gardner, orders were given by Captain Wallace for the *Diana* to patrol a specified area of the bay. While the *Diana* was on the bay between the northeast part of Jamestown and Gould Island, the *Katy* came upon it and began to fire its cannons. The *Diana* returned fire. This smart-fire exchange started a little before sunset and lasted under an hour. *Diana*'s command felt it was not going to make it,

so they intentionally ran it aground near the north end of Jamestown. The British sailors ran away.

The crew of the *Katy* was successful in refloating the *Diana* and, to their delight, found that there were muskets, bayonets and gunpowder on board. Captain Wallace went through the roof. The most successful ship of the war, with over forty prizes to its credit, the *Katy/Providence* was intentionally set on fire in the Penobscot River to avoid capture by the British in August 1779.

As far as the claim for first naval exchange, here are some of the early sea fights of the war that predate the Rhode Island claim: Fairhaven, Massachusetts (May 14, 1775), the Battle of Chelsea Creek in Massachusetts (May 27, 1775) and the engagement at Machias, Maine (June 12, 1775), which has been called "the Lexington of the Sea." Captain Jeremiah O'Brien and his men battled the sailors of the British schooner *Margaretta*, with death resulting on both sides.

19

NEWPORT WAS THE BIRTHPLACE OF THE FIRST AMERICAN SURGEON GENERAL

(Appointed July 25, 1775)

Benjamin Church was born in Newport on August 24, 1734, and was the great-grandson of famous Rhode Islander Colonel Benjamin Church. His family left Newport around 1740 for Boston, where they settled. Church was educated at Boston Latin School and graduated from Harvard in 1754. After studying medicine in England, Church returned to Boston, where he became prominent in revolutionary politics.

An established literary writer, some of his pieces took the form of Patriot propaganda. He accompanied those who officially protested the Boston Massacre. Dr. Church was appointed surgeon general on July 25, 1775. Due to his very questionable lifestyle, it was a position the good doctor would hold for only three months.

As early as December 1774, a colleague of Dr. Church's by the name of Paul Revere doubted the credibility of the high-living, adulterous doctor. Secret information from meetings attended by a select few, of which Church was a member, appeared to be ending up in British hands. As historians later discovered, Church was reporting regularly and reliably throughout the winter and spring of 1775 to Lieutenant General Thomas Gage, commander in chief of British forces in North America. **Church was the first highly placed and deeply buried American "mole" (British spy)**.

The downfall of Dr. Church began in the summer of 1775, when his mistress, a woman of ill repute, gave a ciphered letter to Godfrey Wenwood, a Bannister's Wharf (Newport) bakery and bread shop owner. As a former friend of the woman, Wenwood was instructed to deliver the letter to Captain Wallace of the HMS *Rose*.

Originally, Wenwood didn't realize the importance of the letter, but a month later, he turned it over to American authorities. Subsequently, the woman was arrested and, under interrogation, admitted that the sender of the letter was Dr. Church. When he was appointed to the post of surgeon general, there were only doubts, not proof, of his involvement in espionage.

A Hundred Claims to Fame

On October 3–4, 1775, in Cambridge, Massachusetts, a Council of War was held, presided over by General George Washington. It concluded that Dr. Church was guilty of communicating with the enemy. On October 27, he argued his case before the Massachusetts authorities, but it did not matter. The legislature expelled him from service on November 2. He became the **first American official to be convicted of treason**.

Neither the Council of War nor the Provincial Congress had any power to punish him. Finally, the Continental Congress directed that he be imprisoned. There were no laws outlining punishment. As a result of the arrest and conviction of Dr. Church, Congress made death the maximum penalty for communicating with the enemy. Subsequently, in January 1778, Church was dispatched onto a vessel that was later lost at sea, never to be heard from again. Did he really lose his life, or was the vessel being lost at sea staged?

20

THE LEGISLATURE FORSWORE ITS ALLEGIANCE TO GEORGE III AT THE COLONY HOUSE IN NEWPORT, MAKING RHODE ISLAND THE FIRST INDEPENDENT REPUBLIC IN AMERICA

(May 4, 1776)

The Act of Renunciation is one of the most important events in the annals of Newport and Rhode Island history. This was an important event, but there is much confusion surrounding it. First and foremost, it was not an act of independence but an act of defiance. The passage of this act was a heroic moment, its boldness unmatched.

Compared to the other twelve British North American colonies, Rhode Island enjoyed a considerable amount of self-rule. With the tightening of restrictions imposed by England, the economic climate of this colony—a leader in the movement against the empire—was threatened. Action had to be taken to thwart future incidents. At this time, the British, bent on destruction, were patrolling the waters in and off of Newport.

Normally, each elected officer of this colony had to swear allegiance to the king in order to serve. With the heightening of hostilities, in May 1776, a vote was taken by the General Assembly of the Colony of Rhode Island. It has been said that this vote happened in Newport. For this to have been here would have been extremely risky. There is no record available of how each member voted, but it is known that there were six assent votes.

As the story goes and speculation has it, these six votes were cast by the members from Newport. Newport was the most important center of commerce in Rhode Island. To participate in an act of defiance represented doom for the merchants here, as they had the most to lose.

According to Dr. Patrick T. Conley in his book *First in War, Last in Peace*, "This May 4, 1776, act renouncing allegiance to George III (but not declaring independence) kept Rhode Island in the vanguard of the Revolutionary movement."

The General Assembly of the Colony of Rhode Island passed an "Act for the more effectual securing to His Majesty the Allegiance of his

A Hundred Claims to Fame

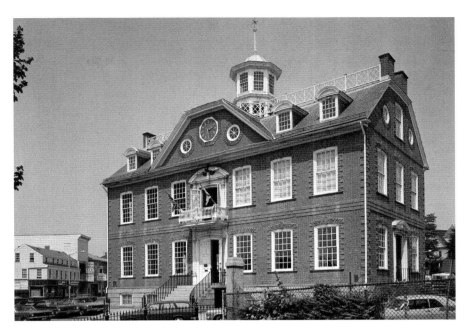

The Old Colony/Old State House was built in 1739–41. This one-time capitol is located at the top of Washington Square in the heart of Newport. This 1971 photograph was taken from Eisenhower Park. *Courtesy Library of Congress.*

The second-floor courtroom of the Old Colony/Old State House as it appeared in 1970. This is where the general assembly for Rhode Island voted. *Courtesy Library of Congress.*

Subjects in this his Colony and Dominion of Rhode Island and Providence Plantations, be, and the same is hereby, repealed."

Passage of this particular act is considered to be the last important in the colonial history of Rhode Island. Perhaps the confusion concerning the location can be attributed to John Russell Bartlett, secretary of the state of Rhode Island from 1855 to 1872. He credited Newport as the location in his edited work *Records of the Colony of Rhode Island and Providence Plantations in New England*.

The original documents are in the possession of the office of the secretary of state, Rhode Island State Archives. The passage of this act took place at the Old State House in Providence, not in Newport.

NEWPORT WAS HOME TO THE FIRST SECRETARY OF THE NAVY

(Elected May 6, 1777)

A distinguished citizen and prosperous merchant of Newport, William Vernon (b. Newport, January 17, 1719), with his vast experience in seafaring activities, orchestrated the building and equipping of vessels for the newly organized American Continental navy.

Vernon was elected president of the Eastern Navy Board on May 6, 1777, in Boston and held that position for the duration of the Revolutionary War. He was so committed to his duties that he repeatedly advanced considerable sums of money to meet immediate demands on the government, and little or no interest was ever paid. Bear in mind, it was not until 1798 that the title "Secretary of the Navy" was first used, when Benjamin Stoddert of Maryland was appointed to that position.

Vernon was a founder and second president of the Redwood Library; a member of the Second Congregational Church, with Reverend Ezra Stiles as pastor; a founding member of the Artillery Company in 1741; and was instrumental in establishing the Newport Bank, the third bank of Newport (chartered 1803). The building is now a branch of Citizens Bank, located on Washington Square at Thames Street.

Both of his homes still stand today. At One Mile Corner, there is his country home, Elmhyrst, located on the southeast corner away from the road (behind the old gas station). The Vernon House, which bears his name and where he died on December 22, 1806, is at the northeast corner of Clarke and Mary Streets. He is interred at the Common Burial Ground nearest Warner Street, marked by the tallest obelisk.

22

THE FIRST FOREIGN ADMIRAL TO BE BURIED ON U.S. SOIL IS INTERRED IN NEWPORT

(December 15, 1780)

Admiral Charles-Louis D'Arsac Chevalier de Ternay was born at Angers, France (January 27, 1723?), and was in command of the French navy, who transported the army of Jean Baptiste Donatien de Vimeur, Comte de Rochambeau (1725–1807), who was lieutenant general and commander of the French expeditionary forces in America. The French, as allies, is the **first and only foreign land and naval force ever to establish itself in this country**. The French fleet arrived in Rhode Island waters in the first half of July 1780.

One of the most notable experiences of Admiral de Ternay before he became gravely ill was accompanying General Rochambeau to Hartford, Connecticut, for a conference with General George Washington. This marked the first time that these leaders had ever met. Considered a skillful navigator, de Ternay was not particularly well liked. His conduct in command was subject to sharp criticism, and it has been suggested that this did not help matters in relation to his health.

The admiral passed away at the French Naval Headquarters, the confiscated home of Colonel Joseph Wanton (Hunter House) on December 15, 1780. The cause of death was an attack of malignant fever. His death caused little emotion from some people, but his funeral procession on the next day was considered very impressive, more impressive than the people of Newport had ever seen. His remains were removed from the house by sailors from his own flagship. The procession moved down Washington Street, through the Long Wharf area, down Thames Street and up Church Street. It was accompanied by chanting priests and sounds of mournful music as the body was brought into Trinity Church Graveyard. Even though the church was Protestant, the customary rites of the Roman Catholic Church were performed.

23

THE FIRST NEWSPAPER PUBLISHED ABROAD BY AN EXPEDITIONARY FORCE WAS PRINTED IN NEWPORT

(1780–1781)

General Rochambeau and Admiral de Ternay landed in Newport in July 1780, with French troops to begin their friendly occupation of this city. The French, in lending their assistance to America, brought with them another potential weapon in the fight for freedom: the printing press. Due to the potential of an extended stay, the press was removed from the French navy squadron warship *Neptune* and set up on shore.

It's possible that the French printing press was used for the printing of orders, administrative documents and the directing of operations for the French fleet. However, the press allowed its editors to provide a more important service in the fight of the colonies: propaganda.

The equipment they possessed was equal to, or possibly superior to, the average printing press found here. The press General Rochambeau and Admiral de Ternay brought with them to Newport may have been used for either or both of the intentions just mentioned. Whatever the intentions, it was the first time a military-service newspaper was published abroad by an expeditionary force.

The newspaper issued by the Imprimerie Royale de l'Escadre was printed near the French naval headquarters. The French phrase "rue de la Pointe," found in the imprint of the *Gazette Francoise*, suggests the house used for the printing was located on Water Street, now called Washington Street, in the Point section of Newport.

In addition, it was the **first French-language newspaper in the United States** and preceded the French newspaper generally credited with being the first in America, *Couri, de l Amerique* of Philadelphia, published in 1784. But Newport cannot claim to have the **first foreign-language newspaper published in the United States**, as that distinction can be attributed to Benjamin Franklin. On May 6, 1732, at Philadelphia, he published the first issue of *Philadphische Zeitung*, thus earning the paper the distinction of being the first foreign-language newspaper in the thirteen colonies.

Margaret La Farge wrote in *Scribner's Magazine* (November 1917), "Chevalier de Ternay sleeps in the churchyard, an alien in a foreign land, Newport, with reverence and gratitude, having laid him among their honored dead." His grave is located in the northeast corner of the graveyard (below the flag), with a granite slab tombstone inscribed in Latin. This photo was taken in 1955. *Author's collection.*

The *Gazette Francoise* is considered the ancestor of *Stars and Stripes*, the newspaper of the American armed forces during the two world wars. Today, there are only a few editions of the *Gazette Francoise* in existence, and the known issues have been preserved by the Rhode Island Historical Society.

In 1993, a plaque was seen commemorating the existence of this enterprise on the outside garden wall of the Hunter House, facing the water. Its whereabouts at this writing are unknown.

24

THE FIRST MEDICALLY EDUCATED DENTAL SURGEON IN THE UNITED STATES PRACTICED IN NEWPORT

(1780–1781)

It has been said that Dr. Jacques Gardette was the "first medically educated dental surgeon in the United States." The way in which it has been written would lead one to believe that Gardette was educated in the United States and lived in Newport. After examining the information, we find a more refined definition of Dr. Gardette's place in Newport and American history. In the eighteenth century, France was the world leader in the practice of dentistry. Dr. Gardette and Dr. Joseph Le Mayeur were dentists who served in the French navy. Both men were instrumental in teaching their techniques to our colonial army during the American Revolution.

Dr. Gardette was stationed in Newport with French troops under General Rochambeau. The exact whereabouts of Dr. Le Mayeur's practice are unknown, but he was stationed on U.S. soil. Dr. Gardette did practice general surgery and dentistry on the people of Newport before he left with the French troops in June 1781.

In relation to Newport firsts, the original statement is incorrect for the following reasons: (1) Gardette was not an American; (2) he was not a resident of Newport, and he practiced here for less than one year; (3) he was one of two French dentists practicing in this country, so he would be considered a co–first practitioner; (4) the United States did not graduate medically educated dental students until 1841. The claim could be considered a Newport first if twisted in the right way! Even though it may not be considered one, Jacques Gardette, along with Joseph Le Mayeur, were valuable assets to our young country.

Josiah Flag of Boston is considered the first native-born American dentist. He started his practice after his discharge from the army in the early 1780s.

NEWPORT WAS THE BIRTHPLACE AND BOYHOOD HOME TO THE FIRST DOCTOR IN THE UNITED STATES TO SUCCESSFULLY VACCINATE WITH COWPOX SERUM AGAINST THE DEADLY DISEASE OF SMALLPOX

(JULY 8, 1800)

Considered to be the most famous native physician of this city, Benjamin Waterhouse (b. March 4, 1754) was one of eleven children. Influenced by reading the medical books of Abraham Redwood in the library that bears the Redwood name, Waterhouse would become one of, if not the, best-educated physician of his era in the country.

At sixteen years of age, he entered upon the study of medicine as an apprentice of Dr. John Halliburton. Following this stint, in 1775, he sailed for London just before the American War of Independence to live and study with a relative of his mother's named Dr. John Fothergill. Waterhouse would study at Edinburgh and Leiden before returning to Newport in June 1782. He would not stay here very long, as he was appointed professor in the first faculty of Harvard Medical School.

Four years later, Dr. Waterhouse began delivering lectures at Rhode Island College (now Brown University). These lectures were **the first (systematic) mineralogy instructions to be given in the United States**. However, his major contribution was considered to be his work on the vaccination for smallpox.

This type of vaccination for smallpox, using cowpox serum, was originated in England by Dr. Edward Jenner. Dr. Waterhouse was the first physician to use Jenner's method in this country.

On July 8, 1800, he inoculated his five-year-old son and others with a pure cowpox vaccine, which was received from Dr. Jenner himself in England. This pure cowpox vaccine provided Dr. Waterhouse with the proper results in the experimentation of a safe vaccination against smallpox. The inoculation was not done in Newport, as some have claimed, but in Cambridge, Massachusetts, where he was professor of theory and practice of physics at Harvard.

A Hundred Claims to Fame

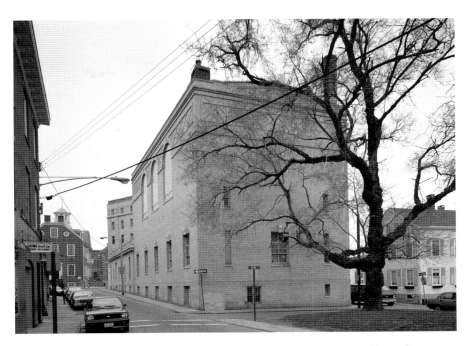

The boyhood home of Benjamin Waterhouse once stood where the Navy Y, now known as 50 Washington Square, presently stands. The tree on the right is located within Liberty Square. *Courtesy Library of Congress.*

The family home where he was born once stood at the southwest corner of Farewell Street and River Lane, opposite of what is now Liberty Square, near Marlborough Street. It is now the site of Emory Lodge and the River Lane Apartments, better known as 50 Washington Square. Dr. Waterhouse passed away in Cambridge on October 2, 1846.

26
NEWPORT WAS THE SITE OF THE FIRST GAS STREETLIGHT IN THE UNITED STATES
(1806)

David Melvill was a pewterer, a maker of household utensils and the proprietor of a hardware store. Melvill was born in Newport on March 21, 1773, and maintained his residence at the southeast corner of Pelham and Thames Streets. In his basement, with crude machinery, he experimented with hydrogenous gas, or inflammable air, produced by a chemical process from pit coal. Experiments in the extraction of the inflammable vapors of the pit coal had been going on in Europe. As the Europeans' developments were kept secret, Melvill made his findings public. He wanted to prove how safe and simple were the methods for gas making.

He succeeded in lighting his home and, in 1806, hung a lantern outside his home, thus earning the distinction of having the first gas streetlight in the United States. It has been claimed that the entire street was lit all the way up to Spring Street. This is an erroneous claim, as the entire street was not illuminated. But this one gas lamp most likely could be seen from Spring Street. People today don't realize that the entire downtown was pitch black.

This light preceded the first demonstration of gas lighting on the Promenade of London, Pall Mall, by one year. Ironically, public lighting by gas was first proposed in Philadelphia in 1803 but rejected as being ridiculous.

Melvill improved on his process and, seven years later, on March 18, 1813, obtained the first U.S. patent for an apparatus for making coal into gas. This was an important year, as he placed advertisements, gave public demonstrations, succeeded in lighting a factory and formed a partnership with Winslow Lewis of Boston.

He placed three different advertisements in the *Newport Mercury* over a six-month period beginning in February 1813 explaining his project and invention. That month, he lit his bathing house and adjoining apartments in the form of a public exhibition to satisfy public curiosity. The price of admittance was twenty-five cents per person. Melvill claimed in the advertisement, "the gas lights are in no way offensive, and agreeable to the eye."

His first commercial success was lighting a cotton factory in Watertown, Massachusetts. Afterward, a partnership was formed with Lewis, and they began targeting the U.S. government to use gas for lighthouses. Lewis was a builder and sperm-oil supplier for lighthouses.

In 1817, Melvill obtained a government contract for a one-year trial, installing a gaslight beacon at the Beaver Tail Lighthouse in Jamestown, Rhode Island. This light proved to be considerably brighter than the previous sperm oil–generated light. In his diary, he reported that this beam of light was visible from Montauk Point, forty miles away. The claim seems impossible, but Melvill probably made the entry as an added reason for the government to renew his contract.

Because best is not always better in the business world, the contract was not renewed due to the strong opposition by persons in the sperm-oil trade, including Melvill's partner. Additionally, Lewis was accused of stealing the patent right from Melvill. In 1819, Melvill published a work under the title *An Exposé of Facts Respectfully Submitted to the Government of the U.S. Relating to the Conduct of Winslow Lewis* to clarify his relationship with Lewis.

The problems with Lewis most likely added greatly to his discouragement. A few years after gas lighting illuminated the streets of Newport, Melvill passed away in obscurity at his home on September 3, 1856. He died not at the site of his invention, but in a house on Frank Street. The present-day location of the Frank Street house is the grassy knoll of Queen Anne Square, the second gas light on the right from Thames Street. This house was moved to Clarke Street and is now a bed-and-breakfast.

He is buried with his family in the Common Burial Ground. No longer marked by a tombstone, he lies to the right of his wife, Patience. In conclusion, David's last name is consistently incorrectly spelled. There is no "e" on the end of Melvill. This is according to the marriage certificate, obituary, family members' gravestone inscriptions and, most important, the probate record (the will).

Today, there is a plaque at the southeast corner of Pelham and Thames Streets commemorating the gaslights' existence. The year on the sign is 1805, although 1806 is the year generally accepted. The first city in the United States to use gaslights on a widespread basis was Baltimore in 1817.

THE FIRST METHODIST CHURCH IN THE WORLD TO BE BUILT WITH A STEEPLE AND BELL IS LOCATED IN NEWPORT

(1806–1807)

In the early days of Methodism, the denomination's chapels were constructed in the plainest and least expensive manner possible. The fathers of the congregation in America made virtue of necessity and built according to their limited means. Many people took great pleasure in decrying pews, bells, steeples, choirs and organs.

Originally called the Methodist Episcopal Church, St. Paul's Methodist Church involves a tradition of the first resident bishop in America, Francis Asbury. When visiting the church for the first time, he was so taken aback by it all that he commented bitterly, "We crossed Narragansett Bay on Friday and came into Newport. Grand house, steeple, pews, ah, what a pliability to evil—they'll be having a choir next!"

Paul Revere is credited with making the first bell to hang in the steeple of the church. It has been said that St. Paul's is the oldest Methodist church in New England, but this is not true. A Methodist church in western Connecticut and the Methodist church in Warren, Rhode Island, were both organized before St. Paul's by a few months. Services are still held in the church today, and the location of St. Paul's United Methodist Church is 12 Marlborough Street.

Located in the oldest section of the city, St. Paul's Methodist Church is situated on the first street to be built in Newport, Marlborough Street. The houses on both sides of the church have been torn down. This 1955 photograph was taken adjacent to Liberty Square. *Author's collection.*

28

THE MAN RESPONSIBLE FOR THE FIRST DEFEAT IN WORLD HISTORY OF A BRITISH SQUADRON AND THE FIRST AMERICAN COMMANDER TO SUCCESSFULLY SHIFT HIS FLAG IN THE MIDST OF BATTLE CALLED NEWPORT HIS HOME

(Battle of Lake Erie, September 10, 1813)

As there is some confusion with Oliver Hazard Perry's actual birth date (b. South Kingstown, Rhode Island, August 20 or 23, 1785), there is wide speculation on why and when the Perry family arrived in Newport from the western side of Narragansett Bay. It has been suggested that Newport afforded the children better educational opportunities and the influence of a seaport. And, perhaps, they came here due to the U.S. Naval career of father Christopher Raymond Perry.

Perry was baptized with his younger brother Matthew at Trinity Church in 1795. After being schooled at Mr. Fraser's, in his early teens, Perry entered the navy as a midshipman. He was placed on board the vessel *General Greene*, where his father was captain. This marked the beginning of his lifelong career serving his country.

He made two tours of the Mediterranean Sea and was commissioned a lieutenant in 1807. Perry was involved in various activities over the years, being responsible in the building and commanding of gunboats in Newport for the government.

On May 5, 1811, Perry married Elizabeth Champlin Mason in the drawing room of her father's home, which once stood at 274–76 Thames Street. (Today, it is part of One Pelham East and the side parking lot.)

A declaration of war was authorized by Congress on June 18, 1812, against the United Kingdom of Great Britain and Ireland. The three main causes of the war were Britain's seizure of U.S. ships trading with France; Britain's seizure of U.S. sailors; and Britain's arming of Indians raiding the western border (the eastern Great Lakes region).

Perry, at the time, felt his job here was not enough and wanted to do more for his country. He let his superior officers know of his wishes. By

early 1813, he was given the command of U.S. naval forces on Lake Erie, with his headquarters at Erie, Pennsylvania. During that spring and summer, Perry oversaw the building, equipping and staffing of a fleet of ten small vessels. He completed this task by August. Now at his disposal were two sister ships, the *Niagara* and the larger *Lawrence*. Perry's flagship, the *Lawrence*, was named after his close friend James Lawrence, who had been mortally wounded months earlier in a sea fight off of Boston. Perry had a banner made with the dying words of Lawrence: "Don't give up the ship!"

Perry assigned the sister ship to Lieutenant Jessie D. Elliott. The two men were far different from each other. Elliott was older, lower in rank and egotistical.

Early in the morning on September 10, 1813, the British squadron under Commander Robert H. Barclay had been sighted on Lake Erie by the Americans. The battle pitted six British against nine U.S. vessels.

Actual fighting began just before noon, and a gap developed between the *Lawrence* and *Niagara*, in effect holding back two-thirds of the American squadron. (Elliott later claimed that light winds caused the gap.) Virtually solo, the *Lawrence* fought the entire British fleet and was practically destroyed in the process. Two-thirds of the *Lawrence* crew were either dead or wounded. Perry rolled up the banner and shifted his command to the *Niagara*. Elliott was in disbelief to see Perry uninjured. Perry ordered Elliott to "bring up" the rest of the squadron, to which he complied. As one historian stated, "Under Perry, *Niagara*'s unfavorable wind immediately became favorable."

Regrouped, Perry proceeded to defeat the British from the decks of the *Niagara*. This event marked the first time in world history that a British squadron had been defeated and the first time an American commander had successfully shifted his flag in the midst of battle. Perry sent his famous message to General William Henry Harrison, who would later become president: "We have met the enemy and they are ours." This was an important victory, although the Treaty of Peace and Amity would not be signed until Christmas Eve 1814.

Now a national hero, Perry eventually returned to Newport. In 1817, he lived in the Jahleel Brenton House on Thames Street—currently the Mary Street municipal parking lot. In the following year, in November 1818, the Perrys bought a house at Washington Square.

Perry did not live here very long, as he was sent on a delicate mission to South America. While gone, his wife, Elizabeth, had her famous dream in

the Washington Square home. She dreamt the death of her husband—"If I were superstitious it would worry me, but I am not, and I shall think no more about it." The next news that she heard was that he was dead!

While in South America, Perry contracted yellow fever and died a few days later on August 23, 1819, at the age of thirty-four on board the *Nunsuch* near Angostura (Ciudad Bolivar) on the Orinoco River in Venezuela. In that day, people thought that they could catch death by having a dead body on board. Fearing the transmission of the disease, Perry's body was taken two hundred miles from his place of death and interred at Port of Spain, Trinidad.

Eventually, the U.S. government dispatched the *Lexington* to Trinidad to bring the remains back. The ship arrived in Newport waters on November 27, 1826. His funeral, held on December 4, was considered the most imposing ever witnessed here and to have exceeded the funeral procession of Admiral de Ternay. With silence prevailing, except for the sound of mournful music and marching soldiers, his procession went along Thames Street. His body was taken to the Old Common Burial Ground and interred. Ten years later, on May 24, 1836, the purchase was completed on his present-day resting spot, which is in Island Cemetery. At one time, this beautiful spot commanded an extraordinary view of the harbor and bay—a fitting tribute to this naval hero.

In his memory, a tall granite obelisk was erected by the State of Rhode Island in the family plot. In reality, Commodore Perry was dug up twice and buried three times, while his brother Matthew was buried twice. His house remained in the family until 1865. It is now known as the Commodore Perry House, Perry Mansion and the Moses Seixas House. The plaque today reads: "Buliod-Perry House/Newport Restoration Foundation." The house is located at 29 Touro Street, next door to the Opera House movie theater, now known as the Newport Opera House Theater & Performing Arts Center. Born on Rhode Island soil, Commodore Oliver Hazard Perry was baptized, educated, reared, married and chose Newport as his home.

A NEWPORT MAN INVENTED THE FIRST FELT MANUFACTURING MECHANICAL PROCESS IN THE UNITED STATES

(1820)

Thomas Robinson Williams was a watchmaker in Newport prior to 1812 and has been credited with inventing the **first successful operating power loom** in this country. The United States today is the largest consumer and producer of wool in the world. Until the 1950s, New England was the center of the weaving industry, before mills moved south and overseas due to various economic reasons.

During the Industrial Revolution, it was stated that "Rhode Island, in proportion to its population, was more largely engaged in manufacturing than any other state." At the turn of the nineteenth century, the Peace Dale Manufacturing Company was the first in this state to use machinery in woolen manufacture. This enterprise was headed by Rowland Hazard. Around 1812, Williams invented his first loom and supposedly received a patent the following year. So successful was this invention that Hazard contracted to have four looms built by Williams.

Williams issued to Hazard a document dated January 1813, in part reading: "Thomas R. Williams of Newport…sole patentee for Williams' Patent Water-looms for the United States of America…have licensed…four of said water-looms, to use and enjoy the same in all places, as fully and absolutely as I could do."

The purchase price for all four was $1,500. Hazard's son Isaac thought differently, once stating that they were "so imperfect that they did not make the web equal to that produced by hand, and the business did not succeed." Williams eventually improved the looms. Afterward, his attention turned to the aspect of felting. This term is applied to the progressive shrinkage of wool.

According to Kane's *Famous First Facts*: "**FELT manufacturing mechanical process** was invented by Thomas Robinson Williams of Newport, R.I. in 1820. The wool is carded and placed in layers until the

desired thickness is obtained, the outside rolls being the finest in texture. The mass is placed between rollers, partly immersed in water, and is beaten, pressed, and given an oscillating movement at the same time. Dyeing and finishing complete the process."

30

TOMATOES WERE FIRST EATEN IN NEWPORT, AND THE PERSON RESPONSIBLE FOR THEIR INTRODUCTION TO THE UNITED STATES AS AN EDIBLE COMMODITY LIVED IN NEWPORT

(1822)

The tomato is native to Central and South America. Explorers carried them back to Europe in the early 1500s. The Italians used it as a food. Often called, among other things, the "love apple" or the "wolf peach," the tomato belongs to the nightshade family. Due to its close resemblance to several poisonous plants, it was long thought to be poisonous and so was used instead as an ornament. Enter Michele Felice Corné (1752–1845), the person generally credited with its introduction as an edible commodity to this country.

Corné arrived in the United States on July 7, 1800, aboard the *Mount Vernon*, owned by the Derby family of Salem, Massachusetts. The logbook of the *Mount Vernon* did not list his name among the passengers on that day. Hence, one cannot be certain that he was on that boat. Some have claimed that he arrived in 1799, but 1800 is considered to be the year of his arrival into the country.

Who was Corné? He was an artist. His paintings may be grouped into landscapes, marines, panoramas and portraits. He utilized a number of mediums, including gouache, oil, pen-and-ink and watercolors on canvas, paper and wood. As the story goes, although never proven, on the day of his arrival, he had tomato seeds in his pocket.

Corné lived in Salem, painting and teaching until 1806, when he moved to Boston. While there, he did one of his most noted works, Abel Bowen's *The Naval Monument*, published in 1816. The book contained twenty-one illustrated paintings of naval engagements that took place during the War of 1812. Each drawing was signed by Corné and described and engraved by Bowen. Corné stayed in Boston until moving to Newport in 1822. When Corné arrived in Newport, he was at least seventy years of age. He spent the last twenty-three years of his life here.

A Hundred Claims to Fame

The home of Michele Felice Corné stands on the southeast corner of Corné and Mill Streets. An exterior wall plaque honors his introduction of the tomato to this country. *Author's collection.*

As far as the Newport claim concerning the first consumption of the tomato, it is a Newport version of nonsense and legend. When Corné lived in Salem, he loved to tell the story of his appetite for the tomato. It is most probable that he introduced it to Newport as an edible commodity, but Corné was previously in Salem for more than twenty years, and he very likely ate it there.

The early to mid-1800s was a time of high anxiety concerning the tomato, and there are references to people standing up in public and spewing tales while eating tomatoes. Some people thought that this would surely result in death. Robert Gibbon Johnson has been credited with the introduction of the tomato as an edible to this country, in September 1820 in Salem, New Jersey. However, this story lacks supportive documentation. So who gets the proper credit for introduction of the tomato? According to Andrew F. Smith in his book *The Tomato in America: Early History, Culture, and Cookery*: "Perhaps the most common tomato myth is that of the introduction story, of which there are many versions, reporting what person or group of people first introduced the tomato

into America. These myths have one aspect in common: little primary-source evidence has ever been offered in their support."

Smith added that he had found more than five hundred versions of the introduction story. One cannot prove where or by whom, but somehow, over time, Corné received the credited. He would be a perfect example of the snowball effect as discussed in our introduction to the book. The great talker and raconteur Corné lived well into his nineties and died on July 10, 1845, in Newport. He is buried in the Old Common Burial Ground. A six-foot obelisk marks the grave.

31

NEWPORT IS THE SITE OF THE FIRST FREE BLACK CHURCH IN THE UNITED STATES

(Congregation Founded January 24, 1824)

On this old church structure, a plaque reads, "Union Congregational Church—built in 1834—First Free Black Church in America." The African American congregation that once occupied this structure was an outgrowth of the Free African Union Society, which was founded in 1780 and is often claimed to be the **first black cultural society and/or mutual aid society of African Americans in the United States**. This claim may or may not be true.

As a religious body, this Newport congregation traces its founding to January 24, 1824, which should not be confused with the year 1780. The original structure on Division Street was built by the Fourth Baptist Church and was purchased in 1835 by Newport Gardner and others. Gardner, a former slave, had gained his freedom and was closely associated with Reverend Samuel Hopkins, pastor of the First Congregational Church. Originally called Color Union Church, the name would eventually be changed to Union Congregational Church.

This original structure was torn down in 1871, and the present structure was built on the existing foundation. But the plaque is not inaccurate. The proper distinction should be "the first black church in Newport," as there were at least four older churches and most probably others established prior to the Newport congregation of 1824.

The Bethel African Methodist Episcopal Church, established in Philadelphia by Richard Allen, has 1793 and 1816 as its founding dates. Also, the African Meeting House, now known as the Museum of Afro-American History, located in Boston, was officially formed by freed slaves in 1805. The present structure was dedicated on December 6, 1806, and claims its meetinghouse as the oldest black church edifice still standing in the United States. In addition, there is the Varick African Methodist Episcopal Zion Church (1818) in New Haven, Connecticut, and the Union United Methodist Church (1818) in Boston. It is most probable that many others were established prior to the Newport congregation.

Services are no longer held at 49 Division Street, since this congregation split into several other congregations and the building became apartments.

32

NEWPORT WAS THE SITE OF THE FIRST POST OFFICE BUILDING ERECTED FOR THAT PURPOSE IN THE UNITED STATES

(1829)

As there were post offices in existence prior to 1829, the key phrase is "erected for that purpose." The first colonial post office dates from 1639, in Boston. The General Court of Massachusetts designated the tavern of Richard Fairbanks as the official repository of mail brought from or sent overseas.

In 1673, monthly service was set up between Boston and New York. One of the trails of the colonial post rider became known as the Lower Boston Post Road, and parts of the royal mail route would cross over Aquidneck Island through Newport. The mails and their routes were always of importance, and with the formation of the Continental Congress, Benjamin Franklin was appointed postmaster general on July 26, 1775. This organization is now known as the United States Postal Service.

In the nineteenth century, word was received in Newport that a bill had been passed by Congress appropriating a sum not to exceed $10,000 for the purchase of a suitable site for a customhouse and post office in Newport. The act was approved on May 24, 1828; in November, land was secured at the corner of Franklin and Thames Streets. By May of the following year, proposals were being received for its construction. Russell Warren was its architect, and the appearance of the proposed building was well received. It was occupied in 1830, but was this building the first?

Kane's *Famous First Facts* states: "**Post office building (U.S.)** built for that purpose was the Custom House and Post Office in Newport, R.I., built in 1829 and occupied in 1830. An act of Congress approved May 24, 1828 (4 Stat. L. 303), authorized the erection of the building. The title to the site was vested in the government on November 12, 1828."

On the same day, May 24, 1828, Congress enacted further legislation for obtaining suitable sites and construction of buildings not to exceed $8,500 and $20,000 in Mobile, Alabama, and Portland, Maine, respectively. On the same day, appropriations were made not to exceed $300 for repairs to

The original United States Post Office and Custom House on Thames Street. The present structure is built on the exact spot as the one pictured. *Author's collection.*

an existing building in Newburyport, Massachusetts, and $12,000 for the erection of an additional building. According to postal historian Meg Harris, it is thought that the latter building was located in Washington, D.C.

The building in Newport survived a fire in 1875 that destroyed the interior. By 1916, it was replaced by the current Federal Building (Post Office) at the same location on Thames Street.

33

THE FIRST TRIAL INVOLVING A CLERGYMAN CHARGED WITH MURDER IN THE UNITED STATES WAS HELD IN NEWPORT

(Trial Began May 6, 1833)

On December 20, 1832, a twenty-nine-year-old mill woman's life was abruptly ended. Her body was found strangled and hanging from a stake on the property of John Durfee in Tiverton, Rhode Island. Some claimed it was suicide, while others claimed it was murder, as the body was found in an unusual position.

When her identity was established, and while burial preparations were being made, Sarah Cornell's belongings were examined for the purpose of obtaining suitable burial clothes. Among her possessions were several letters on different colored papers. One letter read, "If I should be missing inquire of the Rev. Avery of Bristol, he will know where I am. Dec. 20th SM Cornell."

Ephraim K. Avery (1799–1869) was a Methodist minister in Bristol, Rhode Island, who was widely respected by those who knew him for his moral integrity and superior talent. Avery and Miss Cornell did in fact know each other from early days, when she was a parishioner at Avery's church in Lowell, Massachusetts. Their relationship has been characterized as anything from Miss Cornell being a disgruntled parishioner (Avery had once denounced her in a former church in Lowell) to a blossoming love affair. Whatever the case, the relationship between the two is pure speculation.

In March 1833, the Supreme Judicial Court of the State of Rhode Island and Providence Plantations returned a bill of indictment against Reverend Avery for the murder of Sarah M. Cornell. Ironically, Avery was imprisoned at the jail across the street from the Methodist Church on Marlborough Street here in Newport.

On Monday, May 6, 1833, the trial began in the lower hall of the State House (Old Colony House) and was attended by a large number of people. It was covered by some of the major newspapers in the country. During the trial, Avery's lawyer argued that Miss Cornell had forged the

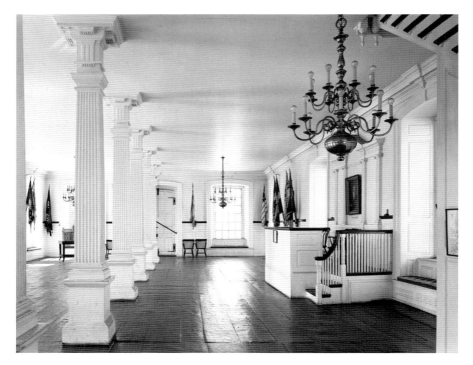

Old Colony/Old State House. Trials were normally held in the second-floor courtroom. But for the sensational murder trial of Reverend Avery, this spectacle was conducted in the lower hall, due to the overflow of people. The trial attracted unprecedented media attention and was considered the longest trial ever held in this country up until that time, with 250 witnesses called. This photo was taken circa 1970. *Courtesy Library of Congress.*

letters, ostensibly written and signed by Avery, and then hanged herself to incriminate the minister. In addition, his lawyer called mostly clergymen, to show that his client was of good character. He then called several women to testify that they knew Miss Cornell and that she was not a good person. In the closing arguments, Avery's lawyer stated that this particular trial was the longest ever held in this country. In all, almost 250 witnesses were called by the government and on behalf of the prisoner.

On Sunday, June 2, 1833, just around noon, with church services ending and bells ringing, the verdict was handed down by the jury: not guilty!

Even though Reverend Avery was acquitted for the murder, everywhere he went, mobs threatened to cause him bodily harm. Eventually he left the ministry and settled in New York State. He became a farmer and died in Ohio in October 1869.

34

NEWPORT WAS HOME TO THE FIRST U.S. AMBASSADOR TO BRAZIL

(Appointed 1841)

The youngest child of Dr. William and Deborah Hunter Malbone, and the only son to survive infancy, he was the second child in the family to be named William. His brother died in 1772 at the age of four, and he was born two years later in Newport on November 26, 1774.

He lived with his mother and sisters on Thames Street before enrolling at Brown University. Upon graduating in 1791, he traveled to England. Deciding against a medical profession, Hunter pursued law studies at the

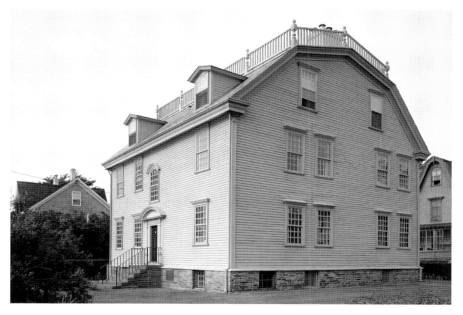

Nichols-Wanton-Hunter House, 54 Washington Street, was built between 1748 and 1754 and purchased by Hunter in 1805. By the 1870s, it was used as a boardinghouse, then as a convalescent home. In 1945, the house was restored under the auspices of the Preservation Society of Newport County. The building is considered the society's first property. The photo was taken in 1971. *Courtesy Library of Congress.*

Inner Temple in London before returning to complete his studies and his admission to the bar at the age of twenty-one.

In 1812, he was chosen to replace C.G. Champlin, who had resigned, as the U.S. senator from Rhode Island. Hunter, a Federalist, fulfilled the remaining two years of Champlin's term and, in 1814, was elected to serve a full six-year term. Having failed in his reelection bid for another six years, he returned to practice law and represent the people of Newport in the Rhode Island General Assembly.

President Andrew Jackson appointed Hunter "charges, d'affaires to Brazil" in 1834. At the request of Emperor Pedro II in 1841, he was elevated to the position of "Envoy Extraordinary and Minister Plenipotentiary" (better known as ambassador). His term expired two years later, and he returned home. Hunter died on December 3, 1849, in the house that bears his name, Hunter House, located at 54 Washington Street. He lies resting at Trinity Church burial grounds, marked by the tallest obelisk in the graveyard.

35

NEWPORT WAS HOME TO THE FIRST AMERICAN TO ATTEND ÉCOLE DES BEAUX-ARTS

(1846)

Richard Morris Hunt was considered one of the most influential U.S. architects of his time. Some have claimed that he was a Newport architect; others claim that Newport was his home. Hunt did have a thirty-five-year association with Newport and was considered a summer resident. He died and is buried in Newport. Some of his architectural projects still stand in Newport today.

Hunt was born on October 31, 1827, in Brattleboro, into a wealthy Vermont family. His father was a U.S. congressman who died when Richard was very young. His mother, an enthusiastic, energetic woman and supporter of the arts, took her children from Brattleboro, Vermont, to live in New Haven, New York and then Boston. Hunt studied and graduated from Boston Latin School in 1843. From there, his family went to Europe, and in 1846, he became the first American to enroll at the famous École des Beaux-Arts in Paris.

There were many components to the education he received there. One of the most important was the atelier (studio), where a student's original idea could be developed under a method of critiquing. At first, there was no official graduation, and students stayed as long as they wanted. But they had to be less than thirty-one years of age. When Hunt attended, there was no graduation. This school no longer exists.

After this period of study, Hunt traveled extensively in Europe and Asia Minor before returning to the United States in 1855, establishing himself in New York City. This marked the beginning of his American career. Two of his many works are the Biltmore House in Asheville, North Carolina, considered to be the greatest country house ever built in North America; and the base of the Statue of Liberty.

Hunt was the first secretary of the American Institute of Architects and the first American to be awarded a gold medal by the Royal Institute of British Architects. The following claims may or may not be true: He is credited with being the first to establish an atelier in the United States, where

he personally taught young architectural students; the first native-born American thoroughly trained in architecture; designer of the first apartment house with a modern layout; and the first American to recognize the need for adequate architectural training for students in this country.

When he arrived in Newport in his early thirties (1860), his brother William Morris Hunt (1824–1879) had been living here for a few years. William maintained a residence at Hilltop and is generally **credited with introducing and popularizing the influence of Barbizon painters into the United States**. He had a studio that included works by the brothers Henry and William James and John La Farge.

During the summer of 1860, Richard met Catherine Clinton Howland, a young woman of social prominence from New York, while at Oaklawn, located on the northeast corner of Narragansett Avenue and Spring Street. The next year, they were married. While they were in Paris, he talked with John Noble Alsop Griswold, a successful businessman. Griswold engaged Hunt to design a home for his family in Newport. That was one of Hunt's first commissions in Newport. The Griswold House (1861–64) is now the Newport Art Museum. While this house was being built, Hunt purchased Hilltop from his brother.

The Griswold House (1861–64), now known as the Newport Art Museum, is one of Richard M. Hunt's first commissions in town. Located on Bellevue Avenue. Seen here in a 1969 photo, the museum's west façade faces the Perry statue at Touro Park. *Courtesy of Library of Congress.*

A Hundred Claims to Fame

The statue of Commodore Matthew C. Perry in Touro Park pays homage to the man responsible for the first treaty of peace, amity and commerce between the United States and Japan (Treaty of Kanagawa, 1854). This 1905 photo was taken from Bellevue Avenue. *Courtesy of Library of Congress.*

Some of his other notable Newport works include: Belcourt Castle, the Breakers, additions to Chateau-Sur-Mer, the Hypoteneuse, Marble House, Ochre Court and lesser-known ones such as the Thomas Gold Appleton House, the Belmont tomb at Island Cemetery, an addition to Levi P. Morton's Fairlawn and the Indian Spring/Busk mansion. In 1993, this house, also known as the "Wrentham House," was Newport's last abandoned mansion and owned by the Van Allen family. Hunt's work at the time was not always appreciated because his clientele were considered a bunch of "robber barons" who liked things in excess.

Not feeling well, Hunt was confined in his room for two weeks at Hilltop when he died unexpectedly on July 31, 1895. His funeral was held at Trinity Church in Newport and was attended by many prominent people. Following his death, a monument was erected at Fifth Avenue and Sixty-Ninth Street in New York City, **the first time an American architect had a monument erected in his honor**.

His house, Hilltop, located on Bellevue Avenue, no longer stands. It is the present-day site of the Hotel Viking. Hunt lies in Island Cemetery, where his gravestone reads, "Laborare Est Orare" ("Work is prayer").

36

NEWPORT WAS THE TEMPORARY SITE OF THE FIRST NAVAL ACADEMY IN THE UNITED STATES

(1861–1865)

Officially opened on October 10, 1845, in Annapolis, Maryland, the academy was known as the Naval School. The name was changed to the U.S. Naval Academy on July 1, 1850.

Due to the outbreak of the Civil War and its proximity to a war zone, the academy was transferred to Newport on May 9, 1861. The academy occupied Fort Adams, the Atlantic House, and used buildings on Goat Island housing laboratories and classrooms. The frigates *Constitution* and *Santee* were moored near the island for training purposes.

At the end of the Civil War, there was a good chance the Naval Academy would remain in Newport for various reasons. However, in the end, it was returned to Annapolis on September 9, 1865. There is a sign commemorating the academy's existence at the corner of Pelham Street and Bellevue Avenue. Originally the site of the Atlantic House (no longer standing), it is now the Elk's Lodge.

During the U.S. Naval Academy's brief stay in Newport, instructor Stephen Bleecker Luce (born on March 25, 1827, in Albany, New York) became a leader in the movement to modernize the navy in the late nineteenth century. He was responsible for a number of significant developments in education and training.

Luce founded the first state maritime school, the Naval Apprentice system for training recruits and the first naval recruit training station. He was the first president of the Naval War College.

Luce had a deep interest in education, and when it came to the literature concerning seamanship being used at the academy, he felt it was grossly inadequate compared to the literature of the other armed forces. He prepared a textbook for his classes, which would become the **first textbook of seamanship in the United States**. It was prepared and published in Newport.

Given to a printer in Newport, the preface was dated "Newport, R.I., May 12, 1862." The first issue was not original work, as Luce compiled

previously printed material on this subject from a variety of sources and put it together very quickly due to time constraints. The textbook, *Seamanship*, was a success and went through many editions and was used by the Naval Academy for forty years.

While in Newport, his family liked the area and decided to remain even when he was out at sea. He permanently settled in Newport in 1880. According to John B. Hattendorf, *Seamanship* was written at 42 Mann Avenue. However, Luce's longtime residence was at 15 Francis Street. He died in Newport on July 28, 1917, at the age of ninety and is buried in the St. Mary's Episcopal Church graveyard at Portsmouth.

Newport owes its naval presence in large part to the strong backing of Rear Admiral Stephen B. Luce. He felt this area was well suited for the modern navy.

37

THE MAN RESPONSIBLE FOR THE FIRST EXTENSIVE GEOLOGICAL SURVEY OF THE GOBI DESERT WAS A RESIDENT OF NEWPORT

(Survey Undertaken 1864–1865)

Professor Raphael Pumpelly (1837–1923) was considered one of the most illustrious geologists and mineralogists of his day. Schooled at the Owego Academy, Pumpelly, at the age of seventeen, decided against attending Yale University and traveled to Europe. That is where he began his scientific and geological training, at the Royal School of Mines at Frieburg, Saxony, Germany. He graduated from that institution in 1859.

His initial job was in the Apache country of Arizona, overseeing the development of silver mines. Two years later, as consulting geologist to the Japanese government, he explored its empire. Due to political instability in that country, he decided to move on. Instead of coming back to the United States, he journeyed the Yangtze River in China. Before making his way overland to St. Petersburg, Russia, he made the first extensive survey of the Gobi Desert (Gobi Desert; the present-day site of Inner Mongolia, China; the majority of this 500,000-square-mile desert is in the Mongolian People's Republic).

This was almost the first professionally scientific geological work ever done in China, and Pumpelly did it privately, with no organizational affiliation or government backing.

Upon returning to the United States after the Civil War in 1866, Pumpelly was appointed the first professor of mining at Harvard University. He held the post for seven years. During this time, he married Eliza Frances Shepard on October 20, 1869. He arrived in Newport in 1879 and was appointed director of the local U.S. Geological Survey branch here. The office was located in the Vernon House on Mary Street.

Professor Pumpelly, with his striking personal appearance and courteous, genial composure, was a familiar figure on the streets of Newport. Associated with the scientific and literary societies of our city, he contributed vast knowledge of the world and gave people a rare opportunity to learn firsthand

about his various explorations. Even though he maintained his residence in Newport, he traveled extensively throughout the United States and around the globe.

He passed away with his daughter and son present on August 10, 1923, at the age of eighty-six in the house that was built for him in the early 1880s. This house no longer stands and was on the grassy knoll to the right of 270 Gibbs Avenue. A new home has recently been erected on the spot.

Marked by the largest tombstone, Professor Pumpelly and his family rest today at Saint Columba's Chapel (formerly Berkeley Chapel and/or Berkeley Memorial church) off Indian Avenue. A resident of Newport for forty-four years, Pumpelly was the **first to set forth clearly the secondary nature of iron ore and establish its age**.

38

NEWPORT WAS THE SITE OF THE FIRST PUBLIC ROLLER-SKATING RINK IN THE UNITED STATES

(August 1866)

The claim has been written two ways: the first roller-skating rink in the United States; and the first public roller-skating rink in the United States. The word "public" can change the entire dynamic of the claim.

The origins of roller skates and skating can be traced to western Europe in the mid-eighteenth century. The first skate patent was issued in France in 1819. As popularity increased, especially in the 1860s, some companies that made skates were advertising in publications read by the masses. In the December 27, 1862 issue of *Harper's Weekly*, the Central Park Skate Emporium, located at Central Park, New York, advertised "Skates 25 cents to 25 dollars—Everything in the skating line (except ponds) to suit all ages, sexes, tastes and purses."

One year later, James Leonard Plimpton, from Medfield, Massachusetts, made improvements and introduced a practical four-wheeled skate called the "rocking skate," which enabled the wearer to skate in curves. In the same year (although not confirmed), Plimpton organized the New York Roller Skating Association and erected a $100,000 rink in New York City. By 1865, there were a few small rinks operating in the eastern part of this country.

Referenced in Kane's *Famous First Facts*, the claim for Newport appears as the "first roller skating rink (public)." The Atlantic House had been used in connection with the U.S. Naval Academy during its stay in Newport (1861–65). By the summer of 1866, the academy was gone and the building no longer operated as a hotel. The New York Skating Association used it for its skating assembly. According to the *Newport Daily News* of August 3, the advertisement in part stated, "Rooms open daily for skating! From 9 AM to 6 PM—tickets 25 cents.…To citizens and visitors of Newport, as a choice, moral, social and highly beneficial exercise and recreation, in which ladies, gentlemen and children may safely participate."

This enterprise lasted for only one month. The Atlantic House was a hotel, not a skating rink. Further complications regarding the claim arise with the term "built for that purpose," because somewhere, someone can lay

claim to having the "first public roller skating rink in the United States built for that purpose." It has not been determined if the New York City rink or others were public or private.

Roller-skating rinks were far different compared to the rinks of today. The conversion of any room would suffice, much like what was done at the Atlantic House, where the dining room was converted for skating. If sporting-goods companies in Boston and New York were advertising roller-skating merchandise four years prior, it is safe to say that there were other rinks. One advertisement even said that the merchandise was "for all purses."

Although Newport was most likely not the first roller-skating rink, it is the earliest on record. The Atlantic House no longer exists; it is the present-day site of the Elks Lodge.

NEWPORT WAS THE SITE OF THE FORMATION AND HEADQUARTERS OF THE FIRST CATTLE CLUB IN THE UNITED STATES

(Formed July 1868)

Have you ever heard of Elsie the Cow? She was a Jersey! Borden's Elsie, the dairy's mascot, adorns its products. American Jersey Cattle Club member Jim Cavanaugh was instrumental in Elsie as a brand design for the 1939–41 World's Fair in New York City.

The Jersey is recognized as a distinct and superior breed of dairy cattle. Noted for its milk's richness, this dairy animal possesses more desirable qualities than the common stock. Brought from the island of Jersey, located in the English Channel, its introduction date to America is unknown. What is known is that the first Jerseys were carried across the Atlantic Ocean in sailing ships.

Because of the duration of sea voyages, there was a need for cows. While pigs and chickens found quarters in the longboat, the cow house was built atop the main hatch. Thus, many of these ships were floating farmyards. Some early breeders of Jerseys in America kept good and accurate records. But most did not, so there was an urgent need to develop reliable records concerning breeding. The claim appeared in *Kane's Famous First Facts*, which reads: "**Cattle club (Jersey cattle**) was the American Jersey Cattle Club, formed July 1868, at Newport, RI, by 43 dairymen who signed a tentative constitution." The claim needs to be reworked to reflect the true origins of the club and its relation to Newport, as Kane's book is a bit inaccurate. The term *club* in essence means "association," and the founding fathers of the American Jersey Cattle Club were enthusiastic owners of Jerseys. They were: Samuel J. Sharpless, Philadelphia; Charles M. Beach, West Hartford, Connecticut; Thomas J. Hand, "Woodlawn," Sing Sing, New York; and Colonel George E. Waring Jr., Ogden Farm, Newport, Rhode Island.

These four men, in July 1868, held an informal meeting at the office of Samuel Sharpless in Philadelphia (not Newport). They proposed a tentative constitution, which included adding men from diverse backgrounds—

farmers, explorers, clergymen, inventors, engineers and writers—to form the club. They all united in the common belief that the Jersey cow was an outstanding contribution to the dairy stock of America. The tentative constitution was issued to these other men. An invitation read: "You may prepare and send in your entries at once to Col. George E. Waring Jr., who is to be our Secretary, without waiting for the formal organization of the Club." The forty-three dairymen did not meet in Newport at all. The organization actually began when Waring received the correspondence.

It has been stated in all American Jersey Cattle Club literature that the first club building (office) was located in Newport, possibly because Waring lived here. Additionally, literature instructed that all communication should be addressed to Ogden Farm in Newport. As club secretary, Waring was the most important person to the origins of the club. He was in charge of compiling a trustworthy herd book and investigated the authenticity of the Jersey, which included the requirement of sufficient evidence of the purity of its breeding.

The Ideal Jersey *Painting by Bonnie L. Mohr, 1991*

This type of cow is a Jersey, a superior breed of cattle. The American Jersey Cattle Club was founded to improve and promote the Jersey breed. *Courtesy of Bonnie L. Mohr.*

Who was Colonel George Edwin Waring Jr. (1833–1898)? He was quite remarkable—an agriculturalist, author and sanitary engineer. During the Civil War, he was commissioned a colonel of the Fourth Missouri Calvary. Afterward, in 1867, Waring came to Newport to become manager of Ogden Farm. This sixty-acre, run-down farm with a barn in the middle of an old apple orchard was surrounded by stone walls—located at the Fork Road and Love Lane, adjacent to a windmill. Waring referred to the farm and his undertaking, which required sufficient capital:

> *I am endeavoring to prove that good farming may be made to pay, where bad farming has been starved out. My aim is to make sixty acres of land which would not, when I took it, support five head of cattle, furnish all the food, winter and summer that will be required by fifty head—except meal and grain for working animals. To do this, I need the best sort of barn, with every convenience for storing hay, fodder, and roots for cutting and steaming food, for sheltering animals in hot and in cold.*

As a writer, Waring wrote about the farm, so much so that it became known throughout the country. After ten years, he moved to a cottage at the corner of Catherine Street and Greenough Place, where he spent the rest of his life. In June 1879, he was appointed special agent of the Tenth U.S. Census, charged with the social statistics of cities. Waring invented many sanitary improvements and was a leading expert on sanitary drainage.

One year prior (1868), the club had held its first meeting at 21 School Street in Newport (now 29 School Street). There were attempts to incorporate the club in Rhode Island. Unsuccessful, the club incorporated in New York instead. Headquarters were moved from Newport on July 1, 1881, to 3 John Street in New York. After various locations, it left there in 1946 for Reynoldsburg, Ohio, where the emphasis remains to improve and promote the Jersey breed.

According to club literature, the original club building was Ogden Farm, Newport. But the farm is more than two miles from the Newport line, located in Middletown. The roads have been renamed Wyatt (Fork Road) and Mitchell (Love Lane). Not much is left of the farm, and there is nothing to indicate that it was a famous place.

The headline of the *Newport Daily News* concerning the death of George Edwin Waring Jr. read, "Long a Citizen of Newport, Deeply Interested in Her Welfare." His Newport home, better known as the

Hypotenuse, can be found at the southeast corner of Catherine Street and Greenough Place.

These superior dairy cattle, which trace their ancestral origins to the island of Jersey, trace one of their most important developments in America to the island of Aquidneck.

NEWPORT WAS THE SITE OF THE FIRST TORPEDO MANUFACTURING STATION IN THE UNITED STATES

(Established Summer of 1869)

Forming the western boundary of Newport Harbor, Goat Island, since its purchase in 1658, has undergone massive cosmetic changes, and its size has grown from ten to thirty acres. It has a fascinating history of fortifications and pirates—in 1723, twenty-six pirates were hanged at Gravelly Point (presently Long Wharf) and were "buried between the ebb and flow of the tide" on the north end of Goat Island.

The founding of the United States Naval Torpedo Station on Goat Island is attributed to David Dixon Porter, who persuaded the Naval Department to establish an experimental station for the research and development of underwater weapons. During the Civil War, the Southern states used various types of torpedoes to cause havoc on the Northerners. In that day, torpedoes were what we now consider stationary mines. Although Newport was not the original chosen site of the torpedo station, there is some speculation on why Newport was selected in the end. It has been suggested that since Newport was a gracious host to the U.S. Naval Academy during the Civil War, the torpedo station was awarded to Newport. Whatever the intentions were, on July 29, 1869, the occupation of Goat Island by the Naval Department was authorized by the secretary of war and placed under the direction of Commander Edmund O. Matthew.

The station was intended to be an experimental station for the development of torpedoes and torpedo equipment, explosives and electrical equipment, as well as to instruct naval officers in the manufacturing and repairing of torpedoes. Construction began, but the island was not open to the public. Military officers and civilian employees were under strict secrecy. Work with explosives made it a dangerous place. In the first fatal accident, two men were killed on August 29, 1881.

Over the years, the station racked up many firsts, with the development of truly mobile torpedoes, such as the **first self-propelled torpedo made in the United States and a torpedo specifically designed for aircraft launching**.

A Hundred Claims to Fame

This circa 1888 photograph shows the original Naval Torpedo Station laboratory on Goat Island. The complex was expanded during the world wars. At one time, the station was the largest manufacturing operation in this state, employing some thirteen thousand people, mostly civilians on an around-the-clock production schedule. *Courtesy Library of Congress.*

The station saw much activity, especially during the world wars, in the form of around-the-clock production. In 1944, more than twelve thousand people were employed. By 1945, the station was so productive and the stockpile of torpedoes so great that it was ordered to stop production. It has been said (although never proven) that 80 percent of the torpedoes used during the world wars were made at the facility.

From the end of World War II to 1951, the station was pretty much abandoned and the facility closed. In that year, the research responsibilities were absorbed by the newly organized Naval Underwater Ordinance Center. In 1970, it became known as the Naval Underwater Systems Center (NUSC). The torpedo complex and the final fortification (Fort Wolcott) were bulldozed into oblivion in the late 1960s. Today, Goat Island is privately owned.

The U.S. Torpedo Station Memorial, a granite monument to those who lost their lives in the service, once stood on the Government Landing adjacent to the Newport-Jamestown ferry slip (today, the: Newport Harbor Hotel). Thought to be bulldozed, it now stands at NUSC in Middletown.

41

NEWPORT WAS THE BIRTHPLACE OF THE FIRST AMERICAN TO INTRODUCE COACHING AS A PASTIME AND TO IMPORT THE FIRST FOUR-IN-HAND COACH TO THE UNITED STATES

(1875)

Delancy A. Kane was the great-grandson of John Jacob Astor. He was born on August 28, 1844, on Bath Road opposite Red Cross Avenue in a house that was not his father's Beach Cliffe—that famous mansion was not constructed until 1852. Bath Road is now Memorial Boulevard.

He spent his early years in Newport and, as a young man, accompanied his parents to England, where he studied at Trinity College, Cambridge, England. Upon returning to this country, Kane entered the U.S. Military Academy at West Point and graduated at the age of twenty-four before serving as a lieutenant in the First U.S. Cavalry. After his service was completed, he married Eleanora Iselin in 1872 while studying law at Columbia in New York. He was admitted to the bar in the following year but never practiced law.

Colonel Kane was very enthusiastic about coaching and was considered to be one of the best whips. He pioneered the introduction of coaching to the United States as a pastime in 1875. Coaching was the premier form of sport driving. He is also credited with bringing the first four-in-hand coach to America from England ("four-in-hand" applies to any vehicle with four horses). Built by Holland and Holland of London, England, he named his coach "Tally Ho." It became so famous that the term "tallyho" became universally known in America and is often incorrectly applied to all coaches and drags.

Colonel Kane spent much of his time in England, but at various times over the course of his life he maintained a residence in Newport and considered himself a native Newporter. Around the turn of the twentieth century, he made a permanent home here and took an active interest in public affairs. He represented the Fifth Ward as an alderman and served one year (1906) as the elected president of that body.

A Hundred Claims to Fame

The cover of *Harper's Weekly*, dated August 22, 1896. The caption reads: "The Annual Coaching Parade At Newport—The Start From Narragansett Avenue, August 22—Drawn By Max F. Klepper." Colonel Kane lived on Narragansett Avenue. *Author's collection.*

His father's house, Beach Cliffe, on Memorial Boulevard no longer exists, but Colonel Kane lived at Oakwood. This house still stands on the corner of Narragansett Avenue and Spring and Dixon Streets. He died on Easter Sunday in 1915 at his wife's family home in New Rochelle, New York. He is buried in Newport alongside his wife, his only son, his parents and his six siblings. His tombstone in Island Cemetery reads "My Faith Is Gods Love."

42

NEWPORT WAS THE SITE OF THE FIRST LAWN TENNIS COURT IN THE UNITED STATES

(About 1875)

Walter C. Wingfield, a British army officer, is generally credited with the invention of modern tennis when he received a patent in February 1874 for his game, called "Sphairistike." Major Wingfield fielded much criticism during his lifetime, as people felt he did not deserve the credit, since the game incorporated ideas from other sports. He made a considerable profit from the sale of patented equipment, including racquets, balls and nets.

In relation to the first tennis court, as the story goes, there was so much confusion over rules, scoring and equipment—the size of balls and racquets and court dimensions—that it has fueled controversy concerning the claim of being or having the first court. The following claims have been made. (1) Mary Ewing Outerbridge is generally credited with laying out the first court at the Staten Island Cricket and Baseball Club in the spring of 1874. She had obtained some of the necessary equipment upon returning from a trip to Bermuda. (2) A court was laid out on the William Appleton estate in Nahant, Massachusetts, in August 1874 or 1875. (3) As the story goes, Mrs. Paran Stevens's son Henry was visiting the Paget family in England (Henry's sister was married to Sir Arthur Henry Paget). Supposedly, Henry returned with the necessary equipment and laid out a court at his mother's estate about 1875 or early 1876. In its infancy, tennis was played by a very small, wealthy group.

It is most probable that it will never be known who was first. Upon a careful examination of the facts, of which there are few, the Newport claim lacks supportive documentation.

Mrs. Paran Stevens was a prominent figure in New York and Newport summer society. The former Marietta Reed married the wealthy Paran Stevens. Her son, Henry Leyden, a sports enthusiast, became involved with Edith Newbold Jones (Edith Wharton) during the summer of 1880. A romance developed, which led to speculation that an engagement was imminent. After much talk by society, the announcement finally happened two years later and was reported in the *Newport Mercury* on August 19, 1882:

"The engagement of Mr. Harry Stevens, only son of Mrs. Paran Stevens, to Miss Edith, daughter of the late George F. Jones of New York, is announced."

But by October, the engagement was off. Perhaps Henry's mother, a society matron, was responsible for the abrupt end, due to her social concerns and financial interests. When Henry either turned twenty-five years of age or got married, his father's $1.25 million estate would come into his possession. But she needed to keep the monies under her control for her own benefit. The Stevens property was located at the northeast corner of Jones and King Streets. Marietta Villa no longer stands. Today, it is the site of CVS Pharmacy at Bellevue Shopping Center.

43

THE FIRST PLANS FOR, AND THE FIRST MODEL OF, THE STATUE OF LIBERTY WERE DONE AT THE STUDIO OF JOHN LA FARGE IN NEWPORT

(1876)

Once known as "Liberty Enlightening the World," the Statue of Liberty is a symbol of freedom, friendship, hope and peace. Not many people know that its creator had ties to Newport. For one thing, he was married here. It has been said that the first plans and model for the statue were done in Newport. It appears that the claim has, in effect, snowballed; it is most probable that it can be attributed to one source. This is in reference to Father John La Farge's book *The Manner Is Ordinary*.

In all due respect to Father La Farge, something went terribly awry in his writings, for which he may, or may not, have been at fault. In his book, he claims that "the first plans for New York's famous Statue were worked out in 1876 by Monsieur Bartholdi in my father's studio in Newport." This was quite impossible, as by 1876 there had been several models made and the hand bearing the torch of Miss Liberty was on display at the Philadelphia Exposition and then at Madison Square in New York City during America's centennial birthday celebration. Bear in mind that Father La Farge was not yet born, so the information concerning 1876 had to have been relayed to him. The story could have been inaccurate in the first place. Perhaps the year referenced was a typographical error. However, on the page of the claim as well as on the next page of his book, there are many erroneous statements.

Regardless of La Farge's proper intentions, the story becomes clear if we start with the year 1871. Frederic-Auguste Bartholdi (1834–1904) does in fact create a model of the statue at the studio of John La Farge Sr. On June 8, 1861, Bartholdi boarded the vessel *Pereire* bound for America. This was his first trip to this country, and when he arrived in New York City, he was amazed at the American way of life. While in New York, he looked up his old friend, John La Farge, whom he had met years earlier in France. La Farge, the artist, heard a knock on his studio door, and Bartholdi was welcomed in.

Since La Farge spent time at Newport, he urged Bartholdi to make use of his studio while he was gone. Enthusiastic about the idea, he also suggested that Bartholdi create a model. Was this the first model to be made of the statue? Some references state that this had been done in the previous year. Either way, the model was made in New York City, not in Newport. La Farge rented and maintained a studio at the Tenth Street Studio Building at 51 West Tenth Street throughout his life. Also, he did in fact have a studio in Newport at the northwest corner of Prospect Hill and Corne Streets.

The completed concept of the statue had not been conceived as yet, but the first plans were certainly under way, and it is evident that they had been for some time. Bartholdi traveled the country with a model to drum up support for his idea, visiting many cities and individuals, including President Ulysses Grant. Interestingly enough, Newport was on his itinerary. Invited by the La Farges, he came to Newport and, while here, met some influential people, including Richard Morris Hunt. Hunt designed the pedestal for Miss Liberty.

Bartholdi, impressed with America, felt good about the initial stage of his project and reception to his idea. He returned to France early in 1872. Additional models were made, and work commenced on the building of the statue. In 1876, Bartholdi returned to the United States, where Miss Liberty's hand bearing the torch was on display in Philadelphia and then in New York City.

In addition to his work, he rekindled the friendship of a woman whom he had met on his previous trip. Many legends abound concerning the identity of the person Bartholdi used as a model for his statue. It has been suggested that this woman, an orphan of French descent, actually lived in the United States. This theory is highly unlikely, since Bartholdi and the woman supposedly had not seen each other in the previous five years, during which work had progressed on the statue.

Her name was Jeanne-Emilie Baheux de Puysieux. As the story goes, while the two were visiting the La Farges in Newport, the question was brought up concerning their relationship. Bartholdi felt that his mother would not approve of this courtship, so he was hesitant to tie the eternal bond with this woman. However, the La Farges felt that Bartholdi, as a man of integrity and influence, should not be cruising the countryside with an unwed girl. A somewhat quick wedding was arranged, and a minister was summoned immediately to the house. The Reverend Charles T. Brooks performed the rite on December 15, 1876, in the parlor of the La Farge home with only the La Farges and their young daughter, Margaret, in attendance.

Supposedly, the new bride had never seen popcorn. Once introduced to it, she was hooked, as many hours thereafter would be spent with her new husband in front of the fireplace with the wire popper. She was, in fact, accepted by Bartholdi's mother, and the two became good friends. The La Farge house still stands at 10 Sunnyside Place in the Kay-Catherine neighborhood of Newport.

THE SPORT OF POLO WAS INTRODUCED INTO THE UNITED STATES AT MORTON PARK IN NEWPORT

(July 10, 1876)

Unquestionably, Newport was one of the first places polo was ever played in this country. However, it was not at Morton Park, but at an adjacent field west of the park. Regardless, this particular polo field was extremely important in the history of the sport.

Early in 1876, James Gordon Bennett Jr. introduced polo to this country when he returned from England with polo balls and mallets. Polo was first played indoors at the old Dickel's Riding Academy at the northeast corner of Thirty-Ninth Street and Fifth Avenue in New York City and outdoors at Jerome Park in Westchester County, New York, with matches held in May and June 1876.

For the summer—grounds were laid out in Newport, which served as the home field for the Westchester Polo Club. Westchester was **America's first polo club**. It was organized on March 6, 1876, in New York City.

The lot selected here was a ten-acre parcel of land owned by Luther Bateman. A nearly nine-foot-high fence was erected enclosing the playing

The original polo field appeared in *Frank Leslie's Illustrated Newspaper* on September 22, 1877. From the rocks, non-paying spectators overlooked the nine-foot-high wooden fence from Deadhead Hill, now the rocky outcropping of Morton Park. A reporter described the area as very romantic in appearance and said that he thought that no better place could have been chosen for the new sport. *Author's collection.*

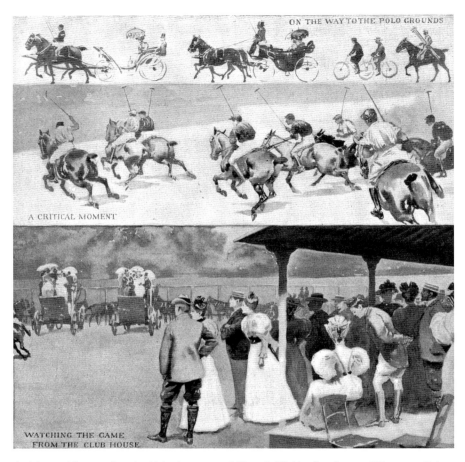

Articles and images found within the pages of *Harper's Weekly* often featured Newport. Polo was first played at the end of Thames Street. Contrary to myth, polo was never played in Morton Park. The introduction of the sport marked the beginning of fashionable Newport as the sporting capital of America. *Author's collection.*

surface. Outside of the lot, toward the east, was Deadhead Hill with its rocky ledges and trees towering above the fence.

The nearly level playing surface was in good order on July 10, 1876, when James Gordon Bennett Jr. and Lord Mandeville competed against two other men. Bennett was the only one who showed up in the proper polo attire, sporting high-top boots, light pants and a blue-and-white shirt with matching cap. Bennett and Lord Mandeville exhibited considerable levels of skill and won the admiration of the guests on hand that day.

Westchester preferred Newport, due to the playing surface and charm offered by America's favorite summer resort. With the exception of Westchester, the Buffalo Club was considered one of the strongest clubs, so the two teamed up for **the first polo match in the United States between two competing clubs, held on August 25, 1877**.

Matches tended to be pickup games between club members. But Westchester, as the odds-on favorite, had more playing experience and better ponies at its disposal than did the Buffalo Club.

In order to win a match, three out of five goals must be scored by one team. This long-talked-about challenge was played before two thousand people, who were seated around the field and on Deadhead Hill. At the time, this match displayed the finest polo ever played in this country. Each of the games was short, sharp and decisive, and Westchester gave its opponent a sound beating, three goals to none, and won the $500 prize.

For years, this area would be known as the Westchester Polo Ground and served as an important social gathering place. Deadhead Hill can still be climbed today in Morton Park. But the polo ground is long gone. The area is now covered by Vaughan, Earl and Meikle Avenues.

NEWPORT WAS THE SITE OF THE FIRST MARINE BIOLOGICAL LABORATORY IN THE UNITED STATES

(Spring of 1878)

Credit concerning the first marine biological laboratory can be given to the father-and-son combination of Louis Agassiz (1807–1873), the famous botanist, and Alexander Agassiz (1835–1910), the marine zoologist and mining entrepreneur. Alexander was responsible for the Newport connection. He arrived in the United States in 1849 and graduated from Harvard University in 1855.

The most important developments happened in 1873, as the first marine laboratory and the first national science summer school were established. Founded by Louis, the entity was named the Anderson School of Natural History at Penikese. Located in the Elizabeth Islands, Massachusetts, the island of Penikese is approximately twenty miles southeast of Newport. The school opened that summer, and a zoological station was established.

However, the year 1873 proved to be a disastrous one as the zoological station failed and Louis and Alexander's wife of thirteen years, Anna, would be dead within eight days of each other around Christmastime. Alexander continued as director of the school the following summer, before the school was discontinued. For various reasons, Alexander would set his sights on Newport.

A few months after the passing of his wife, Alexander purchased a thirty-acre peninsula on the eastern side of the entrance to Narragansett Bay. In the winter of 1874–75, his summer house was built. Originally, a laboratory was set up in one room of the house. In the spring of 1878, a chalet-style laboratory was constructed to the east of the house near the inlet. Agassiz studied here with twelve Harvard students, gathering various forms of sea life. Some of the research conducted included work with flounder, sea urchins and sand fleas. This laboratory preceded the Marine Biological Laboratory at Woods Hole, Massachusetts. The Newport Laboratory was closed to students in 1898 for various reasons.

In later years, Agassiz's gourmet dinners at his home were the talk of Newport. Julia Ward Howe was often in attendance. Her nickname for

A Hundred Claims to Fame

Agassiz was "Dear Zoo." Alexander died aboard his famous research vessel, *The Adriatic*, en route to the United States on March 27, 1910. His home and laboratory still stand today on the grounds of The Inn at Castle Hill.

46

NEWPORT WAS HOME TO THE FIRST FEMALE LIGHTHOUSE KEEPER AND THE FIRST WOMAN TO RECEIVE A CONGRESSIONAL MEDAL

(OFFICIAL APPOINTMENT JANUARY 21, 1879)

Four young men carelessly capsized their small sailboat near Lime Rock, a dangerous outcropping of jagged limestone some six hundred feet from shore, inside the busy harbor. The sixteen-year-old keeper's daughter of the Lime Rock Light was watching. After witnessing the foursome's futile struggle to right their craft, she acted. Alone, she launched her rowboat and skillfully plucked them individually from their life-threatening predicament. It was the Newport fall of 1858, and it began the days that made the ever-vigilant Ida Lewis legendary.

In the winter of 1842, Idawalley Zoradia Lewis was born on Spring Street, just up the hill from the waterfront and her destiny. "Ida" would become America's most famous lighthouse keeper and greatest saltwater heroine of her time, maybe of all times.

In 1854, Captain Hosea Lewis was appointed as the keeper of the new light on the troublesome rocks at the southern end of Newport Harbor. The beacon was housed in a tower, or "sentry box," as he called it. When weather did not permit his daily return home, he sought shelter in a small shed on the rock. Much-needed improvements were planned and started, but it took nearly three years to complete the square granite lighthouse and its attached dwelling to house the commuting keeper's family. By the time the Lewises and their four children moved into the lighthouse in 1857, Ida was fifteen.

Ida's natural love of the sea grew even stronger with the family's new location. Already an accomplished swimmer, she became an experienced rower and a master handler of the oars. She rowed her siblings to and from school and ferried provisions out to the lighthouse, as Lime Rock was not connected to the shore, as it is today. Like other children raised at lighthouses, she assisted in various chores, recording boat sightings, checking the beacon lantern and, of course, pulling people from the sea. Lifesaving was just another part of the job description for lighthouse keepers.

A Hundred Claims to Fame

The cover of *Harper's Weekly*, dated July 31, 1869. The caption reads: "Miss Ida Lewis, Heroine of Newport.—Photo by Manchester Brothers, Providence, R.I." This cover made Lewis famous. *Author's collection.*

In 1857, just a few months after the family took up residence at the lighthouse, her father suffered a stroke and became invalid. Typically, the keeper's wife, if he had one, would assume the responsibilities of keeping the light in circumstances such as these; a new keeper would not be appointed. But Ida's mother's time was quickly occupied with tending to her ailing husband and an ill child, as well. The lighthouse duties now rested on the shoulders of Ida, and no one could have been more suited to the task. For the next twenty-two years, she faithfully kept the light as the de facto keeper of Lime Rock Light, and as at least eighteen souls and later an entire nation would attest, she was more than up to the challenges that awaited her.

Ida's series of dramatic rescues resumed eight years after the first. In 1866, a trio of soldiers from nearby Fort Adams, reportedly under the influence, went for a ride in a skiff. One of them fatefully put his foot through a bottom plank, and in short order, the three found themselves awash, panicked and struggling to save their lives. Ida Lewis was watching. She rowed out to their rescue. When she arrived on the scene, two of the men had already disappeared. The third could still be saved, but his shock and disorientation kept Ida from pulling him into the boat. Instead, she fastened a line to him and proceeded to tow him to safety.

Not long after, on a cold January morning in 1867, workers for the wealthy industrialist August Belmont Sr. were on a dock in the city's inner harbor when a valuable sheep that he engaged them to unload fell into the water and drifted away. The workers launched a nearby boat in an attempt to retrieve the prized animal. The hapless sheep rescuers were immediately imperiled by the icy harbor. Ida Lewis was watching. She saved the men and, yes, also Belmont's sheep. Not more than two weeks later, she ended up pulling in a man clinging to the frigid rocks near the lighthouse. The legend grew.

More rescues added to her already notable resume. In March 1869, two soldiers from Fort Adams had hired a young man to transport them back to the fort from town. During the trip, a raging gale struck. Ida Lewis was watching. This time, she teamed with her brother, and together they managed to save the soldiers. The hired man, however, perished in a watery grave.

Ida was now twenty-seven years old and a bona fide local heroine, but 1869 would really become "her year," as the rest of the nation became aware of her exploits. After her latest rescue, she received a medal from the Lifesaving Benevolent Association of New York with an award of $100. Soon after that, the Rhode Island General Assembly adopted a resolution in her honor. Her life had already been well chronicled locally, but her fame spread rapidly when *Harper's Weekly*, one of the nation's largest magazines with a circulation of more than 100,000, wrote of her deeds. Soon, other national publications picked up the story.

On July 4, 1869, she was duly honored by the citizenry of Newport. A boat was built for her with funds from public subscriptions as a token of their appreciation. The presentation was held at the Parade, now known as Washington Square. They named her new rowboat *Rescue*. Upward of four thousand people attended the ceremony, where Ida was dressed in a black half-veil. After the appropriate speeches of praise and the presentation of gifts, someone in the crowd called for the lifting of the veil. Ida did so graciously while standing in her new boat, to thunderous applause. At the conclusion, an enthusiastic three cheers were given to the heroine of Lime Rock.

In the following month, President Grant paid a visit to Newport. As the story goes (or as legend has grown), he insisted on seeing her—at her home on Lime Rock. The documented facts in this case paint a slightly different scenario, however. In a well-orchestrated manner, Ida, aboard *Rescue*, rowed up to Long Wharf as the presidential party arrived to embark on the trip across the bay. Alone, she stepped up to be introduced to the president. According to the *Newport Mercury*, "This arrangement was carried out to the letter. On being introduced, the President simply said, 'I am happy to meet you, Miss Lewis, as one of the heroic, noble women of the age. I regret that my engagements have been such as not to allow me to call on you at your home but I hope to see you in Washington. Farewell.'"

From that time on, the rich and famous came to pay their respects to Ida at Lime Rock, including Civil War general William Tecumseh Sherman and women's rights activist Susan B. Anthony. At the age of

twenty-eight, with her fame spreading across the nation, Ida Lewis wed Captain William Heard Wilson of Black Rock, Connecticut. The 1870 marriage, however, lasted only two years before the couple separated. There was never a record of divorce. As legend would have it, this was no surprise to many, for it was said that her only true love was Lime Rock.

At about the same time, in 1872, Ida's father died. Despite being an invalid all these years, he retained his official appointments as keeper. Regardless of the fact that Ida, amid all her exploits, had actually kept the light, her mother, as was customary, was named to fill the post of her husband. It was not until January 21, 1879, that Ida Lewis succeeded her mother and received the official appointment as keeper of the Lime Rock Light.

Ida was the recipient of numerous medals over her lifetime. Perhaps none was more important than the one she received two years after her official appointment. This particular medal has been said to be the **first Congressional Medal of Honor** ever awarded to a woman. In July 1881, she was **awarded the gold lifesaving medal (first female)** of the United States Lifesaving Service, accepting the medal in a presentation at the Custom House on Thames Street. Congress had, in 1874, enacted the authorization of gold and silver medals that could be awarded by the Treasury Department to the deserving for their bravery. So, in actuality, the award given to Ida was made not by Congress and thus was not the Congressional Medal of Honor, as it has come to be known. That distinction belongs to Dr. Mary Edwards Walker, for her services during the Civil War. The legend grew.

For the next thirty years, Ida was watching. She maintained her vigil on station at the light spanning a total of fifty-four years. She has been credited with saving eighteen souls from the sea. There were probably other rescues not made public. And who knows how many were saved by her work in averting mishaps?

Was Ida the first female lighthouse keeper in U.S. history? Lighthouse duties tended to be done by a husband-and-wife team. When the man died, his wife assumed the responsibilities, as there were no pensions. Widows made up the largest category of women lighthouse keepers, followed by daughters. It appears that the first women serving in this capacity date to the late eighteenth century. In 1828, the federal register of lighthouse keeper appointments recorded at least ninety-five women—eight appointed before Ida was born. Most women tended lights in safe locations.

This stereoview was taken at Washington Square, just moments before Ida Lewis was honored by the citizens of Newport on July 4, 1869. The boat pictured is the *Rescue*. *Author's collection.*

As the legend has grown around Ida's life, there was speculation as to the cause of her death. It has been suggested that she heard rumors that her lighthouse was to be closed. Fingers pointed at a sensational headline run by the *Newport Daily News* on Thursday, October 19, 1911: "To Abolish Lime Rock Light."

The article went on to say, "Proposition also involves the removal of Ida Lewis as Keeper" and continued, "There is a new set of officials at work on the lighthouse management and some strange things are happening." The article did not support the headline, and no hard facts were contained within it. But, allegedly, the damage was done. On Saturday, two days after the

Daily News headline appeared, Ida suffered a paralytic stroke and was found by her brother, unconscious on the floor of her beloved family home. By Tuesday, October 24, 1911, she had died at age sixty-nine. Did the shock of that news story contribute to the death of the most famous female lighthouse keeper in the nation's history?

It was doubtful that the newly created Lighthouse Bureau would have removed her, since there were no pensions at the time and there had been a longstanding policy not to neglect faithful keepers and their families. In fact, it was more than sixteen years after Ida's death that the Lime Rock Light was finally automated. Logic and hindsight would say that Ida had no need to worry. But logic isn't what drives one to enter the darkness and terror of a gale to save drunken soldiers, alone, in a rowboat. Legends die hard.

Ida lies resting in the Common Burial Ground on the Farewell Street side of the cemetery, marked by an unusual gravestone of anchor and oars and her birthplace, 283 Spring Street. Today, the Lewis home lives on as the Ida Lewis Yacht Club, in tribute to the courageous woman who risked her life for so many. The next time you sail by, take comfort. The heroine of Lime Rock may still be watching.

NEWPORT WAS THE BIRTHPLACE OF THE FIRST DIRECTOR OF THE UNITED STATES GEOLOGICAL SURVEY

(CONFIRMED BY U.S. CONGRESS APRIL 3, 1879)

Clarence King, commonly referred to as "Clare" by his family, was a fifth-generation Newporter. His father, James Rivers King, was involved in the family commerce of King & Talbot during a period in history referred to as the "Opium Wars." James was out to sea when his son was born in Newport on January 6, 1842.

This separation was long and tiresome on the family, but James returned to spend about eighteen months in Newport. He and his wife, Florence, became parents of a daughter named for her mother, Florence. Upon the death of his brother, James returned to China in the spring of 1847 to assist the company. During his absence, a baby girl was born, Grace Vernon. However, tragedy struck, as this child died at fourteen months of age. Clare's mother received the news of James's death in the Orient on that very same afternoon, September 14, 1848. Although the death of James happened on the second of June, it took three months for the news to reach Newport. In that era, news usually traveled as fast as a given ship could sail.

By this time, Clare was six and a half years old and was ready to begin a formal education. His grief-stricken mother felt it was in their best interest to move away. Among the reasons behind her thinking may have been the following: not wanting to lose her only son to a life at sea and wishing to withdraw him from the influence of the family business and the lure of potential adventures that a place such as Newport offered. Seaports offered unlimited opportunities, and Clare had already taken a liking to Newport. But his early Newport days ended as the family moved and lived in Pomfret, Connecticut; Boston, Massachusetts; and New Haven and Hartford, Connecticut, when he was thirteen. King graduated with honors in 1862 from the Sheffield Scientific School at Yale.

He eventually journeyed west with a friend, ending up at the mines of the Comstock Lode in Virginia City, Nevada. These mines were located

northeast of Lake Tahoe, near the current state capital of Carson City. The Comstock Lode was one of the richest gold and silver deposits ever discovered, resulting in a spectacular rush in which immense fortunes were made. King studied and worked the mines, then left by foot over the Sierra Nevada Mountain Range. In California, he spent the next three years working for the California Geological Survey then returned east. By this time, the Civil War had ended and there was increased activity in the surveying of the country's western lands.

King persuaded the government into the most ambitious federal geological exploration survey ever done, the exploration of the 40th parallel (the King Survey) from 1867 to 1872. Congress provided for a geological and topographical exploration by the act of March 2, 1867 (14 Stat L. 457). This territory encompassed the Rocky Mountains and Denver on the east, westward through the Great Salt Lake region to the Sierra Nevada—the present-day Nevada and California state boundaries.

Before he embarked as the head of this exploration, King went to Newport for rest and awaited further instruction. The work on the 40th parallel made him and his men famous. Until then, people had no inkling about this part of the country. King lifted the veil of an entire region. During the survey, King wrote the book *Mountaineering in the Sierra Nevada*, based on his past personal and geological work while he was with the California Geological Survey. He wrote of how fascinating and dangerous the place was. And during the survey, he uncovered the "Great Diamond Hoax," an elaborate plan to defraud investors with fake gems placed in the soil near the present-day state lines of Colorado and Utah. King's discovery was made public when the *San Francisco Evening Bulletin* on November 26, 1872, published the story. So much personal activity went into his work on the 40th parallel survey, which was approximately ten years in the making before its formal completion.

By this time, Congress had authorized other men to do other surveys, and by the end of the 1870s, tensions, rivalries and jealousy had grown among the various scientific survey leaders. To obtain the best results at the lowest cost and to avoid duplication in work, Congress unified all of the government surveys into one. Thus the United States Geological Survey was created as a bureau within the Department of Interior on March 3, 1879 (20 Stat L. 394). The principal functions of the survey included the study of geological structures of the national domain and the classification of the public lands.

Chosen as the first director, King stated that he would serve in this capacity only to get the bureau structured, staffed and implemented. Confirmed on

April 3, 1879, and guaranteed the annual salary of $6,000, with his first full year completed and goals accomplished, King tried to resign from office but was refused. He composed the first annual report of the geological survey before his resignation was finally accepted on March 6, 1881. During his two years in office, he had shown great administrative skill. King entered private practice and, for the rest of his life, was involved in business and scientific work, traveled and served as a consulting expert in important cases concerning mining litigation.

In 1887, King met a woman named Ada in New York. But there was one problem with the relationship, and it wasn't her being twenty years his junior. Ada was a Negro. In this era, interracial marriage was legally permissible in New York, but King's concern for social correctness dictated that his fame, friends and ailing mother would not approve. Fearing a potentially embarrassing situation would create scandal, he never revealed his true identity to Ada, assuming the name James Todd. He did follow his heart and married her in a secret ceremony in September 1888, marking the beginning of a secret double life that included separate residences and five children.

King continued his business activities, but problems arose in 1893, the year of a financial panic that led to a four-year depression in the United States. This resulted in monumental debt for King. Compounding matters, his grandmother and his first son, Clarence, died. The mounting stress of his secret life did not help matters, which may have contributed to a senseless street brawl in Central Park for which he was arrested. At the urging of his close friends, he was committed to an insane asylum. But psychiatric care was not the answer. The cure was rest and relaxation. After a few months, he was released and began work.

Sensing the end was near, Ada was told the entire truth by King before he instructed her to take the children and live in Canada, where there was less prejudice than in the United States. Their farewell was heartbreaking and sad; he said goodbye to his friends and moved to sunny Arizona where, six months later, he died on Christmas Eve 1901.

The longtime Newport family home, where King was born and a spent a lot of time over the course of his life, once stood on the northeast corner of High and Church Streets (today, the site of the Hotel Viking parking lot). King occupies a spot at Island Cemetery. His headstone was knocked over years ago and lies imbedded in grass, which fills with rainwater. His name is barely legible, and the inscription, "I am the Resurrection and the life, saith the Lord," is long since gone.

48

NEWPORT WAS HOME OF THE FIRST FEMALE TELEPHONE OPERATOR IN THE UNITED STATES

(Local Exchange Started April 18, 1879 [?])

In July 1877, the Bell Telephone Company was organized. The first telephone switchboard or exchange was put in operation under the auspices of Edwin Thomas Holmes in Boston on May 17, 1877. This was done in conjunction with his electrical burglar alarm business. The first commercial telephone exchange in the United States was started in New Haven on January 28, 1878. It maintained eight telephone lines and serviced twenty-one subscribers.

At the exchanges, originally, young boys were used as operators. When they proved to be unreliable, the telephone company hired women. Originally, "Ahoy" (not "Hello") was used when answering the phone. The title of "first female operator in the United States" belongs to Emma M. Nutt (not to Kate Friend). Also, Nutt was the first female employee of Bell Telephone and was hired by Holmes on September 1, 1878, in Boston. She retired in 1915; the hiring of Nutt preceded the "Newport first" claim by seven and a half months.

NEWPORT WAS HOME TO THE INVENTOR OF OPALESCENT GLASS

(Patent Awarded February 1880)

Of French descent, John La Farge (1835–1910) was a painter, writer and worker in stained glass. Growing up in New York City, he received a Catholic education in accordance with his religion. An 1853 graduate of Mount Saint Mary's College in Maryland, he initially studied law. Within two and a half years of graduating, he was awarded a master's degree from his alma mater and made his first known oil painting, a self-portrait.

In early 1856, he departed for France with his two younger brothers to complete his education. While there, he visited with relatives, studied and traveled to other European countries. In the fall of the following year, La Farge returned to be with his ailing father and, in time, rented a studio at the Tenth Street Studio Building, designed by Richard Morris Hunt.

As La Farge got to know Hunt, and perhaps at La Farge's suggestion, he went to Newport to study painting under Richard's brother William. He arrived in Newport in the spring of 1859; La Farge was a pupil along with the two James brothers, Henry and William, at William Morris Hunt's studio on Church Street.

While in Newport, he became involved with Margaret Mason Perry, a granddaughter of the naval war hero Commodore Oliver Hazard Perry. Problems arose between the two over differences in their faiths. La Farge, unsuccessful at first, tried to convince her to convert to Catholicism. In December 1859, she and her family headed to Louisiana for a five-month stay. La Farge sensed that there were other suitors. He headed south and got engaged to Perry in the spring of 1860. They were married in Newport by Father William O'Reilly at St. Mary's Roman Catholic Church on October 15, 1860, and would go on to have nine children.

The La Farges owned the house at 24 Kay Street before living at various locations on Paradise Avenue in Middletown. As work warranted, he lived in Boston, New York City and elsewhere during this time. In 1873, Margaret purchased a house with her inheritance on Sunnyside Place.

A Hundred Claims to Fame

The United Congregational Church is located at the southeast corner of Spring and Pelham Streets. The cornerstone was laid on December 5, 1855, and the church was dedicated in 1857. John La Farge's stained glass is on display in the church. This photo dates from 1970. *Courtesy Library of Congress.*

In 1875, as a founding committee member of the School of the Museum of Fine Arts in Boston, La Farge made the transition from painting to working with stained glass. He found that "almost nothing was left of that tradition and that practically no glass of good quality was available in this

country for making windows." For various reasons, La Farge invented a new type of stained glass known as "opalescent glass." Although stained glass had been used previously, his invention was reflected in the technique that he used. La Farge used the medium of watercolors to make studies for his murals and stained-glass windows.

In 1878, he made his first successful opalescent glass window, entitled "Morning Glories." This six-panel window was made for the William Watts Sherman residence in Newport. Probability dictates that this was done at his Newport studio at the northwest corner of Prospect Hill and Corne Streets.

Two years later, in February 1880, he received a patent for opalescent glass. In that year, La Farge received, among other projects, the commission for the decoration of what is now known as the Newport Congregational Church. But La Farge had critics, as some have downplayed the significance of his work in stained glass.

Around this time, La Farge left Newport and lived elsewhere while his family remained at the Sunnyside Place house. Heavily involved in work, he was plagued with problems of debt and health for the rest of his life. In the spring of 1910, he suffered a serious mental illness and was committed to Butler Hospital, an insane asylum located in Providence. Mark McKenna and I conclude that after working with lead for so long, La Farge poisoned himself, causing his illness. He died at Butler on November 14, 1910. The residence that remained in the family until the death of his daughter Margaret in 1956 is located at 10 Sunnyside Place.

NEWPORT WAS THE SITE OF THE FIRST BICYCLE SOCIETY (NATIONAL ORGANIZATION) TO BE FORMED IN THE UNITED STATES AND THE FIRST NATIONAL BICYCLE CONVENTION HELD IN THE UNITED STATES

(Formed May 31, 1880)

In the late 1800s, bicycling became the rage for both sexes. So much so that the first bicycle club was formed in Boston on February 11, 1878.

Within two years, there were numerous clubs across the country. It was the New York Bicycle Club that proposed the Newport gathering. Prominent representatives of various clubs, with some from as far away as Chicago, were present at the Hotel Aquidneck, located on the northwest corner of Pelham and Corne Streets (since demolished). After a lengthy discussion, it was decided that a national bicycling association be formed, to be known as the League of American Wheelmen. Among the objectives were promoting awareness of the sport through touring and defending and protecting the rights of wheelmen.

This organizational meeting was held on a Sunday and was followed by a convention the next morning, when a constitution and bylaws were adopted. Charles Ed Pratt of Boston, the editor of *Bicycle World*, was elected president. Before this convention adjourned, a collection was taken up to defray the expenses of the "meet" scheduled for later that afternoon, and a vote of thanks was given to A.H. Olds for hosting the convention at his skating rink, which no longer exists, on Bellevue Avenue.

In the afternoon following the first national convention, the bicycle riders met on Kay Street near Ayrault Street, and a line was formed under the supervision of Pratt. **This would be the first national bicycle meet ever held in the United States**. It was desired to eclipse the first Hampton Court meet in England, where there were sixty-seven bicycles present. At the Newport meet, there were almost thirty clubs represented by 132 riders in the line. Individual clubs rode together sporting their various fashionable uniforms.

Kay Street and Bellevue Avenue were lined with spectators, but, to the annoyance of the riders, many carriages were in the way. As the parade went down Bellevue Avenue, a large number of carriages and sightseers followed to the end, where the bicyclists were photographed at the boathouse near the end of Ledge Road.

The procession returned over some of the same route and disbanded at Touro Park. The spectators at the scene were treated to some fancy riding by the cyclists. Later that afternoon, a dinner was held at the Hotel Aquidneck. The people of Newport were very impressed, as were the bicyclists who had visited the city over the Memorial Day (then called "Decoration Day") weekend.

51

ROLLER POLO (POLO ON SKATES) WAS FIRST PLAYED IN THE UNITED STATES IN NEWPORT

(July 1880)

According to the book by Wells Twombly, *200 Years of Sport in America: A Pageant of a Nation at Play*: "In Chicago in 1882, it gave birth to a game called 'roller polo.'" But, roller polo was played two years earlier in Newport.

In the 1860s, the roller-skating craze continued with rinks in many parts of the country. In early May 1879, A.H. Olds leased the John G. Weaver lot, located north of the Ocean House. Construction began in June on this 171-foot by 77-foot wooden structure. It opened to the public in grand style on Monday, July 14, 1879. People began to learn the new way of skating in a building brilliantly lighted by 120 gas jets. According to the *Newport Daily News* of September 25, 1879: "The skating rink closed last night, with a gay company and amid a brilliant scene. The management may be congratulated upon the fine success which has attended the enterprise the first year, and the rink may be considered a regular feature of Newport's summer."

The Newport Roller Skating Rink opened under A.H. Olds the following May, and by July, roller polo began play before crowds of upward of six hundred people. Roller polo was polo on skates instead of on horses. The Newport Polo Club was divided into two teams, the Reds and the Blues. These teams played each other mostly on Tuesday and Saturday nights, which proved to be very popular. On July 31, the Blues won and were presented with a handsome floral piece by P.T. Barnum, the exploiter of "freak shows."

Within two weeks, the Newport Club traveled to the other side of Narragansett Bay to compete against a club from Narragansett Pier. Newport won convincingly. Then, the Providence Polo Club traveled to Newport on two occasions; they, too, lost convincingly. Over the years, the public enjoyed skating and watching roller polo. In its third year, a local sports enthusiast, A.C. Landers, was the proprietor.

By 1883, the rink was called the Olympian Club Roller Skating Rink. The Newport club traveled to Boston on January 17, 1883, to take on the Alphas of Lowell, Massachusetts. This long-talked-about match was for the United

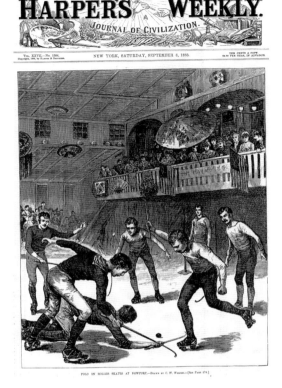

The cover of *Harper's Weekly*, dated September 8, 1883. The caption reads: "Polo on Roller Skates at Newport.—Drawn by C.W. Weldon." This rink occupied the present-day site of center court (championship court) at the International Tennis Hall of Fame, Newport Casino. *Author's collection.*

States championship. In the best-of-three series, the Lowell team won the first, but Newport won the latter two matches, claiming gold medals and the championship.

Although the history is lacking, it has been suggested that roller polo was played a couple of years before 1880. Newport was playing other clubs, and A.H. Olds, who was a player, was known to be a manager for a company that owned 333 rinks around the country.

The rink ceased operation around 1886, and the structure did not appear on the 1888 Newport map. The location is now center, or championship, court of the Newport Casino, now known as the International Tennis Hall of Fame.

52

NEWPORT IS THE SITE OF THE FIRST MULTI-RECREATIONAL FACILITY OF ITS KIND IN THE UNITED STATES

(Officially Opened July 26, 1880)

Born with a silver spoon in his mouth, James Gordon Bennett Jr. (1841–1918) inherited the *New York Herald*. According to stories associated with him, he was notorious for indulging in the demon drink and being a womanizer. Bennett liked riding in his four-in-hand coach stark naked in the countryside, screaming and yelling. But one story that reached legendary proportions (although never proven) happened on New Year's of 1877 in New York City. In front of invited guests, including his fiancée, Caroline May, whom he had met in Newport, Bennett promptly relieved himself into the roaring fire of the fireplace, abruptly ending the party. One version of the story claims it happened in the piano. However, one author has suggested that this would be impossible, since Bennett would have to have been considerably taller in order to achieve the feat.

Regardless of his unusual behavior, Bennett is credited with many achievements. He was the youngest commodore of the New York Yacht Club; he established the **first English-language newspaper in Paris**; and he was the **first American editor to explore the international scene**. It was Bennett who was responsible for a shameless publicity stunt (or marketing ploy) to sell newspapers, when he promoted and financed Henry Stanley's expedition to the uncharted parts of central Africa in search of David Livingstone, who was in search of the origins of the Congo River. (Keep in mind that Livingstone was never lost in the first place!) As a sporting enthusiast, Bennett is credited with the introduction of polo to this country and with being the skipper of the winning yacht in the **first trans-oceanic race**. He won the Atlantic Ocean Race on Christmas Day 1866.

It appears that his days in Newport began in the early 1870s, when he became a summer colonist by renting villas on or near Bellevue Avenue.

Stories abound concerning Bennett. One that has reached legendary proportions concerns the Newport Reading Room incident, which involved

NEWPORT FIRSTS

The façade of the Travers Block located on Bellevue Avenue shows the entrance of the Newport Casino (*center right*). Built in 1880, the casino is the first multi-recreational facility in the United States. *Courtesy Library of Congress.*

Bennett and one of his polo buddies, a man named Captain Candy, better known as "Sugar Candy." A wager was concocted whereby Sugar Candy would mount his polo pony and ride up the short flight of stairs into the exclusive club located on Bellevue Avenue. Needless to say, this episode did not please some members. Bennett, who was never a member, was reprimanded, and Sugar Candy was supposedly shown the door for the last time. As the story goes (never proven), Bennett, in response to this, started the Newport Casino venture. Over the years, there had been talk that Newport needed a social center to accommodate the summer colonists. Bennett answered this need.

In the late summer and early fall of 1879, he purchased land owned by the Sidney Brooks Estate. It included a home on Bellevue Avenue that was directly opposite the planned site for the casino. These two properties on the avenue would forever be associated with Bennett in Newport history.

A limited-stock company was organized, to be maintained by stockholders and subscribers. The architectural design for the complex was done by the firm of McKim, Mead & White. The firm was responsible

for developing the so-called shingle style of architecture used in the construction of the casino. Construction began in January 1880, and work progressed rapidly. This first-of-its-kind multi-recreational facility featured bachelor apartments or rooms, a billiard room, a bowling alley, card rooms, dining rooms, piazzas for strolling, a restaurant, shops, tennis courts, court tennis structure and a theater.

The Newport Casino opened on July 26, 1880. It was both private and public. Members of the general public paid a fee to use the facilities. Bennett eventually sold his share. The Newport Casino over the years has been the setting for many social, cultural and sporting events, but mainly tennis. The casino has claimed to be the first multi-recreational facility of its kind, **America's first summer sporting club and the first country club**. All three claims may be true but have to be clarified. The country club claim is a little misleading since the casino did offer country club activities; the Country Club at Brookline, Massachusetts, is first. This is why the Newport Casino should be classified as the first multi-recreational facility of its kind in the United States.

The Newport Casino has been subject to various changes over the years. However, today, one can walk through the entrance on the avenue and be engulfed in the atmosphere of 1881, when tennis was a little-known sport. The casino is now officially the International Tennis Hall of Fame. It has managed to stand the test of time, unlike Bennett's "Stone Villa," later known as the William F. Whitehouse Estate (it no longer exists). It once stood on the present-day eastern section of the parking lot of the Bellevue Shopping Center. There is a plaque on the wall near the CVS that reads, "The site of James Gordon Bennett's 'Stone Villa.'" However, where the plaque is affixed was actually the site of Mrs. Paran Stevens's home. Two homes occupied the site of the present-day shopping center.

53

NEWPORT WAS THE SITE OF THE FIRST MEN'S SINGLES NATIONAL CHAMPIONSHIP MATCH SANCTIONED BY THE UNITED STATES NATIONAL LAWN TENNIS ASSOCIATION

(Finals, September 3, 1881)

The first lawn tennis tournament on record in the United States was a local round-robin affair with fifteen entries played on the private court of the William Appleton estate in Nahant, Massachusetts, in August 1876.

The first lawn tennis tournament on a national level was played at the Staten Island Cricket Club in September 1880. Open to any player in the United States, the tourney's winner would be dubbed "Champion of America." However, as the story goes and legend has it, this tournament created many problems, with confusion over rules, scoring and equipment. Some players complained that unfamiliar balls affected their play.

It should be noted that this was a critical point in tennis. If the sport was to grow in popularity, then the rules would have to be standardized.

A convention to address these problems was convened on May 21, 1881, in New York City. Delegates or proxies were sent by more than thirty tennis clubs. They agreed on a specified size and weight of equipment; a uniform court; the scoring method of 15, 30 and 40; and the use of the Ayers ball in all national tournaments. Out of this convention was born the United States National Lawn Tennis Association (USNLTA). ("National" and "Lawn" were dropped from this title in 1920 and 1975, respectively).

It was decided that the first officially sanctioned national tournament would be played three months later in Newport. The tourney at the Newport Casino, with twenty-five players entered, began on Tuesday, and the final was played on Saturday, September 3, 1881, between Richard D. Sears of Boston and W.E. Glynn of Staten Island. Sears, at age nineteen, defeated Glynn, 6–0, 6–3, 6–2, to capture the first USNLTA men's singles title. Sears won this title over the next six years on the casino courts and is the only man to capture the title seven consecutive years, before succumbing to an injury.

A Hundred Claims to Fame

There is some confusion over the exact location of the original tennis court used in the finals of 1881. Most likely, it was located between the veranda and the court tennis structure. This photograph was taken in 1913. *Courtesy Library of Congress.*

The men's singles championships were held here until 1914, when Dick Williams became the final champion. More than 130 men had entered this tournament, a far cry from the number who had entered the inaugural tournament more than thirty years earlier. In the following year, the tournament was transferred to Forest Hills, New York.

There were numerous reasons for the departure of the tournament from Newport. It was thought that for the game to grow, a larger revenue base and exposure was needed, which a metropolitan area such as New York City offered. In addition, the lack of available lodging and transportation logistics in Newport compounded matters. One has to remember that at the time, there were no bridges connecting Aquidneck Island to the mainland. Complications arose for many who missed the ferry and had no place to stay.

NEWPORT WAS THE SITE OF THE FIRST SHORE-BASED NAVAL RECRUITING TRAINING STATION IN THE UNITED STATES

(Established June 4, 1883)

The concept of formal training for enlisted seamen was developed in the 1830s by Newporter Matthew C. Perry, who inaugurated the first recruit training program in this country. This program was put in place but did not succeed, due to lack of wide support.

In December 1880, the city of Newport ceded Coasters Harbor Island, originally the site of the former Newport Asylum for the Poor, to the United States for use as a naval training station. It was initially designated as a temporary station. The federal government accepted this gift of land in the following year, and on June 4, 1883, it was officially designated as a naval training station by the Department of the Navy. Recruit training ended in Newport in 1952 with the disestablishment of the station. Eventually, it would evolve into the Naval Education and Training Center (NETC).

In addition, Newport became the site of the **first Naval War College in the United States**. By General Order No. 325 of the secretary of the navy, the United States Naval War College was established on October 6, 1884. The war college is the highest educational institution in the navy. The college, founded by Steven Luce (who served as the college's first president), opened on September 3, 1885. Some of Luce's intentions are best summed up in the words of John B. Hattendorf's *Newport Daily News* article on March 3, 1993:

> What he wanted was a place distant enough from Washington D.C. so that the college wouldn't become an adjunct to the staff in Washington....Luce also wanted the insulation of distance so that "clear and free" academic thinking could flourish, untainted by the demands of politics and policy. What Luce established in the War College…was an institution devoted not to technology or weaponry but to intellect.

A Hundred Claims to Fame

Sailors receive training as clerks. The caption reads: "Naval Training Station, Newport, R. I. Yeoman School—Executive Officers' Class Dec. 23, 1913." *Courtesy Library of Congress.*

Constructed in 1819, this was the Newport Asylum for the Poor. Later, it was used as the original Naval War College building. Located on Coasters Harbor Island, the building is seen in a photograph taken between 1890 and 1901. *Courtesy Library of Congress.*

The original building, the former asylum, still exists today on Coasters Harbor Island and serves as the college museum. Hattendorf added:

> *The stated objective of the college is the preparation of officers for higher command and responsibility. More specifically, the aim is to increase knowledge of the fundamentals of naval warfare and of related subjects which contribute to an understanding of warfare.... The reason for the college's existence to prepare officers for higher command has been expanded to include the further preparation of these officers for duty on major joint and combined staff.*

55

NEWPORT WAS HOME TO THE FIRST AMERICAN TO CLIMB THE STATUE OF LIBERTY

(July 4, 1884)

Levi Morton (1824–1920), the future banker and public official, moved often as a youth, as he was the son of a minister. He and his family lived in Shoreham and Springfield, Vermont, then in Winchendon, Massachusetts.

His introduction to the family business began as a clerk in a country store when he was in his mid-teens. Over the next twenty-five years, he was a leader in American finance. His companies included Morton, Grinnell & Company and Morton, Bliss & Company.

In 1869, he purchased land in Newport on Brenton and Coggeshall Avenues and bought the steep-pitched-roof Fairlawn, at the southeast corner of Bellevue and Ruggles Avenues. Morton and his wife, Lucy, were known for their legendary dinner parties at Fairlawn, and on one occasion, they had President Ulysses S. Grant as a guest. Grant was finishing up a four-day stay in Newport and was the guest of honor on August 24, 1869, the evening before he left town.

Two years later, in the summer, Morton's wife of fifteen years passed away at the age of thirty-five at Fairlawn. There were no children by this marriage, and Morton remarried two years later and eventually had five daughters. During this period of his life, he was very wealthy and rose to new financial heights. Morton did have an earlier business failure and experienced failed political campaigns as well, but he managed to be elected to Congress as a Republican from New York in 1879. Following this term, he went on to become the U.S. minister to France. On July 20, 1881, he left New York City aboard the steamship *Amerique* amid a tremendous send-off by some of our country's most prominent figures.

At the time of Morton's voyage to France, a man by the name of Frederic August Bartholdi was working on his long-term creation, the Statue of Liberty. As the new envoy, Morton was at the right place at the right time. On October 24, 1881, in commemoration of America's centennial of the victory at Yorktown, Morton, in front of distinguished guests, ceremoniously hammered in the first rivet into the first piece of

the statue. (It was driven into the big toe of Liberty's left foot.) On that day, he gave a very complimentary speech praising various people and the friendship that existed between France and the United States, thus beginning a historic process.

Fast-forward three years to the formal delivery of the Statue of Liberty to the American government on July 4, 1884. Morton was once again in Paris and was just as happy on that day as he had been earlier, when he drove in the first rivet. He accepted the statue on behalf of the U.S. government. After some speeches, it was time for the climb. In Morton's official report, he stated, "It was dark in there with nothing to guide our steps but the thousand and one little eyelets of sunlight that came through the rivet holes." Leading the invited guests, as well as Bartholdi, who had climbed the statue many times before, Morton was unaware that groans would be produced by some of the guests, who felt that this was too long a climb. Most descended after going only halfway up. However, Morton, at age sixty, hung in there and was one of the few who reached the topmost point of the statue. From this perspective, the city of Paris took on a miniature appearance. Morton became the first American to climb the Statue of Liberty. The statue was then taken down for shipping and reassembled in the United States.

He served in the capacity of minister to France until the following year, when his political aspirations took him to the office of U.S. vice president under Benjamin Harrison (1889–93). Morton then became the governor of New York (1895–96). His political career ended there.

His association with Newport as a summer resident lasted almost twenty years. Because of his time-consuming schedule, he sold Fairlawn in 1886 and left the parcel of land to the city for use as a park. At the corner of Coggeshall and Morton Avenues (formerly Brenton Road), this land today bears his name, Morton Park.

THE FIRST INTERNATIONAL POLO MATCH IN THE UNITED STATES WAS PLAYED IN NEWPORT

(August 25, 1886)

In the spring of 1886, Griswold Lorillard dined at the Hurlingham Club in England following a polo match. He remarked to his hosts that polo was played in America. This statement was met with surprise and interest. Plans were made and a series agreed upon, consisting of a best-of-three-days' playing.

On Wednesday, August 25, 1886, the Hurlingham Club took to the field against the host club, Westchester. It was an exciting match for the spectators, who had assembled on Deadhead Hill, but the Americans lost to the British, 10 goals to 4. The second match was played the following Saturday, and the results were even more disastrous, as Hurlingham won, 14–2.

The Americans played brilliant individual polo, but they lacked teamwork. In comparison, the British sacrificed individual play for team play. Although the Americans lost the $1,000 cup, their opponents credited them with fair and spirited play.

57

THE FIRST PROFESSIONAL INTERNATIONAL LAWN TENNIS CONTEST IN THE UNITED STATES WAS HELD IN NEWPORT

(August 29, 1889)

Hailing from England, Tom Pettitt, at twelve, was hired as an assistant locker boy before becoming an instructor at the Buckingham Street court tennis structure in Boston in 1876. When the Newport Casino was built in 1880, Pettitt was put in charge of all the courts during the summer; he worked in Boston during the winter.

In May 1885, Pettitt made court tennis history when he beat George Lambert at the Hampton Court facility in England. In the best-of-thirteen-set series, Pettitt won the match, 7–5, thus becoming **the first American player to win the world championship in court tennis**.

As Pettitt attained legendary status, he became involved in the first professional lawn tennis contest. His opponent was an Irish professional lawn tennis player named George Kerr. This match followed the 1889 USNLTA Nationals Tournament, an amateur contest. Henry Slocum retained his singles title.

In this era, a professional was anyone who was involved in the sale of tennis equipment, teaching and other such occupations, which certainly applied to Tom Pettitt. His match predated the first National Professional Championships, which were not organized until 1927, under the auspices of the Professional Lawn Tennis Association of the United States.

The first of a four-match series between Kerr and Pettitt began under overcast skies on August 29 as the two made their appearance and were greeted by applause, especially Pettitt, the sentimental favorite. The first set was close, but the fast-paced Kerr, using his aggressive, hard-hitting talent, combined with an accurate serve, destroyed Pettitt, which left Pettitt's friends quite disappointed. It should be remembered, however, that Pettitt was a court champion, a master of this indoor game, not a great lawn tennis player (he admitted as much). The final score was 6–4, 6–1, 6–1, with Kerr the victor.

The second match of the series took place on September 21 in Springfield, with Pettitt winning handily, 6–4, 2–6, 6–3, 6–4. Some people claimed that Kerr had a wrist injury.

The last two matches were played in Brookline on the grounds of Longwood on September 25 and October 2. At times, Petitt demonstrated some brilliant tennis, but he was clearly outplayed in the third match, 6–3, 3–6, 6–4, 6–4, and in the fourth match, 6–0, 6–2, 4–6, 6–3. On the day of the final, Kerr was proclaimed "Champion tennis player of the world."

The matches did not favor the well-liked Pettitt. One historian stated, "Pettitt's feats with a racquet have become legendary. If only half the accomplishments credited to him are fact, he was a miracle man."

In 1929, Pettitt was honored by the governors of the casino for fifty years of service. He was presented with a silver tray and a check for $10,000. Pettitt was still active until his death in Newport in 1946.

58

NEWPORT WAS THE SITE OF THE FIRST NINE-HOLE GOLF COURSE CONSTRUCTED IN THE UNITED STATES

(1890)

Where and when the first game of golf was played in the United States is open to interpretation, wide speculation and much debate. Evidence suggests that it was played as early as the mid-1700s in Charlestown, South Carolina. There is also evidence of the South Carolina Gold Club being formed in 1786 and the Savannah, Georgia Golf Club starting in 1795. To complicate matters, available information suggests that it was played in New York and elsewhere at an early date.

Golf truly took hold here in the 1880s with a basic reintroduction of the sport. Prior to 1890, courses featured one hole, two holes and so on.

Regarding the first nine-hole golf course to be constructed, the person responsible for this development was Theodore A. Havemeyer, who maintained a residence at the northeast corner of Bellevue, Bancroft and Coggeshall Avenues. He was the son of Frederick C. Havemeyer, who founded the American Sugar Refining Company, the largest sugar refinery in this country. Upon the death of their father, Theodore and his brother Henry ran the enterprise. This did not leave them short of friends or money.

Havemeyer, a man of sporting taste with horses, polo and yachting in his blood, was introduced to golf while vacationing in the French resort of Pau. Within a year of that trip, construction was underway in the spring of 1890 on a nine-hole golf course. Built on land in the Brenton Point area owned by the Grammell family of Providence was a Grammell residence called Ocean Lawn. Totaling approximately forty acres, this ideal location featured stone walls crossing the course. These formed natural hazards. The Bateman House, a hotel, was used as the clubhouse (present-day site of Mary Jane Lane). This course was used four years prior to the construction of the Rocky Farm Course. The location of the original nine-hole course was on the west side of Harrison Avenue at the intersection of Ocean Avenue, east of Brenton Point State Park. There are now seven holes, instead of the original nine holes, and the course is maintained as part of the Newport Country Club.

The Middlesborough Golf Club of Middlesborough, Kentucky, established in 1889, claims that its nine-hole course was laid out in 1889 or 1890 by the English settlers involved in that region's iron industry.

Because the two courses were laid out at approximately the same time, it is too close to call. Due to a lack of critical information, neither site can substantiate its claim. However, Newport is regarded as the first. The first eighteen-hole golf course opened for play in 1893 at Wheaton, Illinois. Charles Blair Macdonald is credited with its design and construction for the Chicago Golf Club.

NEWPORT WAS HOME TO THE FIRST AFRICAN AMERICAN RADIOLOGY SPECIALIST IN THE UNITED STATES

(1894)

Educated in the private schools of Barbados, Marcus Wheatland (1868?–1934) arrived in Boston on November 11, 1887, with very little money in his pocket. He headed for medical school in September 1892 and came to Newport in 1894, perhaps due to his association with two notable African American men, M. Alonzo Van Horne and George Downing. Wheatland received his medical degree from Howard University in 1895 and in the same year was licensed to practice in Rhode Island as a general practitioner. He is considered to be the first known African American physician to have lived and practiced in Newport.

Dr. Wheatland was married in Boston to Irene De Mortie, the granddaughter of Downing, on June 2, 1898. He briefly resided at 23 Thomas Street, home of the Isaac Rice family, before moving to his long-term residence at 84 John Street, where he maintained his medical practice.

The doctor was considered a genial man, quiet, well read and an excellent raconteur. An authority on the X-ray in its application for the treatment of diseases, he possessed the first X-ray machine in Newport. On the staff of Newport Hospital, he provided the X-ray coverage there. Wheatland was well known and from time to time would be seen carrying a box of his equipment to and from the homes of the wealthy. But his practice included all classes of people.

Howard University awarded him an honorary master of arts degree in 1906 (or 1905) and appointed him to its board of trustees in 1910, a position he held until his death. A contributor of numerous medical articles, Dr. Wheatland was a member of the American Electro-Therapeutic Association and the eleventh president of the National Medical Association (the professional society of black physicians). He is the only African American radiologist listed in the early editions of *Who's Who in America*.

After Downing died, Dr. Wheatland purchased the city block that bears the Downing name. He served on the town council of Newport representing the Fourth Ward from 1910 through January 1914. The Redwood Library received 182 volumes of Wheatland's books, as well as pamphlets and journals from 1924 through 1929, although Wheatland was not a shareholder. He died in Newport on August 16, 1934. His funeral was held at Hambly Funeral Home, and the burial was at Island Cemetery. The *Newport Daily News* stated, "His death is a distinct loss to the community. He will be missed."

In February 1994, West Broadway was renamed Dr. Marcus F. Wheatland Boulevard in his honor. Dr. Wheatland gained a national reputation in his field and was the first African American radiology specialist in the United States.

60

NEWPORT HOSTED THE FIRST GOLF TOURNAMENT ON A NATIONAL LEVEL IN THE UNITED STATES

(SEPTEMBER 10 AND 11, 1894)

Originally, golf in Newport was played on the course west of Harrison Avenue. In 1893, Theodore Havemeyer supported two new ventures: the Newport Golf Club and a syndicate named the Newport Country Club. By August 1894, the newly incorporated syndicate had purchased 140 acres of land from Mary A. King and laid out a new nine-hole course the previous spring. Eventually, the two merged in 1917.

But in September 1894, the syndicate invited all golf clubs to Newport for a competition to determine a national champion. The competition began with twenty players, and the match consisted of thirty-six holes, four times around the course in a two-day period (eighteen holes played each day). The winner would be determined by the player having the fewest strokes. This form of play was called "medal play" or "stroke play."

The fog and sticky grass hampered players on the first day, as some deemed the links to be stiff and the ground too hard. One golfer ripped up his card in disgust!

At the completion of the first day of eighteen holes, Charles Blair MacDonald of the Chicago club was the leader with 89 strokes, followed by William Lawrence of the Newport club with a 93. The following day had a large and fashionable crowd in attendance. They watched MacDonald's lead dwindle. On the thirtieth hole, Lawrence tied him and then took the lead on the next hole. Lawrence, the sentimental favorite, won the close competition over MacDonald by 1 stroke, 188 to 189.

MacDonald, who shot poorly at the end, beefed long and loud at the penalties assessed and the method of scoring. He felt that the scoring should have been according to match play, whereas the system used involved scoring hole by hole and the victor being the one winning the most holes in a particular round. MacDonald, with his incredibly large physique, personality, voice and opinion of himself, declared the tournament to be ruled "no contest."

A Hundred Claims to Fame

One of the first, if not in fact the first, published photograph ever taken of the newly completed clubhouse at the Newport Country Club in 1894. *Author's collection.*

However, one month later, St. Andrews Golf Club of Yonkers, New York (the first established golf club in the United States), announced a national amateur championship, but using match play on its Grey Oaks course. Beginning on October 11 and ending two days later in torrential rains, the contest was won by Lawrence Stoddard of the host club. MacDonald was the runner-up.

The players were tied at the final hole, so an extra hole was needed. MacDonald sliced one shot and lost. Once again, MacDonald beefed and declared it "no contest." He said that only a national organization, not an individual club, should sponsor national tournaments. He lost in both Newport and Yonkers, even though the conditions and rules were the same for all competitors.

Both tournaments were later declared unofficial by the USGA, but Newport hosted the first invitational golf tournament on a national level in U.S. history.

NEWPORT WAS THE SITE OF THE FIRST OFFICIAL AMATEUR GOLF TOURNAMENT SANCTIONED BY THE UNITED STATES GOLF ASSOCIATION

(October 1-3, 1895)

In 1894, there were two golf championship contests, one played in Newport and the second in Yonkers, New York. To end the confusion and controversies, it was decided that for golf to grow in popularity, a national governing body needed to be established. It resembled the beginning years of tennis.

Citing this need, Henry Tallmadge of the St. Andrews Golf Club wrote letters to the five most prominent clubs located throughout the country. On December 22, 1894, delegates from their respective clubs met in New York City. The five were: St. Andrews Golf Club of Yonkers-on-Hudson (New York); Shinnecock Hills Golf Club of Southampton (New York); Country Club of Brookline (Massachusetts); Newport Golf Club; and the Chicago Golf Club (Illinois). The agreement stated, "The purpose of this Association shall be to promote the interests of the game of golf...amateur and open championships in the United States." Originally called the Amateur Golf Association, it was later changed to the American Golf Association and finally to the United States Golf Association. The first president was Theodore A. Havemeyer, a person who had substantial free time and money, if needed, to promote the game.

An amateur golfer is someone who has never received any monies from playing or from the sale of any golf items. On October 1, 1895, the first official amateur golf tournament under the rules of the USGA began play on the recently modified Rocky Farm links at the Newport Country Club. Thirty-two entries vied for the $1,000 silver cup donated by Havemeyer. The preliminary competition would be twice around the nine-hole course, and the finals would be four times around, for a total of thirty-six holes at match play. (In match play, each hole is won individually by the player with the fewest strokes, and the player winning a greater number of holes than remain to be played is the winner.)

The first round went quickly, due to the stiff wind ripping the course, which affected everyone. On October 3, the finals were played under a hot sun, pitting nemesis Charles Blair MacDonald and a young player named Charles E. Sands. Even though MacDonald capitalized on the inexperience of the sometimes nervous Sands, he couldn't shake him. By morning's end, the halfway point of the tournament (eighteen holes), MacDonald had won ten holes to five for Sands; three holes were tied.

After the luncheon, MacDonald, who was up by five, won the next seven. On the twenty-fifth hole out of the intended thirty-six holes to be played, he ended it as Sands was mathematically eliminated. The final score was seventeen holes won by MacDonald compared to five won by Sands. MacDonald, who had considerable problems in the competition the previous year, captured the championship.

NEWPORT WAS THE SITE OF THE FIRST OFFICIAL OPEN GOLF TOURNAMENT SANCTIONED BY THE UNITED STATES GOLF ASSOCIATION

(OCTOBER 4, 1895)

Held on the Rocky Farm links at the Newport Country Club the day after the first amateur finals, this tournament was open to any individual, amateur or professional, as long as they represented a particular club. This tourney was scored by strokes, called medal, or stroke, play. The player making the rounds in the fewest number of strokes was the winner. The competition involved eighteen holes to be played in the morning (twice around the nine-hole course); the final eighteen holes were to be played in the afternoon.

On this day, Friday, October 4, 1895, the wind blew strong and the sun was bright for the ten professionals and the one amateur, from Toronto, Canada. The wind greatly affected the long drives. The winner of this tournament was Horace Rawlins of the Newport Golf Club. A virtually unknown player, he was considered a mere lad at just nineteen years of age. Born in Bembridge, Isle of Wight, he learned the game there by serving as a caddy. In Newport, for less than a year, he fared well against the stiff competition.

After the first round of nine holes, Rawlins was tied for third place with 45 strokes, 4 strokes behind the leader, William Campbell. In the second round, where the quality of play leveled off due to the strong winds, Rawlins was in fifth place with a 91, just 2 strokes behind the leader, Willie Dunn. After the third round (twenty-seven holes played), he was in second place with 132 strokes, just 1 stroke behind the leader, Campbell.

Entering the fourth and final round, it was down to Dunn and Rawlins for the championship, but Campbell faded. The final score for 36 holes was Rawlins with 173 (45-46-41-41) besting Dunn at 175 (43-46-44-42).

Campbell, Dunn and Willie Davis were considered the best golfers in the country, but they were not in their best form on this day, losing to a virtual unknown in Rawlins. Rawlins won the purse of $150 and received a gold medal for winning the first U.S. Open sanctioned by the USGA.

63

THE FIRST MAN TO SAIL AROUND THE WORLD ALONE ENDED HIS VOYAGE IN NEWPORT

(JUNE 27, 1898)

Joshua Slocum (1844–1909) grew up in Westport on Brier Island, Nova Scotia. The island is located approximately ninety miles from Bar Harbor, Maine, at the entrance to the Bay of Fundy. Sailing the high seas by age sixteen, Slocum dreamed of doing what no man had ever done before: sail solo around the world. This lifelong goal would become a reality.

Preparation for his journey began with his boat, the thirty-seven-foot *Spray*, which was in need of a complete overhaul. This was done at Fairhaven, Massachusetts, where Slocum was a resident. On April 24, 1895, at age fifty-one, he departed Boston and sailed in an easterly direction. Captain Slocum had intended to reach the Indian Ocean via the Suez Canal. Upon reaching Gibraltar, he was informed by a British admiral that this was an ill-advised route due to pirates operating in the Mediterranean Sea. Heeding this advice, he crossed back over the Atlantic toward South America and on to the Pacific and Indian Oceans. Slocum maintained a westerly direction for the rest of the voyage. His incredible adventures included storms, pirates, ghosts, loneliness, gales, exotic places, ports previously visited and rekindling of old friendships, sea life, equipment problems, paid lectures, receiving of gifts and sightseeing.

Captain Slocum became the first man to sail a solo circumnavigation of the globe on May 8, 1898, near the island of Fernando de Noronha, off the coast of Brazil. This is where he crossed his own outward-bound track on October 2, 1895. Sailing toward the continental United States, his intended point of arrival was New York City, not Newport. He encountered a storm off Fire Island and decided to sail for Newport instead. The weather after the furious storm became remarkably fine. After Slocum's long, incredible adventure, one potential hazard remained: the entrance to Newport was mined as a result of the Spanish-American War. He avoided the mines by sailing close to the rocky shore and dropped anchor in Newport at 1:00 a.m. on June 27, 1898. Captain Slocum had been gone a long time—three years, two months and two days—and had covered a distance of 46,000 miles.

This 1899 photograph was taken by the wife of Major Herbert Bliss. Newporters flock to Washington Square to celebrate the one-year anniversary of the Battle of Santiago (Spanish-American War). Captain Slocum had to gingerly navigate the entrance of Narragansett Bay, as it was mined as a precaution during to the war. *Author's collection*.

He was declared lost at sea in the Atlantic Ocean on November 14, 1909. There are many theories concerning his demise. Most likely, he was run over by a larger craft while sleeping below deck. His book *Sailing around the World Alone* is an excellent account of the trip. During his lifetime, Slocum was considered America's best-known sailor.

64

NEWPORT WAS THE SITE OF THE FIRST PARADE OF HORSELESS CARRIAGES (AUTOMOBILES) IN THE UNITED STATES

(September 7, 1899)

The first parade of horseless carriages in the United States was preceded by a competition judging each vehicle on driving ability and decoration. Sixteen carriages, all decorated with flowers and flags, met at Belcourt Castle on September 7, 1899. An obstacle course was set up in the empty field near Belcourt. Stuyvesant LeRoy won the award for best driving, and Mrs. Hermann Oelrichs's carriage was awarded the prize for best decoration.

According to the *Newport Daily News* of September 8, 1899, "Mrs. Hermann Oelrichs's carriage was a mass of yellow daisies, with two crossed arches of the same flowers over the top. Wide yellow ribbons tied in huge bows adorned a network of delicate flowers above. Upon the top were a dozen white doves." Although Oelrichs won that competition, her vehicle never made the parade. Her automobile lost a wheel due to an axle being damaged in the middle of the course, which became an additional obstacle for the other vehicles.

The automobile parade began at five o'clock and included nineteen horseless carriages. It proceeded down Bellevue Avenue to Old Beach Road. But, suddenly, some drivers balked at the hill and sought different ways to Easton's Beach. When everyone had arrived at the pavilion, they made their way over the hill toward Second Beach. A dinner and dance was held later that evening at Gray Craig Park, the estate located off Paradise Avenue in Middletown.

During the last weekend in Newport of August 1904, the handling of machines (automobiles) proved quite interesting, as there were a total of three non-serious accidents.

The incident that stands out involved W.P. Thompson's machine and a machine owned by A. de Navarro. The latter was driven by the chauffeur Michael Woods. Details of the accident are sketchy due to the lack of information supplied by the courts. However, it happened at Morton and

Newport Firsts

Belcourt Castle was built in 1892 and designed by Richard Morris Hunt as the summer estate of O.H.P. Belmont. This photograph, dated circa 1895, was taken from the field where the automobiles had assembled for an obstacle course. *Courtesy Library of Congress.*

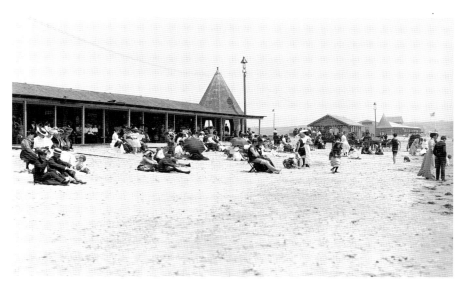

The pavilion at First Beach in 1904. Look closely, as there are no houses, but only farmland occupying the point in Middletown. *Courtesy Library of Congress.*

A Hundred Claims to Fame

Carroll Avenues at an early hour on Saturday. Thompson had considerable damage done to his machine.

After an investigation, Woods was arrested. This was the second complaint against him in a week, and on Sunday, August 28, 1904, he appeared before Judge Baker, who sentenced him to five days in the Newport County jail. This is claimed to be the **first automobile speeding arrest in the United States**. Although he is the first person arrested for the careless driving of an automobile in Newport, Woods does not take the national honor.

That dubious distinction belongs to Jacob German, a cab operator for the Electric Cab Company, the nation's largest public electric cab company. German was booked and jailed after driving at a breakneck speed of twelve miles per hour on May 20, 1899, in New York City, which preceded the claim by Newport by more than five years.

65

FIRST DISTRESS SIGNAL SENT IN THE UNITED STATES VIA THE WIRELESS WAS RECEIVED AND ANSWERED IN NEWPORT

(December 10, 1905)

Wireless radio was a major breakthrough in communications technology. To send or transmit by wireless telegraphy, electromagnetic waves are used to send and receive information in the form of Morse code messages.

Guglielmo Marconi (1847–1937) did not invent the wireless, but he applied certain improvements to the existing devices through experimentation and made the systems practical. At the turn of the twentieth century, it was thought that there was no future in wireless telegraphy. However, Marconi proved everyone wrong when he astonished the world with the first radio message sent across the Atlantic Ocean on December 12, 1901. The transmitted message originated at Poldhu on the southwest tip of England and was received by Marconi at St. John's, Newfoundland, Canada. One year later, he set up a permanent station in South Wellfleet, Massachusetts, linking England with the United States.

At this time, Marconi shifted his attention to the practical side of this form of communication. He envisioned ship-to-shore communication, feeling that this would aid distressed ships at sea and benefit naval operations for governments and commercial business, as opposed to taking on the established land systems. This was big business. In developing a new form of communication, Marconi was thwarted in his attempts, as people said it was not worth the expense of putting it on ships.

At this time, lightships had these apparatuses installed, and the Nantucket Shoals Station was one of them. In service since 1854, the Nantucket Lightship was considered to be one of the most dangerously located lightships in the world, as it was more than forty miles off the shore of Nantucket and two hundred miles east of New York City. Complicated problems arise in such a location because of the inclement weather—the open sea, gales and fog. The situation is made especially hazardous because the lightship is located in the middle of the main shipping lanes.

A Hundred Claims to Fame

Telegraphers learn the wireless at the Naval Training Station. This photograph was taken sometime between 1909 and 1940. *Courtesy Library of Congress.*

The Nantucket Lightship's beacon is the first to be seen by ships arriving in the United States from Europe. In some cases, vessels head straight for the lightship before making the southwest swing toward New York City. The lightship crew was constantly challenged by loneliness, weather and the potential for collisions. But shipping needed to be protected from the dangerous shoals, graveyard to many.

When Nantucket Relief Lightship no. 58 sprang a leak during a gale, the crew resorted to bailing while waiting for a ship to pass nearby. Unbelievably, on that Sunday, December 10, 1905, not a single ship passed. As the water gained and it appeared the ship was not going to make it, the call was made to send assistance as soon as possible and to send aid from anywhere. At this time, SOS ("Save Our Ship" or "May Day") had not been established, so the radio operator on board simply tapped out, "HELP." The United States Naval Torpedo Station on Goat Island in Newport received the transmission, marking the first time a distress signal was sent via the wireless off the U.S. coast.

Newport Firsts

The large wireless antenna at the U.S. Torpedo Station on Goat Island appears on the right side of this turn-of-the-century photograph. Also pictured are horses and carriages descending from the Newport–Jamestown ferry. *Author's collection.*

Boston was notified, and the gunboat *Hist* was dispatched from Newport, but it developed mechanical problems and was forced to return to port. The lightship tender *Azalea* departed from New Bedford, Massachusetts, to lend assistance. Arriving on the scene in the dark of an early Monday morning, the *Azalea* could not get a line aboard because of the heavy seas. When the waves eventually subsided, a line was attached to the lightship and a tow was underway. Before getting halfway to the mainland, the lightship started to sink. The crew of thirteen boarded a small boat and rowed over to the *Azalea* in the nick of time as Nantucket Relief Lightship no. 58, which had weathered many a storm, gave one great heave and plunged beneath the waves.

This story could have had a tragic ending, such as the unfortunate incident that happened in these same waters a little after 10:00 a.m. on May 15, 1934. In a thick fog, the 47,000-ton *Olympic* of the White Star Line struck Lightship no. 117, shearing it in half. Only four men survived of the crew of eleven. Today, a Large Navigational Buoy (LNB) has replaced the lightship as the United States Coast Guard continues its protection of shipping from the dangerous and treacherous shoals off the coast of Nantucket.

66

THE FIRST SUBMARINE TO CROSS THE ATLANTIC OCEAN UNDER ITS OWN POWER DEPARTED THE UNITED STATES FROM NEWPORT

(December 4, 1917)

Keel laid	December 22, 1909, at the Fore River Shipbuilding Company, Quincy, Massachusetts
Launched	May 27, 1911
Commissioned	February 14, 1912
Length	135 feet, 3 inches
Displacement	342 tons

According to Kane's *Famous First Facts*, the submarine left Newport on December 4, 1917, under the command of Lieutenant Chester William Nimitz and arrived at Ponta Delgada, in the Azores. Nimitz had a long association with this city. The submarine crew's mission was to protect the islands from German U-boats during World War I.

The first photograph of German submarine *U-53* as it entered Newport in October 1917. According to newspapers, it left Newport and began sinking foreign ships off the Nantucket Lightship. Since the United States had not entered World War I, little could be done, although our destroyers were on the scene. The *U-53* incident shocked the entire country and, in part, influenced the nation to go to war. *Author's collection.*

NEWPORT WAS THE BIRTHPLACE OF THE INVENTOR OF THE TECHNICOLOR PROCESS FOR MOTION PICTURES

(Debuted November 1922)

Daniel Comstock was born on August 14, 1883, on Ruggles Avenue to Nellie Preston (Barr) and Ezra Young Comstock. His father came from a railroad family and was a conductor for the Old Colony Railroad—the Boston to Newport route. The family lived on Ruggles when it was rural, with not many homes. He was a 1904 graduate of the Massachusetts Institute of Technology and went on to study in Germany, Switzerland and England before returning to become an instructor, assistant professor and then associate professor of theoretical physics at MIT.

Prior to World War I, millions of dollars had been spent on the practical development of motion pictures in natural color. All of these attempts had failed; it was said to be too complicated for various reasons and could never be done. Eventually, this invention would be compared to the telephone in importance. The first practical natural color to be seen on a motion picture screen was done by a process known as Technicolor.

In December 1913, Dr. Comstock became involved with motion pictures when he was asked to evaluate and examine a machine called a Vanascope. Its purpose was to get the flickering out of movies. Feeling that this invention was not practical, Dr. Comstock developed a machine that eliminated the problem. He then turned his attention to putting natural color into the movies. Granted, the Kinemacolor process had been around, but it was not agreeable to the eye, as it produced distressing eye fatigue. For example, when a snow scene was shown, red snow followed by green snow was thrown onto the screen (the eye was supposed to fuse the two colors).

Dr. Comstock felt that this was unacceptable. In 1914 in Boston, a group of investors formed a syndicate, to be known as the Technicolor Motion Picture Corporation. The invention and its development would be carried out by the research engineering firm of Kalmus, Comstock & Wescott, Inc.

Enter Dr. Herbert Thomas Kalmus (1881–1963), who had been a classmate of Dr. Comstock. He is always mentioned as the inventor of Technicolor. Kalmus, however, was the money man, not the inventor.

Comstock directed the scientific work and was the principal inventor. However, this was a complex problem, and a team effort was needed for the long and extremely difficult process. It had many "roadblocks," Dr. Comstock wrote. It was thought by many to be impossible.

At first, they developed a method of splitting up light beams without distorting or blurring the images through a single camera lens. The next project was to build a compatible camera. Having achieved this, another roadblock emerged. There was no negative film on the market sensitive enough to get a quality picture. For example, if a girl wore a sunbonnet, her bonnet and clothing would come out fine, but her facial features in the shaded area could not be seen, even with a bright noonday sun overhead. This problem was eliminated by using existing black-and-white film and treating it with certain chemicals. A double projector system was developed for use with this film.

The next problem was that the film could only be shown using this special projector. Films could be shipped in cans from city to city, but the new film had to be accompanied by the projector from place to place. They decided to take the projector and their new film on a "road show" for public viewing. This was not unusual, since the motion-picture industry in that day lacked well-maintained projectors in theaters, which tended to tear up the films. Hence, owners of quality films would often take their own equipment around to the theaters in order to protect their investment.

The photoplay chosen for the road show was *The Gulf Between*, filmed in Jacksonville, Florida. This uneventful film was shown in various cities. In terms of color photography, the movie proved to be very agreeable to the audiences and the companies' financiers.

The next step in the process was to eliminate the special double projector so that the film could be shipped in cans and used by standard projectors. The group was working on the process of putting colors directly on film when the country entered World War I. Everything came to a halt for the duration of the war as engineers worked for the government. When the Armistice was signed in November 1918, work proceeded on putting color on film; the process was referred to as "two color."

They invented and developed a "gluing machine," which provided the results required, but only after many more roadblocks. Color was important, but so was the quality of the picture. Since people were the center of attention (actors on the screen), they realized that the picture had to be sharp and clear enough to allow one to see the whites of their eyes. This process was completed in 1921.

Newport Firsts

At this time, they felt comfortable with their product. They approached key people in Hollywood, but no one would finance a picture using the process. So in turn, the Technicolor Motion Picture Corporation financed the entire movie. The photoplay chosen was *The Toll of the Sea*; it was filmed in Hollywood, California. The first showing was scheduled for Monday November 26, 1922, at the Rialto Theater in New York City.

But there was one problem. On the Wednesday before the planned showing, something had gone terribly wrong with the solution in the tanks

Actress Joan Crawford, shown here during the 1966 commencement of Vernon Court Junior-College, received an honorary degree and had a theater named after her. Vernon Court was located on Bellevue Avenue. Crawford's career began during the black-and-white era, before transitioning into color film and television. Originally for women, Vernon Court's doors closed unexpectedly amid scandal in 1971. This real-life Bellevue Avenue scandal warranted an FBI investigation. *Courtesy of the* Newport Daily News, *Newport, R.I.*

and the film positive was coming through impossibly dark. Dr. Comstock wrote about his attempt to correct this problem: "I sat at the end of the machine continuously for 47 hours and I've always greatly admired Dr. Kalmus' administrative genius for sitting beside me, hour after hour although he had not been active in the technical side of the development. I've always found that if a man has administrative genius, he is always *where the trouble is* even when he does not know how he can help."

The problem was corrected in the nick of time, and "the first feature film to be photographed by color process" was shown as scheduled. Technicolor was a success and was eventually universally accepted.

When the last contract between the company and the engineers expired in the latter part of 1925, the syndicate was bought out by Comstock & Wescott, Inc. Dr. Kalmus was interested in the business side, but not the scientific aspect, as president of the Technicolor Company. Eventually, a third color component was added to the process, and Technicolor had virtually no competition in the production of colored motion pictures until the early 1950s.

As is well known, Technicolor is now international in scope. The name "Technicolor" is a brand name, just like Kleenex and Frisbee, and is used as a general descriptive. The trade name was invented by Kalmus, Comstock & Wescott, Inc.

Dr. Comstock obtained more than one hundred patents and invented various refrigeration processes during his lifetime. He died in Cambridge on March 2, 1970.

68

NEWPORT WAS THE SITE OF THE FIRST AIRPLANE PASSENGER LINE IN THE UNITED STATES

(June 27, 1923)

After two years of negotiations and with the strong backing of the local chamber of commerce, it was announced in the newspaper on March 26, 1923, that air service between Newport and New York City would begin in the summer of 1923.

On June 27, 1923, the inaugural flight of the Loening Air Yacht (seaplane) had on board manager Grover Loening, pilot George Edwin Rumill and two New York City newspapermen. The *Newport Daily News* headline that day read: "Newport–New York Air Line successfully opened—Large

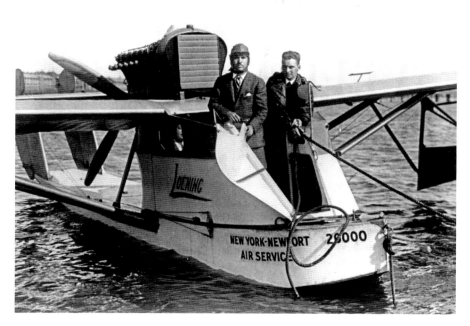

Originally called an "air yacht," this seaplane is shown in a 1923 photograph. A large crowd witnessed its first landing at Coddington Point, which is now the Naval Station at Newport. *Courtesy Library of Congress.*

numbers witness first landing at Coddington Point—what the new service means in the aviation world and to Newport." The newspaper goes on to say, "Today there has been established by actual operation the first commercial airline to be opened in the United States."

This service was founded on the principles of reliability, safety and speed. A ticket cost thirty dollars per passenger for a one-way flight. This line was a success until Friday, July 20, when the air yacht was attempting to land in Newport. The plane suddenly nosedived, which caused injury to passengers, most notably H. Cary Morgan. As a result of the incident, his leg was amputated that weekend, and by Tuesday, July 24, he was dead. The airline operation was suspended immediately, but the August 3 edition of the paper reported that there would be no abandonment of the service due to its success. But it was over. There were no more flights. The line lasted only three weeks.

As tragic as this story is, Newport did not operate the first airplane passenger service in the nation. This distinction belongs to the Tampa–St. Petersburg Airboat Line, which began regularly scheduled service on January 1, 1914. The pilot was Tony Jannus, and his passenger was Mayor Abram Pheil of St. Petersburg. The line lasted a few months during the Florida tourist season, but it ended due to the war. The cost was five dollars one way and ten dollars for a round-trip. The airplane used was the Benoist type XIV Airboat. The Smithsonian Institution recognizes this service as the "World's First Airline." An excellent account of the Newport airline may be found in Grover Loening's *Our Wings Grow Faster*.

A NEWPORT MAN BECAME THE SUBJECT OF THE FIRST BIOGRAPHICAL SKETCH PUBLISHED IN *FORTUNE* MAGAZINE AND MAINTAINED THE FIRST RAILROAD MONOPOLY NOT BROKEN UP BY THE U.S. GOVERNMENT

(*FORTUNE* I, NO. I [FEBRUARY 1930])

Arthur Curtiss James (1867–1941) was Newport's largest private employer, taxpayer and property owner with an estate that covered more than 125 acres. Longtime mass-media innovator and publisher Henry Robinson Luce (1898–1967) chose James for his startup magazine *Fortune*. Luce was responsible for *Life*, *Sports Illustrated* and *Time* magazines. In 1930, *Fortune*, at one dollar an issue, was considered a luxurious publication.

James was among America's wealthiest men, yet he spurned publicity. Self-described in *Who's Who* as a "capitalist," his holdings included well over forty thousand miles of rail, one-fourth (not one-seventeenth, as reported) of the entire track in the United States.

Born in 1867, he was the son of Ellen Curtiss and D. Willis James. His father became a partner in the mining firm of Phelps-Dodge in 1848, metallurgists in the American Southwest. The family was from the East but made their money in the West. James attended the private Arnold School in New York City and graduated from Amherst College in 1889. On April 23, 1890, he married Harriet Eddy Parsons of Northampton, Massachusetts.

When D. Willis died in 1907, Arthur and his mother each received $12 million, which included the largest single stake of Phelps-Dodge shares, along with shares of the Northern Pacific and Great Northern Railroads.

As a generous philanthropist, James's goodwill was shrouded in secrecy; a stipulation of his donation was that if his gifts were publicly revealed, they would be cancelled. Though he was the greatest of all the railroad titans, most of what the public knew of James derived from his achievements in sailing, including a circumnavigation of the globe.

In 1909, James succeeded Cornelius Vanderbilt as commodore of the New York Yacht Club. He served for two years. By this appointment, he

A.C. James gives testimony before the Interstate Commerce Commission in November 1929. James was reputed to be the owner of more railroad stock than any other man in the world at the time. *Author's collection.*

would be forever known as the "Commodore." He purchased Belvoir, a Stanford White creation located on Telegraph Hill. The site offered an incredible panoramic view of the ocean and had been used as an observation post by the Continental army during the American Revolution.

Within a month of its purchase, it was determined that the structure would not meet James's standards; the building was razed. Construction began on a new house, using the existing foundation. The rocky terrain was dynamited, and an army of workers built a railway to the hilltop so supplies could be brought in.

James acquired adjacent properties, including Edgehill, Rocky Farm, the present location of Cluny School and convent on Brenton Road, and the boathouse, which he named Aloha Landing. To complement the mansion and grounds, various gardens were carefully designed. Blasting was done in such a way that the rocks and shrubbery provided a protective barrier from the wind.

There were at least four major gardens: the sunken circular, the thousand-foot rose, the present grassy knoll of Cluny and one of America's most famous gardens, the Blue Garden. Harriet had extensive horticultural knowledge and had won awards in floral exhibits. Rocky Farm was another component of the estate, and the scenery was altered when blasting for a new farm, Surprise Valley Farm, began in 1916. The farm was created as a result of the sale of his father's Madison, New Jersey estate. The prized herd of Guernsey cows there needed a new home. James moved the herd to Newport.

"Perch a Swiss chalet here and there among the rock for the farm folk," the Commodore said. Swiss Village, a miniature replica, was the James estate's only farm and would produce food and support one hundred estate workers, *Aloha*'s crew, the New York house and a few Newport neighbors. Long active in social circles of Newport, New York and Miami, Harriet did extensive charity work. She headed the women's team of the United War Work Campaign and was an ardent supporter of the YWCA, YMCA and Red Cross.

In July 1928, at a U.S. government auction, the Commodore was the highest bidder ($7,200) for Lime Rock, the home of lighthouse keeper Ida Lewis in Newport Harbor. He and Dr. Horace P. Beck were the founders of the Ida Lewis Yacht Club, for which James served as the first commodore. James was president of the Newport Casino and a member of the Newport Reading Room, Newport Clambake Club, Newport Country Club and Bailey's Beach.

James knew that the key to the growth of America was the expansion of its rail system. Never a highly visible presence on Wall Street, in 1926, he announced that he was the majority shareholder in Western Pacific. By 1929, James was estimated to be worth $350 million. He had anticipated the stock market's imminent crash, and his interests survived relatively undamaged.

On November 10, 1931, in the remote town of Bieber, California, James took sledge in hand and, in homage to the first transcontinental rail link in 1869, drove a spike of gold into a tie, linking Chicago via the Great Northern in Seattle to the Western Pacific in California.

Control of the western rails made James a railroad titan. In an era when it was common practice to earn enormous profits through the exploitation of workers and by swindling unwary investors with phony stock schemes, James was an advocate of progressive labor policy, and he played it straight with his shareholders.

A registered Republican, James was a longtime contributor to the GOP. He kept a low political profile until an unpopular law forced him into his first political battle—on the side of the Democrats. He was an opponent of Prohibition, proclaiming, "In Europe they drink their liquor like gentlemen, like we did before they made bums out of us."

James's vehement anti-Prohibition views were likely fueled by an incident that occurred in 1926 while he was sailing on Long Island Sound. The commander of a U.S. Coast Guard cutter believed that James's swift-moving vessel had a cargo of illegal alcohol and ordered a warning shot fired. The Coast Guard subsequently boarded and searched the boat for contraband, with negative results. While large numbers of bootleggers navigated the waters off New England, in vessels small and large, it seems incredible that James's boat, *Aloha*, could be mistaken for any other.

Married for more than fifty-one years, Arthur and Harriet called each other "Bunny," their joint term of endearment. Only the Commodore dared call Harriet by the name. She died in May 1941, and he followed less than three weeks later, both in their seventies.

With no children, they followed the family tradition of philanthropy. The final will and testament created the James Foundation, which was limited to a maximum of twenty-five years. Locally, the Newport Hospital was a beneficiary. Each employee received $500 for each year of service. After twenty-five years and $144,000,000 dispersed, the foundation was liquidated. Shortly thereafter, a similar fate awaited Beacon Hill House. The property had been acquired by the Roman Catholic Diocese of Providence in 1951 as a gift of the foundation.

Once a queen of Newport palaces, it had stood abandoned since the coupled died. The *Newport Daily News* reported that it had become "the scene of drinking bouts, sex orgies and unlimited vandalism." By the 1960s, the once-magnificent gardens were heavily overgrown after years of neglect. In May 1967, someone started a fire in the house that destroyed everything except the shell, which later was ignominiously torn down.

NEWPORT IS THE SITE OF THE FIRST SUSPENSION BRIDGE IN THE WORLD TO USE SHOP-FABRICATED PARALLEL-WIRE STRANDS FOR THE MAIN CABLES; A NEW PLASTIC COVERING SYSTEM FOR CABLE PROTECTION; AND A NEW TYPE OF CABLE ANCHORAGE

(Opened to Traffic June 28, 1969)

Before the Newport Bridge, now known as the Claiborne Pell Bridge, was built, a typical motorist could wait hours to catch the ferry between Newport and Jamestown. Additionally, the ferry was not a twenty-four-hour operation.

Bethlehem Steel Corporation was responsible for its construction, which began in January 1966. Planned to cost $40 million, it came in at a cost of $61 million. The bridge measures 2.13 miles in length, and the two main spans tower four hundred feet above Narragansett Bay.

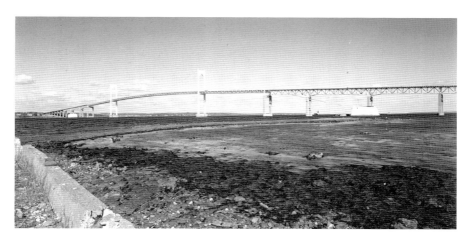

This circa 1969 photo was taken at low tide/sea level from Rose Island, looking north toward the Newport/Pell Bridge, the longest (2.13 miles) and largest suspension bridge in New England. *Courtesy Library of Congress.*

A Hundred Claims to Fame

This circa 1969 aerial view shows Fort Adams, Narragansett Bay and Newport Bridge. Seven islands can be seen in this photograph. The bridge is now known as the Claiborne Pell Bridge, named in honor of a longtime U.S. senator from Newport. Newporters still call the bridge by its original name. *Courtesy Library of Congress.*

The use of shop-fabricated, prefabricated parallel-wire strands eliminated the time-consuming practice of spinning bridge cables wire by wire. Prefabricated on land, the strands were placed on reels and barged from the Long Wharf area to the bridge for quick assembly. Most of the superstructure was prefabricated; the bridge was actually built on land and then assembled on the bay.

The roadway has a vertical clearance of over two hundred feet above the mean high watermark. It is tall enough to allow aircraft carriers to pass underneath.

In time, lawsuits between the state and Bethlehem Steel Corporation arose due to a faulty paint job, which began peeling soon after the bridge was opened. Still called the Newport Bridge by Newporters, the name was changed to honor U.S. senator Claiborne Pell. It is the longest suspension bridge in New England.

71

INTERNATIONAL SAIL TRAINING RACES (TALL SHIP RACES) FINISHED FOR THE FIRST TIME IN THE UNITED STATES IN NEWPORT

(June 1976)

Until 1976, the Tall Ship Races were held every other summer in the waters off the Baltic, around the British Isles and in the North Sea. But for the very first time, the race (not to be confused with the America's Cup) finished in the United States with Newport as the destination. As part of the American bicentennial celebration, Barclay Warburton III was instrumental in bringing the tall ships here.

The race consisted of three legs. The fleet of ships left Plymouth, England, on May 2, 1976, headed for Tenerife, Canary Island. Upon the completion of the first leg, it was straight across the Atlantic Ocean to Bermuda, where other ships joined, swelling the total to ninety-two ships. By the time they reached Newport, 4,500 total ocean miles had been covered.

This last leg, from Bermuda to Newport, which covered 634 miles, was marred by collisions, confusion and acts of nature. At the start, eighteen Class A ships juggled for position, but six were involved in collisions. The *Libertad* (Argentina) and *Juan Sebastiàn de Elcano* (Spain) suffered the most damage.

The large ships ran into one problem: no wind! Plagued by a weeklong drought, they averaged only forty miles instead of covering more than one hundred miles per day.

The *Gorch Fock* (Germany) was in the lead, but the *Dar Pomorza* (Poland) hoped to unseat it, taking a different approach to Newport. Instead of setting a northeast course, Captain Kazimierz Jukiewicz headed west. Sensing that the wind would diminish even more over the next few days, he thought the Gulf Stream current would make for a quicker approach to Newport.

As fear set in, officials called the race off when it became clear that the ships would never finish within the allotted time. If they didn't, some of the planned Newport activities would be jeopardized.

A Hundred Claims to Fame

James Anderson, spokesman for the British Sail Training Association, commented, "The whole purpose is to get the cadets together on shore after their time at sea. It's all to the good, this character training, but there comes a time when enough is enough." When the termination of the race was announced, it needed two-thirds approval of the participating captains. Only Captain H.V. Stackelberg of the *Gorch Fock* wanted to continue under sail.

The eight Class B ships did not finish their race, and *Sayula II* (Mexico) crossed the line on Thursday, June 24. Even though the Class A race was called, the *Dar Pomorza* and *Gorch Fock* would finish together. They arrived in a morning fog and ventured up Narragansett Bay to the awaiting flotilla of pleasure craft. With the race over, ships were in port by Sunday awaiting a long list of activities and events. The celebration offered an opportunity to foster international relations, as most of the participating cadets had never been to America. Newporters mobilized in force to showcase the City by the Sea in connection with the planned activities and the throngs of people expected to descend here.

Never in the twentieth century had so many tall ships gathered together in celebration at one time. Newport never witnessed crowds of this magnitude (unconfirmed reports claimed 400,000 people at the weeklong event). The city, waterfront, harbor and Narragansett Bay were a sea of activity. The newly opened America's Cup Avenue was reserved for pedestrians; automobile traffic was banned. Some ships, longer than football fields, were moored outside the harbor and engulfed by circling pleasure craft.

The entire event was splashed in a wave of goodwill, but there was some controversy. The *Esmeralda* of Chile was the subject of a hot political issue, due to its supposed role in that country's regime as a torture ship in the early 1970s. A gentleman adorned with a white captain's cap in a small

A busy Newport Harbor during the original 1976 tall ship bicentennial celebration. No other Newport tall ship gathering has matched the magnitude of the first one. *Author's collection.*

powerboat—blowhorn and all—protested the ship at her mooring. As he circled the 317-foot vessel, the crackling sound of "Go home, go home" could be heard from the blowhorn. Welcome to America!

On Thursday, July 1, 1976, fog postponed the initial morning start, but the afternoon saw the customary Parade of Sail begin, thus putting Operation Sail '76 into motion. For some, it was a day of celebration. There were family parties with perfect views and old prams full of ice and beverages. An estimated 100,000 people lined the shores and islands of Narragansett Bay to witness the parade as the ships headed for New York City for our country's bicentennial bash.

The entire event was extraordinary! Subsequent tall ship celebrations have failed to match the magnitude and excitement generated by the one in 1976. For some, these events have become old hat. But such celebrations allow a glimpse into a bygone era.

THE FIRST BUS IN THE UNITED STATES TO BE COMPLETELY CONSTRUCTED OF NON-CORROSIVE STAINLESS STEEL BEGAN SERVICE FROM NEWPORT

(1978)

Rhode Island Public Transit Authority's Newport bus no. 7801 serviced the Newport-to-Providence route. The bus, measuring thirty-five feet long by ninety-seven inches wide, logged 375,000 miles between the two cities before it was retired in 1992.

73

NEWPORT WAS THE SITE OF THE FIRST AMERICAN SKIPPER TO LOSE THE AMERICA'S CUP

(September 26, 1983)

Americans had successfully defended the America's Cup for 132 years. In the twenty-fifth defense, Dennis Conner, aboard the twelve-meter yacht *Liberty*, lost the best-of-seven series four to three. The last race was won by the Australians by a margin of forty-one seconds.

Dennis Conner had an excellent chance of winning. He was ahead of the Australians late in the race. However, he failed to "cover" his opponent. (To "cover" means getting in front of and staying directly between your opponent and the direction of the wind. If he tacks right, you tack right. If he tacks left, you tack left. If you stay in control and maintain a coffin lid over your opponent, he cannot sail through you.) Later that evening, a tearful Conner offered no excuses as he addressed the post-race conference at the Thames Street Armory. Conner is also credited with being **the first American to win back the America's Cup**, in 1987.

On the other hand, John Bertrand became **the first foreign skipper to win the America's Cup**. Competing in their seventh challenge for the Cup, the Australians, aboard the twelve-meter yacht *Australia II*, roared back from a three-to-one deficit to win the deciding seventh race.

It was dubbed "the race of the century." The Australians won by a margin of forty-one seconds over the *Liberty*, thus ending the longest winning-streak in sports history.

As darkness descended after an amazing sunset, the Australians paraded clockwise around Newport Harbor before settling in at their berth at Williams & Manchester Shipyard. The wing keel, which people believed was the difference in speed between the two boats, was unveiled for the first time in front of a sea of people. The shipyard where the *Australia II* was berthed no longer exists. It is the present-day site of the Newport Onshore Resort Hotel on Thames Street.

NEWPORT IS HOME TO THE FIRST COMBINED EMERGENCY, TRANSITIONAL AND LOW-INCOME HOUSING COMPLEX IN THE UNITED STATES

(Dedicated March 31, 1989)

History, beaches, yachting, colonial homes and mansions are among the amenities associated with Newport. But one of its most unique features is the diversity of its people, reflecting a wide range of social and economic backgrounds. Newport was a fitting site for this unusual housing complex.

This five-story, yellow-brick building was completed in 1911. It was an important fixture when Newport was a navy town. Known as the Army and Navy YMCA, but commonly referred to as the "Navy Y," it served visiting army and navy personnel. It was a haven for servicemen until the ordered military base shutdowns of the early 1970s. Over the ensuing years, the building became a haven, not for servicemen, but for pigeons. Lying practically vacant, it would eventually open for the 1976 Tall Ship Celebration.

Offering an extraordinary view of Newport Harbor, it could have been a prime target for condominium conversion (or worse, a parking lot). It was underutilized, but by the mid-1980s efforts were being made to transform this structure. After some serious obstacles and the maneuvering for funds in excess of the $5.5 million needed to obtain and renovate this downtown landmark, the project would finally be realized.

This was all made possible by a large-scale community, state and national effort involving elected officials, social-service and housing agencies, local residents and private funding sources. It was the first in the nation to receive funding under the new Stewart B. McKinney Homeless Assistance Act, administered by the U.S. Department of Housing and Urban Development.

The official start of the project was April 8, 1988, with the traditional ceremonies and speeches held across the street at the Old Colony House/Old State House. The construction and renovation was completed within the year, and the ribbon-cutting ceremony was held on March 31, 1989.

Army & Navy Young Men's Christian Association (YMCA) was built in 1911 and is located at the northeast corner of Washington Square, opposite the Old Colony House/Old State House. The Navy Y, as Newporters call it, fills an entire city block. *Courtesy Library of Congress.*

The structure at 50 Washington Square was divided into several areas, including the McKinney Shelter at 15 Meeting Street, the Emery Lodge at 4 Farewell Street and the River Lane apartments at 19 Meeting Street.

The breakdown for the original living arrangements was as follows: the lower-level housed the emergency shelter for men, with eighteen beds; the transitional shelter for men had six rooms, two men per room, for a total of twelve beds. On the second floor, the women's emergency shelter offered six single beds and 1 room for one family. The women's transitional component included two single beds and 1 room for one family. The upper floors were the low-income permanent housing component, with 108 units—70 single rooms, 15 efficiencies and 23 one-bedroom apartments.

This unique project, which reflected the changing times, is located in the oldest section of Newport.

THE FIRST JUDICIAL COMPLEX IN THE UNITED STATES NAMED IN HONOR OF A WOMAN IS LOCATED IN NEWPORT

(Dedicated June 24, 1990)

Located at the top of Washington Square, this two-and-a-half-story structure was dedicated on September 6, 1927. When erected, it replaced two earlier buildings on this site. When this facility was undergoing an extensive $3.5 million renovation, legislation was introduced into the Rhode Island General Assembly to rename the Newport County Courthouse as the Florence Kerins Murray Judicial Complex.

Florence Murray was born in Newport on October 21, 1916, and was a 1933 graduate of Rogers High School. She continued her schooling at Syracuse University. In the following years (1938–40), she lived on the Narragansett Bay island of Prudence as the sole teacher for the one-room schoolhouse. Later, Murray was the only woman to graduate in the class of 1942 from Boston University Law School.

With war clouds looming, Murray opted for military service. Before retiring from the Women's Army Corps in 1946, she had attained the rank of lieutenant colonel, the youngest woman to do so.

Once home, she practiced law and ran a successful campaign for the Rhode Island State Senate. Elected in 1948, Murray served in this capacity for eight years, while at the same time working in a joint law practice with her husband, former U.S. attorney Paul F. Murray.

In 1956, she became the first woman in New England to be appointed to a superior court judgeship. After serving twenty-two years on the bench of Rhode Island's major trial court, Murray was elevated to the state Supreme Court, becoming the first and only female presiding justice.

A proponent of education and women's rights, she received more than forty honors and awards recognizing her contributions to our state government. Murray was duly honored on June 24, 1990, when the Newport Country Courthouse was renamed in her honor. She passed away in Newport on March 28, 2004, and her longtime residence was located on the northeast corner of Kay Street and Bellevue Avenue.

A NOTE ON SOURCES

Remember to use the sources very carefully and don't always believe what you read. In many cases, modern books or articles concerning Newport have taken as true existing information when, in fact, it has often proved inaccurate. This can lead to a snowball effect. Listed here are a few sources. They are fairly accurate and good source material. The Internet was not used in any capacity for research or information in this book.

In most cases, the *Newport Mercury* was a far superior newspaper compared to the *Newport Daily News*. The Newport City Atlases and Newport City Directories, when combined with the newspapers, offer a tremendous wealth of information and are excellent cross-references. Keep in mind that the 1882 postal service change required the renumbering of houses and buildings throughout Newport.

Recommended List

The Biographical Cyclopedia of Representative Men of Rhode Island. Providence, RI: National Biographical Publishing, 1881.

Bridenbaugh, C. *Cities in Revolt: Urban Life in America, 1743–1776.* New York: Oxford University Press, 1955.

———. *Cities in the Wilderness: The First Century of Urban Life in America, 1625–1742.* New York: Ronald Press, 1938.

A Note on Sources

Dexter, F.B., ed. *The Literary Diary of Ezra Stiles*. New York: Charles Scribner's Sons, 1901.

Downing, A.F., and V.J. Scully Jr. *The Architectural Heritage of Newport, Rhode Island: 1640–1915*. 2nd ed. New York: Clarkson N. Potter, 1967.

Jordy, W.H., and C.P. Monkhouse. *Buildings on Paper: Rhode Island Architectural Drawings, 1825–1945*. Providence, RI: Bell Gallery, Brown University, 1982.

Kane, J.N., S. Anzovin and J. Podell. *Famous First Facts*. 5th ed. New York: Random House, 1997.

Peterson, E. *History of Rhode Island*. New York: John S. Taylor, 1853.

Sources to Be Used with Caution

Bartlett, J.R., ed. *Records of the Colony of Rhode Island and Providence Plantations in New England*. 10 vols. Providence, RI: A.C. Greene, 1856–65. Use with extreme caution.

Bayles, R.M., ed. *History of Newport County, Rhode Island*. New York: L.E. Preston, 1881.

Elliott, M.H. *This Was My Newport*. Cambridge, MA: Mythology, 1944. Use with extreme caution.

Federal Writers' Project. *Rhode Island: A Guide to the Smallest State*. Boston, MA: Houghton Mifflin, 1937.

Mason, G.C. *Reminiscences of Newport*. Newport, RI: Charles E. Hammett, 1884.

Simister, F.P. *Streets of the City: An Anecdotal History of Newport, Rhode Island*. Woonsocket, RI: Mowbray, 1969. Use with caution.

Van Rensselaer, J.K. *Newport Our Social Capital*. Philadelphia, PA: J.B. Lippincott, 1905. Use with caution.

BIBLIOGRAPHY

Newspapers and Periodicals

Boston Globe
Boston Sunday Herald
Frank Leslie's Illustrated Newspaper
Harper's Magazine
Harper's Weekly
Log of Mystic Seaport
Newport Daily News
Newport Mercury
Newport This Week
New York Times
Providence Journal
Scribner's Magazine

Maps and Atlases

Blaskowitz, Charles. *A Plan of the Town of Newport, Rhode Island*. London: William Faden, 1777.
Hopkins, G.M. *Atlas of the City of Newport, Rhode Island*. Philadelphia, PA: G.M. Hopkins, 1883.

Bibliography

———. *City Atlas of Newport, Rhode Island.* Philadelphia, PA: G.M. Hopkins, 1876.

Richards L.J. & Co. *Atlas of the City of Newport and Towns of Middletown and Portsmouth, Rhode Island.* Springfield, MA: Richards, 1907.

———. *Atlas of the City of Newport, Rhode Island.* Springfield, MA: Richards, 1893.

Stiles, Reverend Ezra. *Map of Newport.* Newport, 1758.

Articles and Primary Sources

Amacker, Milton W. "A Century at Castle Hill." *Rhode Island Yearbook '74.* Providence: Rhode Island Yearbook Foundation, 1973.

Barrows, C. Edwin, ed. "The Diary of John Comer." *Collections of the Rhode Island Historical Society* 8 (1893).

Bicknell, Thomas W. "Early Education in New England." *Magazine of New England History* 2, no. 3 (July 1892).

Bridenbaugh, Carl. "Colonial Newport as a Summer Resort." *Rhode Island Historical Society Collections* 26, no. 1 (January 1933).

Browne, Howard S. "Newport's Revolutionary Physicians." *Newport History: Bulletin of the Newport Historical Society* 54, part 1, no. 181 (Winter 1981).

Callender, John Rev. "An Historical Discourse of the Civil and Religious Affairs of the Colony of Rhode Island and Providence Plantations." *Collections of the Rhode Island Historical Society* 4 (1838).

Campbell, Paul R., and Glenn W. LaFantasie. "Scattered to the Winds of Heaven—Narragansett Indians 1676–1880." *Rhode Island History* 37, no 3 (August 1978).

Cole, James S. "Newport's Early Circus." *Newport History: Bulletin of the Newport Historical Society* 64, part 4, no. 221 (Fall 1991).

Comstock & Westcott, Inc. "The Story of the Beginnings of Technicolor 1914–1925." Unpublished.

Conley, Patrick T. "Revolution's Impact on Rhode Island." *Rhode Island History* 34, no. 4 (November 1975).

De Wire, Elinor. "Women of the Lights." *American History Illustrated* 21, no. 10 (February 1987): 43–48.

"The First Professional Match in America." *American Lawn Tennis* 21, no. 11 (November 20, 1927).

Impelliter, Vincent R., mayor of New York. Letter to Dean J. Lewis, mayor of Newport, July 15, 1953 (copy at Newport Historical Society).

Journal of the History of Medicine and Allied Sciences 1, no. 1 (January 1946): 25–40.

Krumbhaar, E.B. *Doctor William Hunter of Newport, Rhode Island.* Reprinted from *Annals of Surgery*. Philadelphia: J.B. Lippincott Company, January 1935.

La Farge, Margaret. "Old Newport." *Scribner's Magazine* 62, no. 5 (November 1917).

Mason, George C. "The United Company of Spermaceti Chandlers." *Magazine of New England History* 2, no. 3 (July 1892).

Metz, William D. "The Road to Rebellion." *Rhode Island Yearbook '74.* Providence: Rhode Island Yearbook Foundation, 1973.

Newport Birth Certificates, Death Certificates, Marriage Certificates. Newport City Hall, Newport, Rhode Island.

New York Department of Health. Certified copy of entry in "Bodies in transit for the year 1866–68," from William Stern, Borough Registrar, Manhattan, May 11, 1954 (copy at Newport Historical Society).

Oestreich, Alan E. "Marcus Fitzherbert Wheatland, MD." *Journal of the National Medical Association* 87, no. 11 (November 1995).

Peabody Museum of Salem. *Michele Felice Cornè 1752–1845—Versatile Neapolitan Painter of Salem, Boston & Newport.* Salem, MA: Peabody Museum of Salem, 1972.

Rhode Island Historical Preservation Commission 1977. *The West Broadway Neighborhood, Newport, Rhode Island.* Statewide Historical Preservation Report N-N-2.

Rhode Island State Archives. C#00204. "Rhode Island Colony Records."

Rider, Hope S. "The History of the Sloop Providence." *Continental Sloop Providence Commissioning* 24 (October 1976).

"Stage Coaches to Newport, RI." *Old Time New England. Bulletin of the Society for the Preservation of NE Antiquities* 26, no. 2 (October 1935).

"Stage-Coach Routes." *Rhode Island Historical Society Collections* 31, no. 3 (July 1938).

Warburton, Barclay. "Sail Training as a Modern Idea." *Tall Ships '76.* Newport, RI: Cruising World Publications, 20–22.

Books

Adamson, Hans Christian. *Keepers of the Lights.* New York: Greenberg, 1955.

Allen, Helen Farrell, Robert Beach, Bud Collins and Allison Danzig. *The International Tennis Hall of Fame: Newport, Rhode Island.* Newport, RI: National Tennis Foundation and Hall of Fame, 1979.

Bibliography

Amory, Cleveland. *The Last Resorts*. New York: Harper and Brothers, 1948.

Asimov, Isaac. *Isaac Asimov's Book of Facts*. New York: Grosset & Dunlap, 1979.

Baarslag, Karl. *SOS to the Rescue*. New York: Oxford University Press, 1935.

Backus, Isaac. *A History of New England with Particular Reference to the Denomination of Christians Called Baptists*. Vol. 1. Newton, MA: Backus Historical Society, 1871, 277–81, 348–51.

Baker, Paul R. *Richard Morris Hunt*. Cambridge, MA: MIT Press, 1980.

Bearse, Ray, ed. *Massachusetts: A Guide to the Pilgrim State*. 2nd ed. Boston: Houghton Mifflin, 1971.

Bent, Newell. *American Polo*. New York: Macmillan, 1929.

The Biographical Cyclopedia of Representative Men of Rhode Island. Providence, RI: National Biographical, 1881.

Biographical Directory of the American Congress 1774–1961. Washington, D.C.: United States Printing Office, 1961.

Bishop, J. Leander. *A History of American Manufactures from 1608–1860*. 3rd ed. Vol. 2. Philadelphia, PA: Edward Young, 1868.

Boatner, Mark Mayo, III. *Encyclopedia of the American Revolution*. New York: David McKay, 1966.

Bourne, Russell. *The Red King's Rebellion*. New York: Atheneum, 1990.

Brewerton, George D. *Ida Lewis, The Heroine of Lime Rock*. Newport, RI: A.J. Ward, 1869.

Bridenbaugh, Carl. *Cities in Revolt: Urban Life in America, 1743–1776*. New York: Alfred A. Knopf, 1955.

———. *Cities in the Wilderness: The First Century of Urban Life in America, 1625–1742*. New York: Ronald Press, 1938.

Carruth, Gorton and Associates, eds. *The Encyclopedia of American Facts and Dates*. 4th ed. New York: Thomas Y. Crowell, 1966.

Carse, Robert. *Keepers of the Lights: A History of American Lighthouses*. New York: Charles Scribner's Sons, 1969.

Chapin, Ann A., and Charles V. Chapin. *A History of Rhode Island Ferries 1640–1923*. Providence, RI: Oxford Press, 1925.

Clark, William Bell. *George Washington's Navy*. Baton Rouge: Louisiana State University Press, 1960

Clayton, Barbara, and Kathleen Whitley. *Historic Coastal New England*. Old Saybrook, CT: Globe Pequot, 1992.

Coggeshall, W.J., and J.E. McCarthy. *The Naval Torpedo Station Newport, Rhode Island—1658 through 1925*. Newport, RI: Training Station Press, 1920. Reprint, Remington Ward, 1944.

Bibliography

Cole, J.R. *History of Washington and Kent Counties, Rhode Island*. New York: W.W. Preston, 1889.

Conley, Patrick T. *First in War, Last in Peace*. Providence: Rhode Island Bicentennial Foundation and the Rhode Island Publications Society, 1987.

Cooper, J. Fenimore. *History of the Navy of the United States of America*. 2nd ed. Vol. 1. Philadelphia, PA: Lea and Blanchard, 1840.

Coughtry, Jay. *The Notorious Triangle*. Philadelphia, PA: Temple University Press, 1981.

Crane, John, and James F. Kieley. *United States Naval Academy: The First Hundred Years*. New York: Whittlesey House McGraw-Hill, 1945.

Crews, Guy M. *History of the American Jersey Cattle Club, 1868–1968*. Columbus, OH: American Jersey Cattle Club, 1968.

Cummings, Parke. *American Tennis*. Boston: Little, Brown, 1957.

Davis, Lucius D. *History of the Methodist Episcopal Church, in Newport, R.I.* Newport, RI: Davis & Pitman, 1882.

Dexter, Franklin Bowditch, ed. *The Literary Diary of Ezra Stiles*. New York: Charles Scribner's Sons, 1901, 1: 346, 347, 399, 618–20, 626–28; 2: 124, 161.

Dictionary of American Biography. 20 vols. with 10 supplements. New York: Charles Scribner's Sons, 1928–1995. Published under the auspices of the American Council of Learned Societies.

Dow, George Francis. *Whale Ships and Whaling*. Salem, MA: Marine Research Society, 1925.

Downing, Antoinette F., and Vincent J. Scully Jr. *The Architectural Heritage of Newport, Rhode Island 1640–1915*. 2nd ed. New York: Clarkson N. Potter, 1967.

Drake, Edward. *Early Seafights of the American Revolution*. New Bedford, MA: Sons of the American Revolution, New Bedford Chapter, 1930.

Drake, Samuel Adams. *Old Boston Taverns and Tavern Clubs*. Boston: W.A. Butterfield, 1917.

———. *Old Landmarks and Historic Personages of Boston*. Boston: James R. Osgood, 1873.

Dunbar, Seymour. *A History of Travel in America*. Indianapolis, IN: Bobbs-Merrill, 1915.

Dupuy, Trevor N., and Gay M. Hamerman, eds. *People & Events of the American Revolution*. New York and Dunn Loring, VA: R.R. Bowker Company and T.N. Dupuy Associates, 1974.

Earle, Alice Morse. *Stage-Coach and Tavern Days*. New York: Macmillan, 1905.

Ellis, George W., and John E. Morris. *King Philip's War*. New York: Grafton Press, 1906.

Bibliography

Fifty Years of Lawn Tennis in the United States. New York: United States Lawn Tennis Association, 1931.

French, Allen. *General Gage's Informers*. New York: Greenwood Press, Publishers, 1968.

Fulmer, Robert M., and Harold Koontz. *A Practical Introduction to Business*. Homewood, IL: Richard D. Irwin, 1978.

Gallagher, Joan. *The John Clarke Property, Newport, Rhode Island: Its History and Archaeology*. Providence, RI: Public Archaeology Laboratory, Department of Anthropology, Brown University, 1981.

Garrity, John A., and Mark C. Carnes, eds. *American National Biography*. 24 vols. New York: Oxford University Press; American Council of Learned Societies, 1999.

Gleason, Sarah C. *Kindly Lights: A History of Lighthouses of Southern New England*. Boston: Beacon Press, 1991.

Gow, R.M. *The Jersey: An Outline of Her History During Two Centuries—1734 to 1935*. New York: American Jersey Cattle Club, 1938.

Gregory, Ruth W. *Anniversaries and Holidays*. 3rd ed. Chicago: American Library Association, 1975.

Griffis, William Elliot. *Matthew Calbraith Perry—A Typical American Naval Officer*. Boston: Cupples and Hurd, 1887.

Griswold, Frank Gray. *The International Polo Cup*. New York: Duttons, 1928.

Groce, George C., and David H. Wallace. *The New York Historical Society's Dictionary of Artists in America 1564–1860*. New Haven, CT: Yale University Press, 1957.

Guinness, Desmond, and Julius Trousdale Sadler Jr. *Newport Preserv'd*. New York: Viking Press, 1982.

Hamilton, Dr. Alexander. *Gentleman's Progress: The Itinerarium of Dr. Alexander Hamilton 1744*. Edited with introduction by Carl Bridenbaugh. Chapel Hill: Published for Institute of Early American History and Culture by the University of North Carolina Press, 1948.

Hatch, Jane M., ed. *The American Book of Days*. 3rd ed. New York: H.W. Wilson, 1978.

Hattendorf, John B., B. Mitchell Simpson III and John R. Wadleigh. *Sailors and Scholars: The Centennial History of the U.S. Naval War College*. Newport, RI: Naval War College Press, 1984.

Hazard, Thomas Robinson. *The Jonny-Cake Papers of "Shepherd Tom," Together with Reminiscences of Narragansett Schools of Former Days*. Boston: D.B. Updike, Merrymount Press, 1915.

Bibliography

Hedges, James B. *The Browns of Providence Plantations*. Cambridge, MA: Harvard University Press, 1952.

History of the United States Postal Service. Washington, D.C.: United States Postal Service, 1994.

Hollen, Norma, and Jane Saddler. *Textiles*. 2nd ed. New York: Macmillan, 1964.

Horne, Charles E., III. "United States Naval War College." *The 1972 Rhode Island Yearbook*. Providence: Rhode Island Yearbook Foundation, 1971.

Hunt, William Dudley, Jr. *Encyclopedia of American Architecture*. New York: McGraw-Hill, 1980.

James, Edward T., Janet Wilson James and Paul S. Boyer, eds. *Notable American Women, 1607–1950*. Cambridge, MA: Belknap Press of Harvard University Press, 1971, 1: 219, 220, 662, 663; 3: 465, 466.

James, Sydney V. *Colonial Rhode Island: A History*. New York: Charles Scribner's Sons, 1975.

Jenkins, J.T. *A History of the Whale Fisheries*. London: H.F. & G. Witherby, 1921.

John La Farge: Watercolors and Drawings. Yonkers, NY: Hudson River Museum of Westchester, 1990.

Johnson, Melvin Maynard. *Freemasonry in America Prior to 1750*. Cambridge, MA: Caustic-Claflin, 1917.

Jones, Rufus M. *The Quakers in the American Colonies*. London: Macmillan, 1911.

Jordy, William H., and Christopher P. Monkhouse. *Buildings on Paper: Rhode Island Architectural Drawings 1825–1945*. Providence: Brown University, Rhode Island Historical Society, Rhode Island School of Design, 1982.

Kane, Joseph Nathan, Steven Anzovin, and Janet Podell. *Famous First Facts*. 5th ed. New York: H.W. Wilson, 1997.

Keim, Randolph. *Rochambeau*. Washington, D.C.: Government Printing Office, 1907.

Kerrigan, Evans E. *American War Medals and Decorations*. New York: Viking Press, 1964.

King, Clarence. *Mountaineering in the Sierra Nevada*. 4th ed. Boston: James R. Osgood, 1874.

La Farge, John. *The Manner Is Ordinary*. New York: Harcourt, Brace, 1954.

Lathrop, Elise. *Early American Inns and Taverns*. New York: Robert M. McBride, 1926.

Levitt, Michael, and Barbara Lloyd. *Upset: Australia Wins The America's Cup*. New York: Workman, 1983.

Bibliography

Lillie, Frank R. *The Woods Hole Marine Biological Laboratory*. Chicago: University of Chicago Press, 1944.

Lippincott, Bertram. *Indians, Privateers, and High Society: A Rhode Island Sampler*. Philadelphia, PA: J.B. Lippincott, 1961.

Lippincott, Horace Mather. *Early Philadelphia: Its People, Life, and Progress*. Philadelphia, PA: J.B. Lippincott, 1917.

Loening, Grover. *Our Wings Grow Faster*. Garden City, NY: Doubleday, Doran, 1935.

Loughrey, Mary Ellen. *France and Rhode Island, 1686–1800*. Morningside Heights, NY: King's Crown, 1944.

Lovell, R.A., Jr. *Sandwich: A Cape Cod Town*. Sandwich, MA: Sandwich Archives and Historical Center, 1984.

Macy, Obed. *The History of Nantucket*. Boston: Hilliard, Gray, 1835.

Manchester, Herbert. *Four Centuries of Sport in America 1490–1890*. New York: Derrydale Press, 1931.

Manning, Cecelia. *A Physical History of the Newport Casino*. Privately published, 1987.

Marcus, Jacob Rader. *Early American Jewry: The Jews of New York, New England and Canada 1649–1794*. Vol. 1. Philadelphia, PA: Jewish Publication Society of America, 1951.

Martin, H.B., and A.B. Halliday. *St. Andrew's Golf Club (1888–1938)*. New York: Rogers Kellogg Stillson, 1938.

Mason, George C. *Annals of the Redwood Library and Athenaeum, Newport, R.I.* 2 volumes. Newport, RI: Redwood Library, 1891.

———. *Newport Illustrated in a Series of Pen & Pencil Sketches*. Newport, RI: C.E. Hammett Jr., 1871.

———. *Reminiscences of Newport*. Newport, RI: Charles E. Hammett Jr., 1884.

Maver, William, Jr. *Maver's Wireless Telegraphy: Theory and Practice*. New York: Maver, 1904.

McConnell, Campbell R. *Economics*. 9th ed. New York: McGraw-Hill, 1984.

Melvill, David. *A Fac-Simile of the letters produced at the trial of the Rev. Ephraim K. Avery, on an indictment for the murder of Sarah Maria Cornell, taken with great care, by permission of the Hon. Supreme Judicial Court of Rhode Island from the original letters, in the office of the clerk of said court*. Newport, RI, 1833.

Menke, Frank G. *The Encyclopedia of Sports*. 5th ed. South Brunswick, NJ: A.S. Barnes, 1975.

Millar, John Fitzhugh. *Building Early American Warships*. Williamsburg, VA and Providence, RI: Thirteen Colonies Press and Rhode Island Publications Society, 1988.

Bibliography

Mills, James Cooke. *Oliver Hazard Perry and the Battle of Lake Erie*. Detroit, MI: John Phelps, 1913.

Mott, Frank Luther. *American Journalism*. New York: Macmillan, 1941.

Munsell, Joel. *A Court Martial Held at Newport, Rhode Island, In August and September, 1676, for the Trial of Indians, charged with being engaged in King Philip's War*. Albany, NY, 1858.

The National Atlas of the United States of America. Washington, D.C.: United States Department of the Interior Geological Survey, 1970.

Natkiel, Richard, and Anthony Preston. *The Weidenfeld Atlas of Maritime History*. London: Weidenfeld and Nicolson, 1986.

Nelson, Wilbur. *The Hero of Aquidneck*. New York: Fleming H. Revell, 1938.

———. *The Life of Dr. Clarke*. 5th printing. Providence, RI: Private Bank–Hospital Trust, 1983.

O'Brien, Robert, ed. *The Encyclopedia of New England*. New York: Facts on File, 1985.

O'Connor, Richard. *The Scandalous Mr. Bennett*. Garden City, NY: Doubleday, 1962.

Packard, Francis R. *History of Medicine in the United States*. New York: Paul B. Hoeber, 1931, 1: 286, 295, 297, 298; 2: 984, 985.

Paul, Raymond. *The Tragedy at Tiverton*. New York: Viking Press, 1984.

Peterson, Edward. *History of Rhode Island*. New York: John S. Taylor, 1853.

Philadelphia Architecture: A Guide to the City. Cambridge, MA: MIT Press, 1984.

Phillips-Birt, Douglas. *The History of Yachting*. New York: Stein and Day, 1974.

Placzek, Adolf K., ed. *Macmillian Encyclopedia of Architects*. New York: Free Press, 1982, 2: 436–44.

Pout, Roger. *The Early Years of English Roller Hockey: 1885–1914*. Kent, England: Roger Pout, 1993.

Price, Willadene. *Bartholdi and the Statue of Liberty*. Chicago: Rand McNally, 1959.

Prince, Thomas. *The Vade Mecum for America: Or a Companion for Traders and Travelers*. Boston: D. Henchman and T. Hancock, 1731.

Pumpelly, Raphael. *My Reminiscences*. 2 vols. New York: Henry Holt, 1918.

Putnam, George R. *Lighthouses and Lightships of the United States*. Boston: Houghton Mifflin, 1917.

Rayner, Ranulf. *The Story of Yachting*. New York: W.W. Norton, 1988.

Representative Men and Old Families of Rhode Island. Chicago: J.H. Beers & Co., 1908, 1: 229, 230.

Rhode Island: A Guide to the Smallest State. Boston: Houghton Mifflin, 1937.

Rice, Kym S. *Early American Taverns: For the Entertainment of Friends and Strangers*. Chicago: Regnery Gateway, 1983.

Bibliography

Richards, J.M., ed. *Who's Who in Architecture from 1400 to the Present Day*. London: Weidenfeld and Nicolson, 1977.

Richman, Irving Berdine. *Rhode Island: A Study in Separatism*. Boston: Houghton Mifflin, 1905.

Rider, Hope S. *Valour Fore & Aft*. Annapolis, MD: Naval Institute Press, 1977.

Roberts, Robert B. *Encyclopedia of Historic Forts*. New York: Macmillan, 1988.

Robertson, Patrick. *The Shell Book of Firsts*. London: Ebury Press and Michael Joseph, 1974.

Rose, Albert C. *Historic American Roads*. New York: Crown, 1976.

Rosten, Leo, ed. *Religions of America*. New York: Simon and Schuster, 1975.

Rugg, Henry W. *History of Freemasonry in Rhode Island*. Providence, RI: E.L. Freeman & Son, 1895.

Sargent, Porter E. *A Handbook of New England*. Boston: Porter E. Sargent, 1916.

Schroder, Walter K. *Defenses of Narragansett Bay in World War II*. Providence: Rhode Island Bicentennial Foundation, 1980.

Seltz, Don C. *The James Gordan Bennetts: Father and Son*. Indianapolis, IN: Bobbs-Merrill, 1928.

Senna, Carl, ed. *RI 350—The Spirit Burns Brighter*. Providence: Rhode Island Black Heritage Society, 1986.

Slocum, Joshua. *Sailing Alone Around the World*. New York: Century, 1900.

Slocum, Victor. *Capt. Joshua Slocum: The Life and Voyages of America's Best Known Sailor*. New York: Sheridan House, 1950.

Small, Walter Herbert. *Early New England Schools*. Boston: Ginn, 1914.

Smith, Andrew F. *The Tomato in America: Early History, Culture, and Cookery*. Columbia: University of South Carolina Press, 1994.

Snow, Edward Rowe. *Famous New England Lighthouses*. Boston: Yankee, 1945.

Stackpole, Edouard A. *The Sea-Hunters, The New England Whalemen during Two Centuries: 1635–1835*. Philadelphia, PA: J.B. Lippincott, 1953.

Starbuck, Alexander. *History of American Whale Fishery from Its Earliest Inception to the Year 1876*. Washington, D.C.: Government Printing Office, 1876, 1: 20, 149–53.

Stein, Susan R., ed. *The Architecture of Richard Morris Hunt*. Chicago: University of Chicago Press, 1986.

Stones, Edwin Martin. *Our French Allies*. Providence, RI: Providence Press, 1884.

Teller, Walter Magnes, ed. *The Search for Captain Slocum*. New York: Charles Scribner's Sons, 1956.

———. *The Voyages of Joshua Slocum*. New Brunswick, NJ: Rutgers University Press, 1958.
Thacher, James. *American Medical Biography: Memoirs of Eminent Physicians Who Have Flourished in America*. Boston: Richardson & Lord and Cottons & Barnard, 1828, 1: 304–6.
Thomas, Allen C. *A History of the Friends in America*. 5th ed. Philadelphia, PA: John C. Winston, 1919.
Thompson, Edmund R. *Secret New England Spies of the American Revolution*. Kennebunk, ME: David Atlee Phillips New England Chapter Association of Former Intelligence Officers, 1991.
Thorndike, Joseph J., Jr., ed. *Three Centuries of Notable American Architects*. New York: American Heritage, 1981.
Townsend, George Alfred. *Lives of Harrison and Morton*. Philadelphia, PA: Hubbard Brothers, 1888.
United States Lawn Tennis Association. *Official Encyclopedia of Tennis*. New York: Harper and Row, 1972.
U.S. Treasury Department. *Register of all Officers and Agents, Civil, Military, and Naval, in the Service of the United States, on the Thirtieth September, 1851*. Washington, D.C.: Gideon, 1851.
Van Doren, Charles, and Robert McHenry, eds. *Webster's American Biographies*. Springfield, MA: G. & C. Merriam, 1974.
Waern, Cecilia. *John La Farge: Artist and Writer*. New York: Macmillan, 1896.
Waring, George E., Jr. *The Handy-Book of Husbandry: A Guide for Farmers, Young and Old*. New York: E.B. Treat, 1870.
Webster's New Geographical Dictionary. Springfield, MA: G. & C. Merriam, 1972.
Weeden, William B. *Early Rhode Island: A Social History of the People*. New York: Grafton Press, 1910.
———. *Economic and Social History of New England: 1620–1789*. Boston: Houghton Mifflin, 1890, 2: 455, 456.
Weisberger, Bernard A. *Statue Liberty: The First Hundred Years*. New York: American Heritage, 1985.
Whitridge, Arnold. *Rochambeau*. New York: Macmillan, 1965.
Who Was Who in America: Historical Volume 1607–1896. Chicago: A.N. Marquis, 1963.
Wilkins, Thurman. *Clarence King*. New York: Macmillan, 1958.
Williams, Thomas J. *Coasters Harbor Island and the Newport Naval Training Station: Their Activities and Growth*. Newport, RI: Training Station Press, 1937.
Wind, Herbert Warren. *The Story of American Golf*. New York: Farrar, Straus, 1948.

Winsor, Justin, ed. *The Memorial History of Boston*. Vol. 4. Boston: James R. Osgood, 1883.

Withey, Henry F., and Elsie Rathburn Withey. *Biographical Dictionary of American Architects (Deceased)*. Los Angeles: Hennessey & Ingalls, 1970.

Yarnall, James L. *John La Farge in Paradise: The Painter and His Muse*. Newport, RI: William Vareika Fine Arts, 1995.

Young, Bob, and Jan Young. *Frontier Scientist: Clarence King*. New York: Julian Messner, 1968.

Youngken, Richard C. *African Americans in Newport: An Introduction to the Heritage of African Americans in Newport, Rhode Island: 1700–1945*. Providence: Rhode Island Historical Preservation & Heritage Commission; Rhode Island Black Heritage Society, 1995.

INDEX

A

Agassiz, Alexander 118
Aloha 175
American Jersey Cattle Club 102, 103, 195, 196
America's Cup 180, 181, 184, 197
Aquidneck Island 199
Atlantic House 96, 100, 101
Avery, Ephraim K. 89, 198

B

Baptists 20, 194
Bateman House 150
Belcourt Castle 95, 161
Bennett, James Gordon, Jr. 115, 116, 137
Boston Latin School 16, 62, 93
Boston, Massachusetts 16, 20
Brenton House 78
Butler Hospital 132

C

candles 42, 43, 48, 58
Cape Cod 198
Charles II, King of England 28
Charleston, South Carolina 57
Charter of 1663 19, 28, 50
Church, Benjamin 34
circus 55, 56
Clarke, John 18, 19, 22, 28, 29, 196
coaching 108
Coddington, William 28
Common Burial Ground 67, 75, 79, 84, 125
Comstock, Daniel 168
conscientious objector 31
Cornell, Sarah M. 89

D

Deadhead Hill 116, 117, 147
de Ternay, Charles Louis D'Arsac Chevalier (Admiral) 68, 69
Dorchester, Massachusetts 16

INDEX

E

Easton, Nicholas 22

F

Fairhaven, Massachusetts 61, 159
Fairlawn 95, 145, 146
Flushing, New York 20
Fort Adams 96, 121, 122
Franklin, Benjamin 69
Freemasonry 24, 197, 200

G

gas streetlight 74
Gazette Francoise 69, 70
Goat Island 50, 51, 96, 106, 107, 165
golf 150, 151, 154, 155, 156
Grant, Ulysses S. 145

H

Harper's Weekly 100, 122, 191
Hartford, Connecticut 68
Havemeyer, Theodore 150
HMS *Liberty* 50
HMS *Rose* 60
HMS *St. John* 50
Hunter House 68, 70, 92
Hunter, William 193
Hunt, Richard Morris 93, 113, 130, 194, 200

I

International Tennis Hall of Fame 136, 139, 193
Island Cemetery 79, 95, 109, 128, 153

J

James, Arthur Curtiss 174
Jamestown, Rhode Island 75
Jamestown, Virginia 16, 57

K

Kane, Delancy A. 108
King, Clarence 126
King Philip's War 18, 33, 195, 199

L

La Farge, John 130
League of American Wheelmen 133
Lewis, Ida 120
"Lexington of the Sea, the" 61
Long Wharf 50, 68, 106, 122, 179

M

Macdonald, Charles Blair 151
Machias, Maine 61
Malbone, Deborah 47
Marconi, Guglielmo 164
marine biological laboratory 118

INDEX

Masonic Grand Lodge 24
Medal of Honor 123
Melvill, David 74
Middletown, Rhode Island 104
Morton, Levi P. 145
Morton Park 115, 117, 146

N

Nahant, Massachusetts 110, 140
Nantucket Relief Lightship 165, 166
New Haven, Connecticut 85
Newport Casino 136, 138, 139, 140, 148, 176, 198
Newport Country Club 150, 154, 176
Newport Daily News 189
Newport Mercury 14, 55, 189
New York, New York (New Amsterdam) 13, 15, 20, 31, 39, 46, 53, 57, 87, 90, 93, 94, 100, 104, 108, 110, 111, 112, 113, 115, 122, 128, 130, 133, 137, 140, 141, 145, 150, 156, 163, 170, 172, 174, 176, 191, 192, 193, 194, 195, 196, 197, 198, 199, 200, 201, 202

O

Ogden Farm 102, 103, 104
Old Colony House 89

P

Penikese Island, Massachusetts 118
Penn, William 23
Pettitt, Tom 148
Philadelphia, Pennsylvania 39
pirates 51, 106, 159
Plymouth, Massachusetts 16
polo 115, 116, 117, 135, 136, 137, 138, 147, 150
Portsmouth, Rhode Island 192
Providence, Rhode Island 28, 190
public school 15, 16
Pumpelly, Raphael 98
Puritans 20, 21

Q

Quakers 20, 21, 22, 23, 31, 36, 58, 197

R

Redwood Library and Athenaeum 11, 198
Rehoboth, Massachusetts 34, 43
Rivera, Jacob Rodriguez 43
Rochambeau, Jean-Baptiste-Donatien de Vimeur 68
roller skating 100, 101

S

Salem, Massachusetts 193
Sandwich, Massachusetts 20, 198
slavery 34, 57, 58, 59

Index

Slocum, Joshua 159
spermaceti 42, 43, 48, 49, 58, 193
Statue of Liberty 93, 112, 145, 146, 199
Stiles, Ezra 44
St. Paul's United Methodist Church 76
Swiss Village 176

Washington, George 56, 68
Waterhouse, Benjamin 72
whaling 42, 195
Wheatland, Marcus 19, 152, 153, 193
Williams, Roger 18, 28

T

tall ships 180, 182, 193
Tally Ho 108
Taunton, Massachusetts 35
Technicolor 168, 170, 171, 192
tennis 110, 139, 140, 148, 149, 156
Tiverton, Rhode Island 89
tomato 82, 83
Touro Synagogue 13
Trinity Church 47, 68, 77, 92, 95

U

United States Postal Service 87, 197
U.S. Naval Academy 96, 100, 106

V

Vernon, William 67

W

Waring, George E., Jr 102, 103

ABOUT THE AUTHOR

A research historian, author and lecturer for thirty years, Brian Matthew Stinson grew up in Newport on upper Ayrault Street, located in the Kay-Catherine neighborhood. Stinson attended the Newport neighborhood schools of Cranston-Calvert and Mumford before graduating from St. Michael's and Rogers High. As a youth, Stinson spent summers between Newport and Wellfleet, Massachusetts, where his family had a summer home.

Stinson started his business career at age eight, when he delivered the *Providence Journal* to more than one hundred houses on a route that stretched from Kay-Catherine all the way up Broadway to One Mile Corner. Every morning, Stinson rode his bicycle, tossing newspapers with a golden retriever and then riding half of Cliff Walk—all before school.

Stinson was fortunate enough to never lose a football game and won the state championships at Rogers High under the guidance of legendary coach John Toppa Sr. Stinson could be found at local parks such as Cardines, Freebody and the Rich and indoors at the Boys Club, YMCA and the Hut. Stinson was a three-sport all-star and holds a scoring record for most goals in an indoor soccer season at the Hut that still stands.

Stinson earned the distinction of being the first paid parking lot attendant in Newport history, when Brick Market Place was built. He

About the Author

witnessed the destruction of downtown Newport from there and watched the original tall ship celebration during our country's 200th birthday.

During his college years, Stinson spent his summers working on the local beaches as an ocean lifeguard, starting with Gooseberry on Ocean Drive and the Newport Recreation Department's Kings Park and First Beach. He developed youth soccer camps in Newport—the first to do so.

Stinson received a marketing degree from Franklin Pierce in Rindge, New Hampshire. As a freshman, he was a sports editor for the school's information office and was a starter on the varsity soccer team. In addition, Stinson was elected the first marketing club president and provided radio color commentary for the college's basketball team. Stinson earned numerous intercollegiate athleticism and sportsmanship awards and ran his own advertising campaign for local merchants in the Monadnock Region.

It was there that Stinson became the first Franklin Pierce student to take the required undergraduate thesis and turn it into a business. He produced the *101 Colleges of New England Video Series*, which was distributed to high schools and libraries across the country.

Stinson has been published in various publications including the *Newport Daily News* and the sailing publication *WindCheck* magazine. He was a regular contributor and research historian for *Newport Life Magazine* for almost a decade, finishing in 2009. Stinson has also been a regular contributor to *Newport This Week*.

Additionally, he authored *Newport Notables* and was the head researcher for Rockwell Stensrud's *Newport: A Lively Experiment, 1639–1969*, published in 1997 and 2007, respectively. Both works were done under the auspices of the Redwood Library & Athenaeum in Newport, where he is a longtime member and shareholder.

Stinson has done research for authors across the United States and is considered to an expert on Newport. Presently, he is in the process of authoring a biography of philanthropist, railroad titan and yachtsman Arthur Curtiss James.

An avid rower who enjoys the surf, biking and skiing, Stinson has never married and has no children. He lives in Newport, where every day seems like vacation.